SECRET LIVES

OF

GREAT ARTISTS

Library of Congress Cataloging in Publication Number: 2008923885
ISBN: 978-1-59474-257-6

Printed in China

Typeset in Helvetica and Trade Gothic
Cover designed by Doogie Horner
Interior designed by Karen Onorato
Illustrations by Mario Zucca
Edited by Mindy Brown

10 9

Quirk Books
215 Church Street
Philadelphia, PA 19106
www.quirkbooks.com

SECRET LIVES

OF

GREAT ARTISTS

WHAT YOUR TEACHERS NEVER TOLD YOU ABOUT MASTER PAINTERS AND SCULPTORS

QUIRK BOOKS
PHILADELPHIA

BY ELIZABETH LUNDAY

ILLUSTRATED BY MARIO ZUCCA

CONTENTS

INTRODUCTION

Not all artists led tormented, tumultuous lives. Several, in fact, took perfectly ordinary paths, enjoyed successful careers, and, in the fullness of time, died.

Yet many of the most famous artists staggered from one crisis to another. Rembrandt watched all his worldly possessions disappear in a humiliating bankruptcy. Jacques-Louis David nearly lost his head during the French Revolution. And Andy Warhol got himself shot by a radical feminist. Several developed serious addictions (yes, you, Dante Gabriel Rossetti), a few had criminal records (how do you plead, Henri Rousseau?), and at least one regularly beat up his wife. (Hey, Edward Hopper, it's no excuse that she gave as good as she got.)

Still, not all artists had it tough. Marc Chagall grew up in a close-knit family bound by love and faith—unlike Leonardo da Vinci, who was illegitimate; Jackson Pollock, whose family took a head-first plunge into poverty; or Georgia O'Keeffe, who watched her father succumb to chronic alcoholism and her mother to tuberculosis.

Nor did they all have dramatic love affairs. Jan Vermeer adored his wife (or seems to, for the couple had fifteen children). In that regard he is wholly different from Claude Monet, who started sleeping with his second wife while his first was dying of cancer, or Pablo Picasso, who had a hard time keeping up with all his mistresses. Diego Rivera and Frida Kahlo's complex relationship was fraught with its fair share of drama, including two marriage ceremonies and the assassination of a twentieth-century political figure. Of course, a few artists avoided the issue altogether: The reportedly celibate Michelangelo believed abstinence extends the human lifespan, and he lived to be eighty-eight.

You can't even claim that all artists are crazy. It's true that Edvard Munch thought strangers on a train were police sent to spy on him, and Vincent van Gogh had that whole ear thing, but they're the exceptions. Paul Cézanne,

with his morbid fear of being touched, and Salvador Dalí, with his unusual sexual proclivities, were probably not insane, they were just . . . odd.

For this book, I collected the most outrageous tales about major artists—all the good stuff your art history professors left out. Of course, I had to be selective. Great art didn't start with the Renaissance or end with the death of Andy Warhol, and it isn't limited to the work of these thirty-five individuals. I chose the artists you're most likely to recognize—those whose paintings and sculptures clog our daily lives, showing up on mouse pads, pencils, tote bags, and posters.

You'll learn which artist was convicted of murder, which died of syphilis, and which signed death warrants. You'll discover which two artists have Broadway musicals based on their paintings, and who made a guest appearance on *The Love Boat*. You'll find out who suggested that firing a gun was an acceptable method of attracting a waiter's attention and who held orgies in his living room. Along the way you'll encounter a few incompetent kings, a couple of corrupt popes, a horde of nefarious Nazis, and at least one notorious Communist. Not all of the stories have happy endings, and you may learn that your favorite artist was an adulterer, a cheat, a cad, or worse.

But one thing is for sure: You'll never view art the same way again. On your next museum visit, you'll entertain friends and annoy tour guides with the dirt on the illustrious artists whose artworks fill the galleries. With your new perspective on Michelangelo's nudes, Monet's water lilies, and Warhol's Marilyns, you'll be quick to contribute a witty quote to pretentious cocktail party conversation or add a scandalous anecdote to a boring term paper.

Of course, don't let all the scuttlebutt get in the way of your appreciation of art. A person can paint like a master and still be an ass. On the other hand, knowing the trials and traumas that many artists endured can enhance your understanding of their ultimate success, and a biographical detail may shed new light on a confusing composition.

In the end, maybe we should be glad most artists died of something other than boredom. Many of the best lived on the edge of chaos, where great art is born.

JAN VAN EYCK

1385?–JULY 9, 1441

ASTROLOGICAL SIGN:
UNKNOWN, BUT CLEARLY WITH
ICONOCLASTIC LEO TENDENCIES

NATIONALITY:
FLEMISH

STANDOUT WORK:
THE ARNOLFINI PORTRAIT (1434)

MEDIUM:
OIL ON OAK PANEL

ARTISTIC STYLE:
NORTHERN RENAISSANCE

SEE IT YOURSELF:
NATIONAL GALLERY, LONDON

"JAN VAN EYCK WAS HERE." ◄ QUOTABLE

At first glance, *The Arnolfini Portrait* seems unremarkable. It's a cozy domestic scene, complete with fluffy-tailed dog and dirty shoes. Only on closer inspection do the details come to life: the reflections sparkling on a chandelier, shadows falling on a carved wooden finial, cherries blooming on a tree outside. And when your eye reaches the room's back wall you notice an ornate Latin script that reads, "Jan van Eyck was here. 1434."

It is a signature—one of the first artist's signatures in history. For a painter to draw such attention to himself was unprecedented. Artisans painted anonymously to the glory of God, and they didn't worry about things like shading, perspective, or depth. Then out of the blue comes this purely secular painting of a man and a woman with their dog. It has shadows, three-dimensional representation, and a signature. This painting wasn't just new, it was revolutionary.

AN ARTIST BY ANY OTHER NAME

We don't know much about van Eyck except that he was born in Flanders (part of present-day Belgium), but give the guy a break. He was inventing the idea of the artist, and no one thought to jot down his biography.

The first we hear of him is in 1422, when he was working at The Hague as court painter to the Count of Holland. In 1425, van Eyck took the position of court painter and *varlet de chambre*, a position of honor, to Philip the Good, duke of Burgundy. Philip esteemed van Eyck, sending him on diplomatic missions, serving as godfather to his children, and giving a pension to his widow. The duke's records include a letter in which he chews out his staff for failing to pay the artist's salary on time.

One of van Eyck's first known paintings is also one of his most famous. The Ghent Altarpiece is an enormous multipanel painting created for St. Bavo Cathedral in Ghent. It includes an inscription stating that it was begun by Hubert van Eyck but completed by Jan in 1432. Of Hubert we know zilch, although the inscription claims "none was greater" in art; historians believe he was Jan's older brother.

The ornate altarpiece rejects centuries of artistic tradition. Instead of flat, symbolic representation, it achieves an unprecedented sense of three-dimensionality, particularly through the depiction of light and shadow. Van Eyck also revolutionized the use of color by choosing paints with an oil base

rather than tempera (egg-based). Oil paints can be applied in layers to create translucent color; they also dry slowly, allowing for retouching. (That's why Michelangelo didn't like oils—he thought they were for wimps.) The result is more depth and brilliance and greater control.

MIRROR, MIRROR, ON THE WALL

This point brings us back to van Eyck's most famous painting, the *Arnolfini Portrait*, dated 1434. The man is dressed in a fur-trimmed cloak and wears an enormous, pouffy black hat (de rigueur for the Burgundian smart set); the woman wears a white headdress, green gown, and blue underdress. A round, convex mirror in an ornate frame hangs on the back wall, reflecting the window, the couple, and, most intriguingly, two barely visible figures standing in a doorway, exactly where you would be if you were looking into the room. Above the mirror is that strange signature: "Jan van Eyck was here."

What makes this painting important? First, its subject. It is not religious: These are ordinary people, not saints or martyrs or even royalty. Second, the realism is extraordinary. Light floods in through the window, bathing the woman's face in a soft glow. The fur lining of the man's robe seems soft and fluffy; the skin of the orange on the windowsill looks dimpled.

Questions remain about who and what the painting shows. Early inventories describe it as a portrait of a man named Hernoul le Fin, and nineteenth-century scholars connected the name to the Arnolfini family of Italian textile merchants working in Bruges. For more than a century, it was believed the painting showed Giovanni di Arrigo Arnolfini and his wife, Giovanna Cenami, until it turned out that the couple married thirteen years after the date on the painting. Scholars are now split. Some believe it shows Giovanni with a previous wife, whereas others think it depicts a different Arnolfini altogether.

"KING OF PAINTERS"

After van Eyck's death on July 9, 1441, his reputation as the "king of painters" spread throughout Europe. One of the greatest inheritors of his tradition was seventeenth-century Dutch artist Johannes Vermeer (1632–1675), whose light-drenched, middle-class interiors owe much to van Eyck's legacy. Van Eyck also granted later artists a greater sense of their own importance. Throughout his oeuvre, he draws attention to his signature;

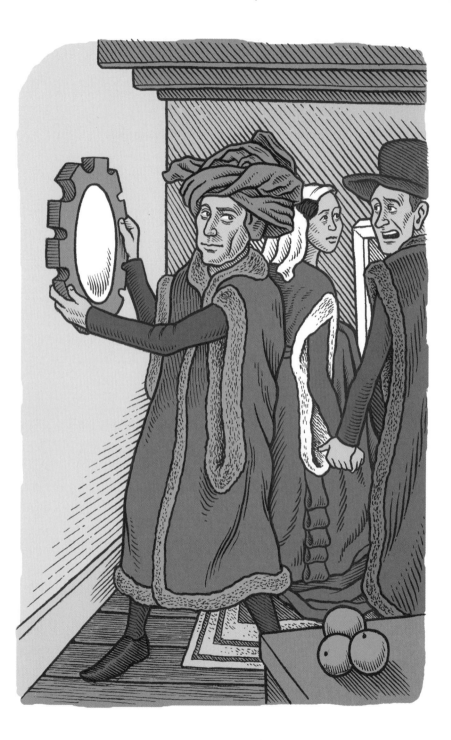

several paintings even proclaim, "Jan van Eyck made me." We may not know much about him, but his prominent signature suggests that he believed in his importance as an artist.

!

IS SHE OR ISN'T SHE? THAT IS THE QUESTION

Most people's first reaction to the *Arnolfini Portrait* is, "Wow, that woman is really pregnant!" Snickering always follows because the painting was assumed to depict a marriage or, even worse, a betrothal. Was a shotgun (crossbow?) wedding in the offing?

Turns out the lady was merely dressed in the fashions of the day. In the 1400s, dresses had so much extra fabric gathered in front that women had to lift them just to walk. (If you think that's ridiculous, I have two words for you: leg warmers.) So we can't assume Mrs. Arnolfini is preggers just because she looks about five minutes from going into labor.

MASTER ARTIST OR MASTER CHEATER? MODERN THEORISTS HAVE CLAIMED THAT JAN VAN EYCK'S REALISM WAS LITERALLY DONE WITH MIRRORS: BY STRATEGICALLY PLACING A CONVEX MIRROR, HE COULD EASILY TRACE THE FORMS PROJECTED ON A WALL.

TRADE SECRETS

Many theories have tried to explain the sudden introduction of realism into van Eyck's work, but the most revolutionary is the one proposed by contemporary British artist David Hockney and physicist Charles M. Falco. The pair suggests that van Eyck used optical aids such as curved mirrors and small lenses to create his nearly photographic images. Evidence for their theory plays a prominent role in the *Arnolfini Portrait*: the convex mirror between the two figures. If the mirror were flipped to the concave side, it could be used to reflect an image on a wall, which van Eyck could then have traced.

In his 2001 book *Secret Knowledge: Rediscovering the Lost Techniques of the Old Masters*, Hockney argues that the technology of mirrors and lenses was well known in van Eyck's time. Since using lenses would result in subtle shifts of perspective, Hockney and Falco have looked for—and claim to have found evidence of—these shifts in paintings. They also claim that no other theory explains the rapid development of realism in art. To explain why no contemporary records describe van Eyck or his contemporaries mucking about with mirrors, Hockney and Falco respond that artists would have kept the technique a trade secret.

Art historians have generally pooh-poohed Hockney's ideas. They say that fifteenth-century glass was too imperfect to cast clear images and that the very idea of projection would have been alien to Renaissance thinking. Plus, no Renaissance artistic treatise mentions optics. The debate rages on.

LITTLE LAMB LOST

The restoration of the Ghent Altarpiece in 1950–51 uncovered many retouchings and poorly handled restorations, so art experts worked to undo the damage. When studying X-rays of the painting, they found the image of the Lamb of God had been extensively repainted, with the original lamb hidden under a clumsy imitation. Restorers began uncovering the older lamb, starting with its head, but the people of Ghent grew impatient and wanted their altarpiece back. Restorers had no choice but to return the painting with the restoration incomplete. Today, if you look closely at the lamb, you'll see that it has not two ears, but four.

SANDRO BOTTICELLI

1444–MAY 17, 1510

ASTROLOGICAL SIGN:
UNKNOWN, BUT ONE COULD
CONJECTURE LIBRA, TO HONOR
HIS MUSE VENUS

NATIONALITY:
ITALIAN

STANDOUT WORK:
THE BIRTH OF VENUS (CA. 1486)

MEDIUM:
TEMPERA ON CANVAS

ARTISTIC STYLE:
ITALIAN RENAISSANCE

SEE IT YOURSELF:
UFFIZI GALLERY, FLORENCE, ITALY

May you live in interesting times," goes the curse, and Sandro Botticelli's times were interesting indeed. Born during the golden age of the Florentine Renaissance, he worked under the patronage of "Il Magnifico" Lorenzo de' Medici, survived invasions and attempted coups, and trembled to the fiery preaching of the renegade friar Girolamo Savonarola.

Born Alessandro di Mariano Filipepi, Sandro, as he was called, was one of four surviving children. His acquired surname, Botticelli, is derived from his brother's nickname, Botticello (meaning "little barrel"). Today, Botticelli is best remembered for a painting that only gets weirder the more you know about it: *The Birth of Venus*. Experts still struggle to interpret it. Is it a straightforward depiction of a classical myth? a complex philosophical treatise in art? Venus, inscrutable on her half shell, offers no answer.

A WORD FROM MY SPONSORS

Renaissance Florence formed the hub of a great wheel of commerce that extended northwest to Scotland and southeast to the Levant. The city purported to be a republic, but one famous family ruled behind the scenes. The Medicis grew astronomically rich by inventing international banking. Lorenzo the Magnificent was only nineteen when, on the death of his father, he took control of both the bank and the city of Florence. Botticelli became part of Lorenzo's charmed inner circle. Strolling through his patron's sculpture garden and dining on roast peacock, the artist must have acutely felt the contrast to his father's tannery, stinking to high heaven from chicken dung and horse urine.

Botticelli received a basic education and apprenticed with a local artist. By 1470 he was running his own workshop, and in 1475 he completed *The Adoration of the Magi*, the painting that would bring him fame. Just as significant as his tender depiction of the Madonna and Child was his homage to his patrons, the Medici. Since medieval times, artists had been slipping their sponsors' portraits into religious compositions, and in this work Botticelli includes most of his client's family. Plus he tucked in yet another portrait, that of a young man dressed in a mustard-yellow gown, staring directly, almost challengingly, at the viewer: It is the artist himself.

Not long after completing the *Adoration*, the Medici asked Botticelli to record a more gruesome subject: a commemoration of the Pazzi conspiracy. The Pazzi, a prominent Florentine family, partnered with fellow Medici ene-

mies Pope Sixtus IV and the archbishop of Pisa to achieve a "regime change" in Florence. Their plan: Murder Lorenzo and his brother Giuliano. On April 16, 1478, during high mass in the Florence Cathedral, assassins savagely attacked the brothers. Stabbed several times, Giuliano died instantly, but a wounded Lorenzo managed to escape and barricaded himself in the church's baptistry. The conspirators headed for the main square, intending to rouse the populace, but instead the Florentines dragged them off in chains. They were hanged that night. Just to drive home the point that justice (or revenge—as if there were a difference) would be swift for those who dared attack the Medici, the family commissioned Botticelli to paint a fresco of the eight primary conspirators swinging to their deaths.

VENUS ON THE HALF SHELL

After a brief stint in Rome painting frescoes in the Sistine Chapel (which are now mostly ignored by visitors craning to see Michelangelo's ceiling), Botticelli returned to a Florence that was in a rage over classicism. Florentines lit candles to Plato and talked earnestly about the soul, and it was in this atmosphere that Botticelli completed his "mythologies," paintings including *Primavera* and *The Birth of Venus*. Their style is a strange mix: Though the figures represent classical gods and goddesses, the scenes are pure Renaissance inventions, strongly influenced by Neoplatonic philosophy. In *The Birth of Venus*, the goddess of love perches on a seashell, having just been born from the foam of the sea. In a philosophical interpretation, Venus personifies beauty, and since beauty is truth, the work becomes an allegory of truth entering the world. Or maybe it's a straightforward celebration of love and an homage to feminine beauty—take your pick.

CHANGING TIMES

Lorenzo de' Medici died in March 1492, despite receiving such medical treatments as pulverized pearls to cure a lingering illness (ah, good old Renaissance medicine). Control of Florence then passed to his eldest son, Piero, who is remembered aptly as "The Unfortunate." Piero brought on his own downfall two years later by handing over control of the city to the invading French army. Outraged Florentines stormed the Medici palace, and the family fled into exile.

Botticelli's patrons abandoned him, but he easily found work making sacred art. Lucky for him, religious fervor was on the rise in Florence. A few

years earlier, the friar Savonarola had stormed into town and made quite a stir, serving up fiery sermons denouncing the sins of, well, everybody. After the French invasion, Savonarola persuaded the French king to leave the city, and a grateful populace handed over political control to the zealous monk.

Once-freewheeling Florence became a strict theocracy. Troops of young men known as "little angels" wandered the streets, harassing women who wore brightly colored silks or showed too much bosom. The angels broke into private homes searching for frivolous items such as playing cards, cosmetics, and pornography, which they confiscated and burned at the "bonfire of the vanities," a sixty-foot-high conflagration in the main square. How Botticelli reacted to all this brouhaha is unclear. Sixteenth-century biographer Giorgio Vasari claimed the artist supported Savonarola and burned his own paintings, but no other evidence links the two men. Yet, a new tone is evident in Botticelli's work of the 1490s, one of increased simplicity, austerity even. Paganism was out, Christianity was in.

> AN ANNOYED SANDRO BOTTICELLI ONCE THREATENED TO CRASH A LARGE ROCK ONTO HIS NEIGHBOR'S ROOF IN RETRIBUTION FOR MAKING TOO MUCH NOISE.

Savonarola couldn't rain hellfire and brimstone against the powerful forever. He managed to ignore excommunication in 1497, but a year later, when Pope Alexander VI threatened Florence with interdiction, city leaders realized further support of the friar would ruin the economy. Savonarola and his closest associates were arrested, tortured, and executed. Vasari falsely reported that Savonarola's fall from grace so disturbed Botticelli that he never painted again, but in fact he completed several more works, both religious and mythological. By the time Botticelli died of unknown causes in 1510, art had passed him by—his pale Madonnas seemed passé compared to Michelangelo's contorted nudes.

Botticelli remained forgotten for some three centuries. Only in the mid-1800s was his work rediscovered and once again appreciated by the masses. Though his religious paintings pass almost unnoticed today, his mythologies have assumed iconic status, although of a curious sort. *The Birth of Venus* is found on coffee cups, as screen savers, and in episodes of *The*

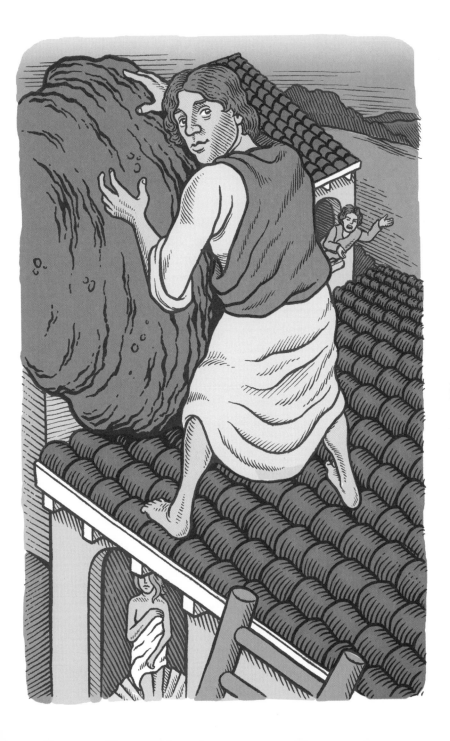

Simpsons, but we still don't quite know what to make of it. Perhaps the problem is that the painting's full meaning has been lost over the centuries. More than Leonardo da Vinci, more than Michelangelo, Botticelli was a man of the Florentine Renaissance.

!

ROCK 'N' ROLL

But what of Botticelli the man? Giorgio Vasari (known for his entertaining but sometimes embellished biographies) describes the artist as "whimsical and eccentric" and claims he was a great practical joker. One story recounts how a weaver bought the house next to Botticelli and installed looms that caused such a racket Botticelli was unable to work. The artist complained to the neighbor, who replied that he could do what he pleased with his own house. So atop his own roof Botticelli placed a large rock, seemingly ready to crash through his neighbor's ceiling at any moment. When the neighbor complained, Botticelli replied that he could do what he pleased with *his* own house. It didn't take long for the neighbor to remove the looms.

LITTLE VESSEL ALL FULL

Among other talents, Lorenzo de' Medici was an enthusiastic poet; his works include tender sonnets and ardent religious poetry. However, Lorenzo wasn't above using his poetic powers to poke fun at his favorites. In a short poem, Lorenzo punned on the surname Botticelli, Italian for "little barrel" or "little vessel," as well as the artist's apparent love for the good food served at the Medici table:

Botticelli, whose fame is not small,
Botticelli I say, he's insatiable.
More insistent and indiscreet than a fly.
How many fool-hearted things he did that I remember!

If he is invited to dine,
He who invites him does so at his own caution,
As he won't open his mouth to speak,
No, he won't even dream about it, so full his mouth is.
He arrives a little bottle and leaves a bottle full.

SHE'S A SUPER FREAK!

Poor Venus. The beauty of her face in *The Birth of Venus* manages to distract us from her disproportioned body. The figure lacks shoulder blades or a sternum, and her left arm hangs strangely from her side. The breasts are perfectly round and too small for her body, her torso is too long, and her belly button is placed too high on the abdomen. Her weight is shifted so far onto her left hip that she appears in imminent danger of falling into the ocean, and how she manages to stand on the shell is anyone's guess. Yet these flaws in no way detract from the image. Botticelli always placed elegance above realistic depiction of form, and even if Venus's neck is freakishly long, it is still undeniably beautiful.

LEONARDO DA VINCI

APRIL 15, 1452–MAY 2, 1519

ASTROLOGICAL SIGN:
ARIES

NATIONALITY:
ITALIAN

STANDOUT WORK:
THE MONA LISA (CA. 1503–7)

MEDIUM:
OIL ON POPLAR PANEL

SEE IT YOURSELF:
MUSÉE DU LOUVRE, PARIS

QUOTABLE

"ART IS NEVER FINISHED,
ONLY ABANDONED."

Leonardo da Vinci is the poster-boy for many things—including sheer brilliance—but another claim to fame could be Most Attention-Deficient Artist. This guy's got ADD written all over him. He was always distracted, losing interest, skipping from one project to another, and generally not finishing much. You've got to wonder what he would've achieved had he been on a steady dose of Ritalin.

Leonardo left behind only a handful of paintings—fewer than twenty, with some badly damaged or incomplete. His sculptures were either unfinished or later destroyed. What we seem to have in abundance are his notebooks—some 13,000 pages—and experts believe many more notes have been lost. Even with so few artworks to judge him by, Leonardo is recognized as one of the world's greatest artists. He is hailed as the ultimate Renaissance man, even though most people know only one of his paintings.

The myth of Leonardo rests on the *Mona Lisa*, a simple portrait of a woman on a balcony. The mass of tourists who crowd Paris's Louvre Museum every year—some 8.3 million in 2006—to gaze at this mysterious work accept without question that it is the best of all paintings and that Leonardo is the greatest of all artists. So . . . is it? Was he?

CHECKERED PAST

Leonardo was born April 15, 1452, in the small town of Vinci in the idyllic Tuscan hills, but hardly into a happy nuclear family. His parents were unwed and from different social classes; illegitimate Leo lived with his father, who married another woman. From his humble beginnings, he worked his way up the social ladder, becoming artist to kings and dukes.

About age seventeen, Leonardo apprenticed with artist Andrea del Verrochio in Florence and by 1472 was taking on his own commissions. Then in 1476, along with four other young men, Leonardo was publicly—and anonymously—accused of sodomy. Although homosexuality was tolerated by the ruling Medici family, sodomy was illegal and punishable by death. Authorities briefly imprisoned Leonardo; he probably got off with a warning because one of the other accused men had powerful political ties. The warning had no effect, however; Leonardo appears to have had several homosexual relationships through the years.

When Leonardo abruptly left Florence for Milan in 1482, it is tempting to think he was escaping a troubled reputation. Or it may be just another

example of his tendency to drift from one task to another—he did leave behind several unfinished projects and a few irked sponsors. Once in Milan, Leonardo offered his skills as a military engineer, musician, and artist to the ruling duke Ludovico Sforza. Odd combo, although apparently Leonardo was a talented lute player. Even stranger is the military-engineering claim, although at the time art and architecture were considered interchangeable, and most architects promoted their skills in fashioning defensive apparatus.

DINNER FOR THIRTEEN

Sforza seems never to have built any of Leonardo's war machines, among them catapults, rudimentary tanks, and "fire-throwing engines." Instead he commissioned paintings, including in 1495 *The Last Supper*, which takes up an entire wall of a church refectory (dining hall). Given the painting's iconic status today, it's hard to believe that the composition was unconventional at the time. Earlier medieval artists had typically presented Christ and his disciples as serene and untroubled. Leonardo, by contrast, chose to show the disciples' emotional reactions to Christ's announcement that he would be betrayed—the men gesture and exclaim, draw back in horror, and lean forward to argue.

Unfortunately, only hints of Leonardo's original achievement remain—the painting has been irreparably damaged, mostly because of the artist's penchant for experimentation. He disliked the technique of fresco, in which paint is applied directly onto wet plaster. Once the plaster dries, the painting cannot be retouched, making shading and blending colors difficult. So instead Leonardo decided to paint on dry, rather than wet, plaster. Bad choice. The dried plaster soon began flaking off the wall, and restorers have been trying to save the work ever since. Not to mention that in 1796 French troops threw rocks at the wall; clumsy restoration attempts in the 1800s destroyed more than they preserved; and during World War II the building was bombed. A 1999 restoration is believed to have stabilized the painting, but it remains a bit of a blur.

WHEN THE GOING GETS TOUGH, SKIDADDLE

The Last Supper was not Leonardo's most important assignment in Milan. More prestigious was the commission for the *Gran Cavallo*, a massive horse cast in bronze. Leonardo sculpted a clay model and designed frames for

casting, but the horse was never finished due in part to ever-troubled Italian politics, which cut short not only Leonardo's efforts but Sforza's rule as well. As French forces attacked Milan, Sforza seized the seventy tons of bronze intended for the sculpture and used it to cast cannons. The conquering French invaders used the clay horse model for target practice.

Leonardo, meanwhile, fled to Florence. There he drew up plans to alter the course of the Arno River, sketched a remarkable flying machine, and spent several months in the court of the powerful (and murderous) Cesare Borgia. He also painted a portrait of a Florentine housewife, Madonna Lisa Gherardini, wife of Francesco del Giocondo. You may have heard of it.

FROM MYSTERY TO MASTERPIECE

About 1503–6, Leonardo painted "La Gioconda" (a.k.a. the *Mona Lisa*), a woman with brown eyes, a wide forehead, and a round chin. She wears an elegantly pleated gown, and her hands rest on the arm of a chair. The loggia where she sits juts improbably over a precipice overlooking a vista of roads and rivers, hills, and valleys.

So what was new? First, her pose. Lisa sits turned away from the viewer but has shifted her upper body to face us. This off-axis position, a form of *contrapposto* (Italian for "opposite"), lends a sense of movement to the figure. The fantastic landscape was another innovation, since most paintings of the period had little background.

But ask most people what is distinctive about the *Mona Lisa* and they say the figure's enigmatic gaze and, above all else, her "mysterious" smile. "Do you smile to tempt a lover, Mona Lisa? Or is this your way to hide a broken heart?" crooned Nat King Cole in his number-one song from 1950. Lisa's smile is slight, and her face is certainly hard to read—but none of that is unique to the *Mona Lisa*. Leonardo painted other women with enigmatic stares, such as Ginevra de' Benci and many a Virgin and saint. The painting's reputation has more to do with its history than its subject—but that's getting ahead of the story.

In 1506, Leonardo headed back to Milan, where scientific investigations interested him more than artmaking. Seven years later he moved to Rome at the invitation of Pope Leo X, but he seemed unwilling to compete with fellow artists Michelangelo and Raphael. So in 1516 Leonardo left Italy, becoming the "king's painter" of Francis I of France but in fact paint-

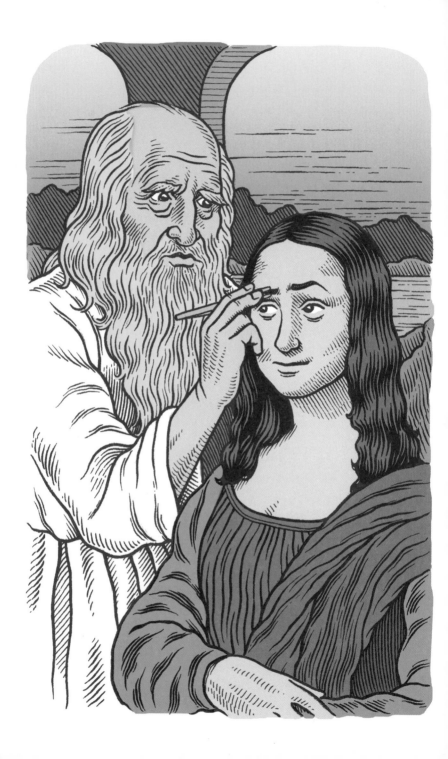

ing little. His real job was to provide stimulating conversation for the king, but their scintillating discourse was cut short when Leonardo died of a stroke in 1519.

The king took possession of Leonardo's artwork, so the *Mona Lisa* passed into the hands of the French crown and out of the public eye for several centuries. After the French Revolution, Napoleon took a shine to Lady Lisa and briefly had the painting moved to his bedroom at the Tuileries Palace. In 1804, the work was hung in the Louvre, a portion of the palace that was converted into a museum. Not that anyone noticed—Michelangelo's and Raphael's works were far more popular.

It took the interest of French Symbolist poets of the mid-nineteenth century to transform the *Mona Lisa* into a masterpiece. They developed a fascination with femmes fatales, women believed to be as devouring as they were beautiful, and for some reason they lumped *Mona Lisa* into this category. English critic Water Pater expanded this notion in 1869: "She is older than the rocks among which she sits; like the vampire, she has been dead many times and learned the secrets of the grave."

WHO WAS RESPONSIBLE FOR "PLUCKING" MONA LISA'S EYEBROWS? EITHER LEONARDO DA VINCI NEVER GOT AROUND TO PAINTING THEM, OR THEY WERE REMOVED AT THE HANDS OF A LATER RESTORER.

LISA ON THE LAM

From there, all it took to cement public fascination was theft. In 1911, a museum visitor found the *Mona Lisa*'s spot on the wall empty. A slipshod investigation followed, and the work was feared lost forever. Then in 1913, Vincenzo Peruggia, a former Louvre employee, contacted a Florence art dealer about selling the work. It turned out Peruggia had hidden overnight in a broom closet and snuck out the next morning with the painting stashed under his coat. Peruggia claimed his motive was a patriotic desire to return the *Mona Lisa* to Italy.

The recovery of the *Mona Lisa* was an international event, and from then on its fame was undisputable. For years, the Louvre tried to treat the work like any other painting, but museum officials finally gave in to pressure from

staff to post signs directing people to the painting. It now hangs in a special exhibit space within a climate-controlled, bulletproof enclosure. Not bad for a simple portrait painted by a man who rarely finished anything.

OUR PLUCKY HEROINE

Ah, the eyebrows of the *Mona Lisa*! The first written description of the work praised them to the skies: "The brows could not be more natural: the hair grows thickly in one place and lightly in another following the pores of the skin," wrote Giorgio Vasari in 1547.

The problem? The figure has no eyebrows. Really—go look. Not a brow in sight.

Some art historians have claimed that Lisa Gherardini must have plucked her eyebrows, following a whim of Florentine fashion, but that appears unlikely since other portraits of the period, including those by Leonardo, show women with eyebrows. Either Leonardo never got around to painting them or they were inadvertently removed in a later restoration.

As for Vasari, he never actually saw the work. Most likely he saw an unfinished copy or heard a description of it from someone who remembered it incorrectly. Accuracy was never his forte.

IS THERE A DOCTOR IN THE HOUSE?

Contemporary physicians have turned their attention to the health of the woman depicted in the *Mona Lisa*. Based on the painting alone, she has been diagnosed as suffering from an enlargement of the thyroid gland, strabismus (crossed eyes), Bell's Palsy, bruxism (habitual grinding of the teeth), and, alarmingly, "an asymmetrical hypofunction of the facial muscles." Poor woman. It's a wonder she could smile at all.

ICON BASHING

All it takes for artists to knock a work of art is for the public to like it. That's been the fate of the *Mona Lisa*, which has been the subject of more artistic insults and adaptations than any other painting. Notorious Dada artist Marcel Duchamp got the ball rolling in 1919 when he purchased a postcard of the *Mona Lisa* and drew a mustache and goatee on her face. He called the work *L.H.O.O.Q.*, which in French sounds like the phrase "Elle a chaud au cul" (She has a hot ass).

And they were off! In 1953 photographer Philippe Halsman completed a photomontage of the face (and prominent mustache) of Salvador Dalí dressed in the gown and set against the background of the *Mona Lisa*. Andy Warhol combined multiple screenprints of the figure in *Thirty Are Better Than One* in 1963, and René Magritte eliminated the image of the *Mona Lisa* altogether in his 1960 work *La Joconde* (the French title for the portrait) since everyone already knows what it looks like. In recent years, Rick Meyerowitz turned Lisa into a gorilla; Yasumasa Morimura depicted her as naked and hugely pregnant; and Artus Pixel added a Batman costume in a work titled *Batmona Lisa*.

THE FACE OF EVIL

Leonardo's dilly-dallying irritated almost everyone who worked with him, particularly those waiting for him to complete projects. As he made haste slowly on *The Last Supper*, the prior of Santa Maria delle Grazie complained to the Duke of Milan that work was taking too long. Leonardo explained that he was trying to find a face evil enough to represent Judas, but if he couldn't find the perfect model he could "always use the head of that tactless and impatient prior."

There were no more complaints to the duke.

DECODING THE CODE

So, a couple of years ago a book came out—
The Da Vinci Code. Heard of it?

There is much to debunk about the story it tells, but we'll just pick one point. Leonardo was never called "da Vinci." It's a place name, meaning "of Vinci," that denotes his birthplace. You wouldn't call someone "Of Poughkeepsie," now, would you? In Renaissance Italy, unless you were an aristocrat, like the Medici, surnames were slippery, undefined things. Leonardo signed legal documents "Leonardo ser Piero [son of Piero] da Vinci" and was referred to simply as "Leonardo."

As for all the other stuff about secret societies and hidden messages—you know it's fiction, right?

ALBRECHT DÜRER

MAY 21, 1471–APRIL 6, 1528

ASTROLOGICAL SIGN:
GEMINI

NATIONALITY:
GERMAN

STANDOUT WORK:
KNIGHT, DEATH, AND THE DEVIL (1513)

MEDIUM:
ENGRAVING

ARTISTIC STYLE:
NORTHERN RENAISSANCE

SEE IT YOURSELF:
SEVERAL LOCATIONS, INCLUDING UNIVERSITY COLLEGE
LONDON, THE FINE ARTS MUSEUMS OF SAN FRANCISCO,
AND THE METROPOLITAN MUSEUM OF ART IN NEW YORK

*"IF A MAN DEVOTES HIMSELF TO ART,
MUCH EVIL IS AVOIDED THAT HAPPENS
OTHERWISE IF ONE IS IDLE."*

QUOTABLE

Build a brand. Establish a reputation. Create a trademark and promote the heck out of it. Give the market what it wants and never miss an opportunity to sell, sell, sell. That's how you get ahead in business, and it's also how Albrecht Dürer got ahead in art. Dürer networked and negotiated himself to the top of the Renaissance heap, achieving fame in Northern Europe rivaling that of Michelangelo in Italy. His status rested in large part on his masterful engravings and woodcuts, mediums perfectly suited to mass distribution.

But for all his business savvy, Dürer saw himself not as a man of trade but as a man of the arts. He brought the concept of the artistic genius to Germany—although, when you come down to it, his glorification of the artist worked as not-so-subtle self-promotion. He knew the value of image, and he spent time and energy crafting his own.

ART FOR THE MASSES

Albrecht Dürer was one of eighteen children—only three of whom survived childhood—born to Albrecht Dürer the Elder, a goldsmith, and his wife, Barbara. After finishing his training, marrying the daughter of a prominent brassworker, and studying Italian art in Venice, the ambitious young Albrecht set up his own workshop in 1495, at age twenty-four, and soon became an established member of the Nuremberg thinking set. Dürer's new friends, many of them well-known humanist scholars, inspired him to treat his work as one of the liberal arts rather than as mere craft.

Meanwhile, in his workshop Dürer explored the potential of printing. Prints made from woodcuts or engravings were portable and reasonably priced, making them an ideal product for a burgeoning middle class looking to decorate their homes and businesses. But Dürer had the vision to make printmaking an international enterprise. Instead of waiting for a patron or a publisher to come to him with a commission, he designed and produced prints on popular topics. He then hired salesmen to promote his work around Europe. Soon Dürer prints were hanging on walls from Rotterdam to Rome.

He also explored engraving, notably in his three "master prints" including *Knight, Death, and the Devil* (1513), which shows a resolute knight on horseback journeying through a menacing landscape. The skeletal figure of Death stands ghostly pale against the darkness of a shadowy crag, while the Devil, a multihorned goatlike creature, skulks among straggly tree roots.

FRIENDS IN HIGH PLACES

As Dürer completed this religious work, he was well aware of conflict brewing in the Catholic Church. Rocked by scandal and plagued by corruption, the Church made an easy target, and criticism reached new levels in the 1510s. Dürer was acquainted with some prominent critics, including the famous humanist Erasmus of Rotterdam. (Erasmus's book *Handbook of the Christian Soldier* might have been an inspiration for *Knight, Death, and the Devil*.) So it's not surprising that Dürer expressed interest when, in 1517 in Wittenberg, a monk named Martin Luther started challenging Church teachings on the nature of penance and the pope's authority. Dürer read Luther's *Ninety-Five Theses* soon after it was translated into German and would later be drawn deeper into the debates that ultimately led to the Protestant Reformation.

In 1520 Dürer traveled to the Netherlands to attend the coronation of the new Holy Roman Emperor, Charles V, on the way picking up an illness (probably malaria) that plagued him the rest of his life. Back in Nuremberg, he completed several treatises on art, texts he believed were essential in raising the status of his profession. He died on April 6, 1528, not quite fifty-seven years old, after weeks of torment due to recurring fevers. Outpourings of grief came from across Northern Europe, with Luther writing, "It is natural and right to weep for so excellent a man."

DÜRER "FÜHRER"

In death, Dürer took on saintlike status. Three days after the funeral, his body was exhumed and a death mask was made; fans got the idea from Italy, where at least masks were made *before* burial. In the nineteenth century, Dürer festivals became the rage, and in 1840 a monumental bronze statue of the artist was erected in Nuremberg; it bears the inscription, "Father Dürer, give us thy blessing, that like thee we may truly cherish German art; be our guiding star until the grave!"

In the 1920s, Nazis embraced Dürer as the "most German of German artists" (even though his father had been born in Hungary) and featured one of his self-portraits in their magazine *Volk und Rasse* (People and Race). The mayor of Nuremberg presented Hitler with an original print of *Knight, Death, and the Devil*, and Nazi artist Hubert Lanzinger evoked Dürer's engraving in a painting of Hitler as an armored knight, a work that would be silly if it weren't so creepy. Dürer's reputation managed to survive intact,

with both East and West Germany battling to claim his legacy in the Cold War years.

PAGING THOMAS KINCADE

Today, when great art is only a download away, it's hard to appreciate Dürer's impact on his era. The work of earlier artists was almost only found in either churches or the homes of the rich. Dürer's prints, by contrast, were priced to sell, and most middle-class families could afford them. That isn't to say Dürer cheapened art. Quite the opposite. He took pains to elevate the status of the artist from craftsman to intellectual. But if Dürer was a great artist, he was also an amazing businessman who no doubt today would be hawking his wares on home-shopping networks worldwide.

> A FORERUNNER TO THOMAS KINCADE, ALBRECHT DÜRER HAWKED HIS WARES BY DESIGNING AND PRODUCING POPULAR PRINTS THAT APPEALED TO THE MASSES.

THE MAN IN THE MIRROR

Dürer completed his first self-portrait when he was only thirteen and repeatedly returned to his own image as the subject of both drawings and oil paintings. One of his later painted portraits, from 1500, is startling. The twenty-eight-year-old shows himself in full-frontal view, his mournful expression staring directly at the viewer and his hair falling to his shoulders. No mistaking it—he looks like Jesus Christ. The intent was deliberate but not, in fact, blasphemous. Dürer sought to remind his audience that, like all people, he was made in the image of God (according to the Bible). Of course, as always with Dürer, business motivations lurked behind his artistic choices. The painting was a great way to show off his skills, and it's easy to imagine his sales pitch: If I can make myself look like the Son of God, just think what I can do for you!

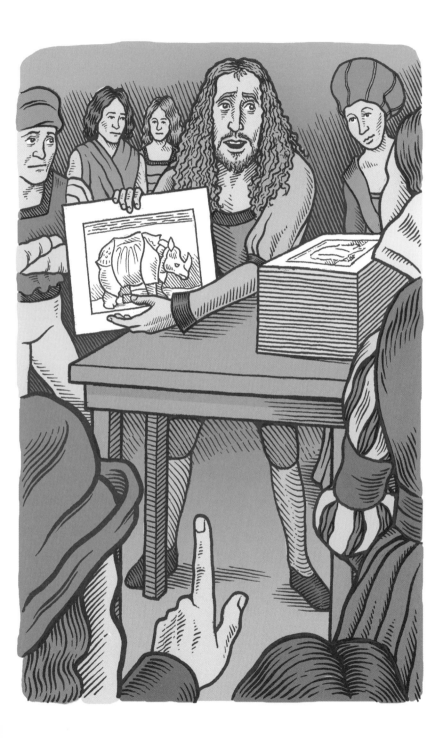

STOP, THIEF!

Like any successful businessman, Dürer worried about forgeries—a real threat because, at the time, it was not illegal to copy another artist's work. He first attempted to protect his art by adding his monogram—the now-famous D nestled between the "legs" of a larger A—to all his prints and paintings, in essence creating the first trademark. Unfortunately, the monogram was just as easy to copy, so although it helped promote his reputation, it did little to safeguard his work. In fact, Dürer was forced to take legal action against Venetian artist Marcantonio Raimondi, who copied his works, marked them with the "AD" monogram, and published them without permission.

Dürer's next step was to obtain the very first copyright in a special grant from Emperor Maximilian. He proclaimed his new right in the 1511 engraving *Life of the Virgin*:

> Hold! You crafty ones, strangers to work, and pilferers of other men's brains. Think not rashly to lay your thievish hands upon my works. Beware! Know you not that I have a grant from the most glorious Emperor Maximilian, that not one throughout the imperial dominion shall be allowed to print or sell fictitious imitations of these engravings? Listen! And bear in mind that if you do so, through spite or through covetousness, not only will your goods be confiscated, but your bodies also placed in mortal danger.

Perhaps Hollywood should rethink the copyright warnings included in DVD releases, although it would probably do about as much good as it did for Dürer. That is, none whatsoever.

THE PREPOSTEROUS RHINOCEROS

Some of Dürer's most enduring works are the simplest. His watercolor of a hare is more popular today than any of his elaborate altarpieces, and his 1515 woodcut of a rhinoceros was not only charming but influential as well.

Dürer created his rhinoceros, a ponderous creature with spotted armor, despite never having laid eyes on the beast. He based his engraving on a written description and sketch from a letter by a Lisbon-based businessman to a friend in Nuremberg. Lisbon residents had been treated to the sight of an Indian rhinoceros sent as a gift from the Sultan of Cambray (now Gujarat) to the king of Portugal. Dürer's engraving was immediately hugely popular. Although we know today that Dürer's depiction of the animal's anatomy is riddled with inaccuracies, it was accepted as realistic until the eighteenth century.

MICHELANGELO BUONARROTI

MARCH 6, 1475–FEBRUARY 18, 1564

ASTROLOGICAL SIGN:
PISCES

NATIONALITY:
ITALIAN

STANDOUT WORK:
CREATION OF ADAM (1508–1512)

MEDIUM:
FRESCO

ARTISTIC STYLE:
ITALIAN RENAISSANCE

SEE IT YOURSELF:
SISTINE CHAPEL, THE VATICAN, ROME

QUOTABLE

"IF PEOPLE ONLY KNEW HOW HARD I WORK TO GAIN MY MASTERY, IT WOULDN'T SEEM SO WONDERFUL AT ALL."

Michelangelo was a man of uncertain temper and explosive tendencies, deep affections and sudden rages—in short, of *terribilità*, an Italian term that translates as "emotional intensity" or "awesomeness." Pope Leo X, who disliked confrontation, was reported to have said: "Michelangelo is impossible, and one cannot deal with him."

The one sure way to spark Michelangelo's *terribilità*-ness was to call him a painter. He considered himself a sculptor—even signing his letters "Michelangelo Buonarroti, Sculptor"—and got into a serious huff when people confused the two crafts. He considered sculpture not only his true calling but also the highest form of art. Yet for a man who didn't consider himself a painter, what marvelous things he did paint! The Sistine Chapel frescoes represent, for many art historians, the greatest achievement of the High Renaissance. Ironically, Michelangelo didn't want the project, which he viewed as a distraction from his beloved work in marble. It's undeniable that he created sculptures of astonishing power and sensitivity, but his paintings are immediately recognized as masterpieces of Western art.

THE MAKINGS OF A SCULPTOR

Supposedly descended from aristocracy, the Buonarrotis had come down in the world, and they didn't like it. Perhaps that's why Michelangelo's father, Ludovico, was so enraged when his son announced his intention to pursue a career as an artist. Ludovico grudgingly arranged Michelangelo's training in the workshop of a Florentine painter, although the temperamental youth constantly quarreled with his master. Fortunately, about 1490 he was able to transfer to a more amenable artistic environment: Lorenzo de' Medici's sculpture garden. Lorenzo, the great patron of Sandro Botticelli, had assembled a priceless collection of ancient and contemporary sculpture and sponsored a workshop for aspiring sculptors.

Michelangelo skipped town in time to miss the French invasion of Florence, returning about 1495 to witness the friar Giralomo Savonarola's domination of the city before he hightailed it again by 1496, this time to Rome to undertake sculptures for several local cardinals. While in Rome, Michelangelo completed his *Pietà* (1499), a masterful depiction of the Virgin Mary holding the lifeless body of Christ across her lap. The grouping is a sculptural tour de force, with amazingly lifelike details and textures, from the folds in Mary's gown to the cascading curls of Christ's hair.

THE CASE OF THE POMPOUS PONTIFF

The *Pietà* secured Michelangelo's reputation—but only in Rome. Upon returning to Florence in 1501, he had to establish himself all over again. He met the challenge thanks to a narrow, fourteen-foot block of marble that had been sitting in the courtyard of the Florence cathedral since 1463. He accepted a commission to complete a sculpture from the block, which had been worked and abandoned by earlier artists because of problems with the stone. Michelangelo found a way to accommodate the block's shallow depth—which allowed no room for error—and the final product, *David*, won over the reserved Florentines.

Then came an unexpected invitation—or, rather, summons—from Pope Julius II. Vain as a peacock, Julius wanted Michelangelo to memorialize him by sculpting the most magnificent tomb ever created. Michelangelo became obsessed with the project and sketched plans for a mausoleum that would include more than forty figures. After a stay in Carrara, known for its quarries of outstanding marble, he returned to Rome, only to get the holy cold shoulder. It seems that in the intervening months, the pope had decided, with characteristic immodesty, to build the greatest church in Christendom by demolishing the fourth-century sanctuary of St. Peter's and erecting an enormous new basilica in its place. All the pope's attention—and money— was transferred to the building and away from Michelangelo's project.

NOBODY PUTS MICHELANGELO IN A CORNER! UNDER A CEILING, MAYBE . . .

Michelangelo smelled conspiracy. The architect for the new St. Peter's was his sworn enemy Donato Bramante, and he suspected that Bramante had been plotting against him to curry papal favor. After several attempts to meet with the pope, Michelangelo suddenly, and without permission, decamped for Florence.

Well! No one walked out on Julius. The pontiff sent angry letters to Michelangelo, who grudgingly journeyed to meet him and then apologized on his knees. The pope made him do penance in the form of a larger-than-life sculpture of himself. (The work has not survived; cast in bronze, it was melted down into a cannon less than four years later.) Then the pope announced that Michelangelo's next project would be painting the Sistine Chapel ceiling. The artist couldn't refuse, but once again he smelled a rat.

He suspected Bramante had schemed to get him assigned to the job, knowing Michelangelo disliked painting and hoping he would fail.

But paint he did. For the large vaulted space, Michelangelo developed a complex arrangement of scenes, figures, and trompe l'oeil architectural elements that sum up the Old Testament. Nine main panels show events from the opening chapters of Genesis, starting with the creation of the cosmos and ending with Noah and the Flood. The swirl of figures results in a dynamic, tumultuous whole, while the logical arrangement prevents the work from collapsing into incoherence. You can trace Michelangelo's progress across the ceiling as he gained confidence and experience. The last scenes are the most memorable, particularly the Creation of Adam. An exquisitely muscled Adam gazes languidly at God, a bearded man supported by a tumult of angels. God stretches out a purposeful finger to touch the drooping hand of Adam and impart the spark of life.

ONE PART INSPIRATION, TWO PARTS PERSPIRATION

Several myths have arisen about the Sistine Ceiling frescoes. First, Michelangelo did not work lying on his back. A massive scaffold hung below the ceiling, and he worked with his arms overhead. Nor did he complete the entire project himself. Several assistants worked alongside him, grinding pigments and mixing plaster. It is true that several quit during the approximately four years it took to complete the ceiling—hardly surprising since the team lived together in Michelangelo's small studio and shared a single bed. Since Michelangelo believed bathing was bad for his health, the staff may have been eager to make for the door as soon as possible. Pope Julius, in the meantime, had little opportunity to enjoy his gift to the world; he died a few months after the completion of the frescoes in 1519.

To Michelangelo's relief, the next few popes were more interested in sculpture and architecture than in painting, although many of his projects during these years were never attempted or left incomplete. The Medici Chapel, for example, is an extraordinary monument containing the prized sculptures *Night*, *Day*, *Dusk*, and *Dawn*, but some of the figures are only roughly worked.

Ultimately, Pope Clement VII couldn't resist Michelangelo's painting skills, and he commissioned the artist to put the finishing touch on the Sistine Chapel with a massive fresco on the wall behind the altar. *The Last*

Judgment shows Christ and the Virgin Mary supervising the end of the world. They are surrounded by a maelstrom of saints, patriarchs, and martyrs, many carrying symbols of their martyrdom. (St. Bartholomew, who was flayed, holds his own skin, the face of which is believed to be a wry self-portrait by Michelangelo.) Below this heavenly realm, the saved rise from the ground while the damned are dragged to hell by hideous horned demons. Painted between 1535 and 1541, *The Last Judgment* makes clear how much Michelangelo had evolved in nearly thirty years, becoming more adventuresome in his compositions and use of color.

THE ARTIST AS A REALLY OLD MAN

Michelangelo was sixty-six when he completed *The Last Judgment*, an old man for the time, but he still had more than twenty years ahead of him. He lived out his days in Rome. Much of his time was devoted to the architecture of St. Peter's Basilica, begun many years before by Pope Julius. The artist was hammering away on the *Rondanini Pietà* six days before he died on February 18, 1564.

> MICHELANGELO HAD SUCH REPELLENT BODY ODOR THAT HIS ASSISTANTS COULDN'T STAND WORKING FOR HIM.

An unseemly tussle broke out over what to do with Michelangelo's remains, with both Rome and Florence vying for the honor of burying him. At first, the body was moved to a Roman church, but Michelangelo's nephew disguised the coffin as a bale of merchandise and snuck his uncle's corpse out of the city. It took three weeks for the coffin to arrive in Florence, where it was ceremonially opened so the crowd could view, and even touch, the body. Michelangelo was finally laid to rest in his old parish church of Santa Croce, with members of the artist's academy in Florence designing an overwrought tomb.

Michelangelo became the measure against which all other artists were judged. You either emulated him or departed intentionally from the standard he set. As late as the nineteenth century, sculptor Auguste Rodin regarded Michelangelo as his inspiration. Not until the rise of modernism in

the twentieth century was Michelangelo dislodged from his position as "Ultimate Artist."

!

BENT OUT OF SHAPE

The young Michelangelo was a bit of a jerk who delighted in mocking the drawing skills of his peers. He bore the scars of one particularly merciless teasing his whole life. The artist Pietro Torrigiano recalled the incident with some satisfaction years later: "One day he provoked me so much that I lost my temper more than usual, and, clenching my fist, gave him such a punch on the nose that I felt the bone and cartilage crush like a biscuit. That fellow will carry my signature till he dies."

And so he did. Michelangelo's nose was squished and flattened, with a distinct hump in the middle, according to contemporary portraits.

PORTRAIT, SCHMORTRAIT

When Michelangelo began the Medici chapel in Florence, he was criticized for his sculpted portraits of the two cousins to whom the tomb is dedicated. Observers commented that the depictions of Lorenzo, Duke of Urbino, and Giuliano, Duke of Nemours, bore no resemblance to the dead courtiers. Michelangelo had no patience with such quibbles, retorting, "In a thousand years, no one will know how they looked."

NUDE DUDES

Michelangelo believed that the depiction of the naked body, particularly those of men, represented art's highest achievement. So deep was his devotion to the male nude that even his female nudes look like men. His sculpture *Night*, for example, features strange balloon-shaped breasts emerging from the muscular abdomen of a man. That Michelangelo disliked using female models was perhaps due to ignorance—some scholars

question whether he ever saw a naked woman.

Ultimately, this love of all things naked got Michelangelo in trouble. When he completed *The Last Judgment*, in the newly conservative atmosphere of the 1530s, critics immediately attacked him for showing saints and martyrs au naturel. One author wrote to him, "A brothel would avert its eyes in order not to see such things." After some debate, the church hierarchy agreed that the figures were lascivious and hired lesser painters to add drapery over the naughty bits. Michelangelo got the message. In later frescoes, only the rare angel is shown unclothed.

ABSTINENCE MAKES THE HEART BEAT LONGER

About Michelangelo never seeing a woman naked—it sounds outlandish, but it's possible. The artist never married, and his rare relationships with women were purely platonic.

His interactions with men, however, are more open to interpretation. During his later years in Rome, he formed deep bonds with at least two much younger men. It was all the fashion for men to "love" their young companions and write them passionate poetry. Certainly many such relationships were consummated (see "da Vinci, Leonardo"), but others were not. Michelangelo was an impressionable young man in Florence when homosexuality had been condemned by the friar Savonarola. Years later he claimed he could remember the exact tone of Savonarola's voice, and he was witness to the ravages of the new illness syphilis. Michelangelo frequently advocated abstinence, which he believed prolonged life. Given that he died shortly before his eighty-ninth birthday, perhaps he was on to something.

RAPHAEL SANZIO
(APRIL 6, 1483—APRIL 6, 1520)

Alas, the vagaries of artistic reputations. One day you're the most popular artist in the world, the next you're yesterday's news. Take Raphael. Sure, he got his own Teenage Mutant Ninja Turtle, but most people have never heard of this High Renaissance wunderkind. Born in 1483 and trained by his artist father, Raphael Sanzio da Urbino arrived in Rome in 1508. Pope Julius II took an immediate shine to the charming twenty-five-year-old, a fact that pleased Michelangelo not at all; the older artist was convinced that Raphael was trying to edge him out of favor. For his part, Raphael was eager to learn from Michelangelo, sneaking into the Sistine Chapel at night so he could study the works by candlelight. He paid homage to his rival in his masterpiece *The School of Athens*, painting a portrait of Michelangelo as the philosopher Heraclitus.

Leo X, the next pope, named Raphael as architect of St. Peter's and planned to make him a cardinal, despite Raphael's devotion to both his mistress, Margherita, and his fiancée, Maria Bibbiena. Before he could take high office, Raphael died at age thirty-seven (Vasari claimed he fell ill after a night of amorous excess with Margherita), and all of Rome mourned the loss. All except Michelangelo, who always complained that Raphael "learned all he knew from me."

Today Raphael's most popular image is a detail from the *Sistine Madonna* (1512–14) showing two cherubs leaning on what seems to be the picture frame. Set against a background of clouds, they look over their heads, one resting his chin on his hand and the other propping himself up on folded arms. The baby angels, though adorable, are just part of a much larger and more solemn work, yet their charm has made them a favorite for Christmas cards and dorm-room posters. Most people have no idea who the artist is, leaving Raphael as forgotten as last year's hit single. ■

MICHELANGELO MERISI DA CARAVAGGIO

SEPTEMBER 29, 1571–JULY 10, 1610

ASTROLOGICAL SIGN:
LIBRA

NATIONALITY:
ITALIAN

STANDOUT WORK:
THE CALLING OF ST. MATTHEW (1599–1600)

MEDIUM:
OIL ON CANVAS

ARTISTIC STYLE:
BAROQUE

SEE IT YOURSELF:
CONTARELLI CHAPEL, SAN LUIGI DEI FRANCESI, ROME

NOTHING FIT FOR FAMILY CONSUMPTION ◀ **QUOTABLE**

Anger-management therapy: Caravaggio needed it. The guy careened from one brawl to another. He couldn't stop ticking off someone or getting pissed off himself. And since he walked around armed to the teeth, the results were often grim and, on at least one occasion, fatal. That's right, Michelangelo Merisi da Caravaggio was a convicted murderer. Other artists in this book might have been jerks. They might have been troubled or obsessive or annoying. But only Caravaggio did someone in.

Yet if Caravaggio had a penchant for trouble, he also had a gift for creating dramatic, unflinching art that brought new emotion to tired religious themes. And, fortunately for him, he had a knack for attracting powerful patrons so enraptured by his talent that they repeatedly rescued him from scandal.

But in the end, not even Caravaggio's admirers could save him from himself.

FROM RICHES TO RAGS

Michelangelo Merisi came from a modest but connected family; his father served as the steward to Francesco I Sforza, the Marchese of Caravaggio, hence his surname (à la Leonardo). Caravaggio's early childhood was spent in the luxurious Sforza household in Milan, but all that comfort disappeared when the plague swept through Lombardy, killing Caravaggio's uncle, grandfather, and father all on the same day. Caravaggio was six years old.

After a childhood spent back in his hometown, in 1584 the twelve-year-old was apprenticed to a painter in Milan, although he ended his apprenticeship early under unknown circumstances. The next four years are a blank, and then suddenly Caravaggio turns up in Rome, utterly destitute. He worked as a servant, churning out three portrait heads a day in the studio of a Roman hack artist, until finally he found the time and money to complete a few paintings. Some are self-portraits, and others take as their theme life on the streets and in the brothels of Rome. *The Cardsharps*, for example, presents a scene the artist might have seen play out dozens of times: a wealthy and innocent young man being fleeced by two practiced cheats.

FROM RAGS TO RELIGION

Caravaggio finally caught a break when the wealthy Cardinal del Monte spotted *The Cardsharps* in a local shop and invited the artist to work as a painter-in-residence in the del Monte household. Well-fed for the first time in years,

Caravaggio completed paintings for powerful church officials and religious institutions around Rome. He soon developed his mature style, which features dramatic interpretations of traditional religious themes. Take *The Calling of St. Matthew*, for example. The work depicts the moment Christ selects the sinner Matthew to be his disciple. Caravaggio set the painting in a grimy tavern, with five men sitting around a battered old table. Jesus, accompanied by another disciple, stands in the doorway and points to Matthew, who in turn points to himself as if to say, "Who, me?" Earlier artists had used hovering angels or parting clouds to signify the moment of conversion, but Caravaggio's solution is much simpler: Light indicates the touch of grace. It pours in behind Christ and falls full upon Matthew, while the rest of the painting is plunged into dreary shadow. Caravaggio pioneered this chiaroscuro style, which is characterized by extremes of light and shadow.

FROM RELIGION TO RAP SHEET

But success didn't have a calming effect—it only gave Caravaggio enough time to get into really big trouble. He would buy expensive clothes and then wear them until they fell apart; he used an old canvas as a tablecloth; he insisted on wearing a fashionably long rapier even though carrying a sword was forbidden to commoners. His rap sheet with the Roman police grew long and detailed, full of brawls over prostitutes and squabbles over artistic ability.

His patrons continued to defend him, until he crossed the line to murder. Caravaggio's victim, Ranuccio Tommasoni, was no choirboy, and indeed he seems to have been an out-and-out thug. The two quarreled over the outcome of a tennis match, or a bet on a tennis match, or somewhere near a tennis match (the details are fuzzy), and in a brawl involving a dozen people, Ranuccio was killed. Friends smuggled the wounded Caravaggio out of town, but they couldn't stop his conviction for murder and the subsequent sentence: the death penalty. The artist now had a price on his head.

A FEW GOOD KNIGHTS

Caravaggio headed for Naples, outside papal territory and near the Marchesa di Caravaggio, who remembered him from his Lombardy days. Strangely, Neapolitan society welcomed the irrepressible artist, treating him more as a visiting celebrity than a fugitive. But soon he set off again, this time for

the island of Malta, famous for its intrepid knights. This order of warrior monks combined courageous defense of the Mediterranean with dedication to chastity, obedience, and religious devotion. Caravaggio probably hoped that acceptance into a religious order would help him achieve a pardon back in Rome. Perhaps he also felt some remorse. The emotional depth of his paintings reveals that he was more than a mere bully, and perhaps his conscience pricked.

Caravaggio took the oath of the Knights of Malta on July 14, 1608, standing before the altarpiece he had painted during his novitiate. Located in the church's oratory, *The Beheading of St. John the Baptist* is his largest and one of his most dramatic works, depicting the saint thrown to the ground as an executioner stands ready to chop off his head. Blood spurts from John's neck, pools at his side, and drips toward the bottom of the canvas, where we find, as though written in blood, Caravaggio's only known signature.

> CARAVAGGIO ORDERED WORKMEN TO POSE FOR HIM HOLDING A RECENTLY BURIED CORPSE. WHEN, OVERCOME BY THE STENCH, THEY DROPPED THE BODY, THE ARTIST DREW HIS DAGGER AND FORCED THEM TO RESUME THEIR STANCE.

For more than a year, his behavior was faultless, but sometime in September 1608 he quarreled with another prominent knight (whose name is now unknown), seriously wounding him. We don't know Caravaggio's motive, although one early biographer claimed that he was "blinded by the madness of thinking himself a nobleman born." The artist-turned-monk was thrown into a prison cell known as the "birdcage"—a pit carved into limestone. Soon after, he reportedly "escaped" and fled to Sicily. But no one could escape from such a cell without help; clearly, someone powerful had arranged to get him out of Malta. The knights formally expelled him from the order in a ceremony in which he was described as a "foul and rotten limb."

THE MURDERER HAS TWO FACES

Caravaggio moved around Sicily, again acting more like a visiting dignitary than a man on the run. In 1609 he abruptly returned to Naples and the protection of the Marchesa di Caravaggio. It's assumed he learned that someone—presumably the knight he wounded on Malta—was on his tail. Reports

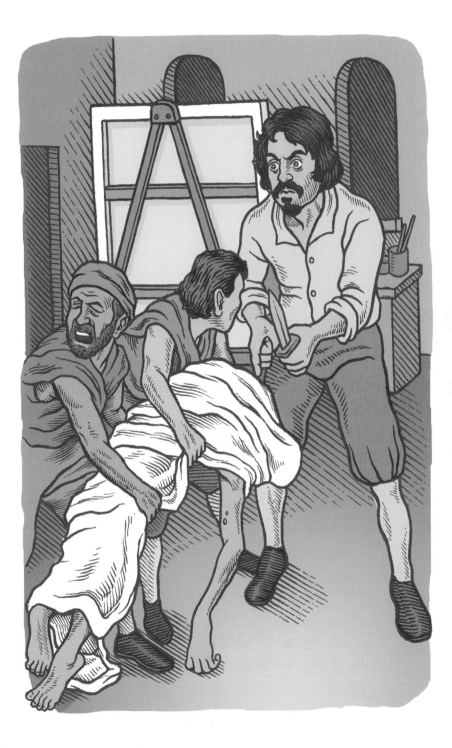

from this time describe him as wearing a dagger even while sleeping. Caravaggio might have stayed safe in the marchesa's palace, but the town's taverns proved irresistible, and in late October he emerged to sample their wares. In the doorway of one popular bar, he was surrounded by armed men, stabbed in the face, and left for dead. The knight finally had his revenge.

Caravaggio spent months convalescing in the marchesa's care, and the wounds left his face almost unrecognizable. Yet his creative drive pulsed stronger than ever. As soon as he was able to hold a brush, he began painting again. *David with the Head of Goliath* is the most haunting works of these days. Emerging from velvety darkness into a shaft of light, a young David holds a gleaming sword in one hand and the head of the giant Goliath, mouth agape and neck dripping blood, in the other. What's really strange about the painting is that both figures are self-portraits, with David as the young Caravaggio, full of innocence and promise, staring mournfully at Goliath, his current old self, face worn from carousing and scarred from fights.

PARDON ME!

The future still seemed to hold potential when news from Rome reported that a pardon was in the works. Barely healed, Caravaggio set out from Naples aboard a small ship, but when a storm forced the vessel to seek shelter in a small town, the captain of the local garrison arrested him, mistaking him for a local banditto. It took a hefty bribe to free him, and by then the ship had headed north, carrying all his possessions. Frantic to catch up, Caravaggio set out in the brutal heat of an Italian summer. What happened next remains unclear. Perhaps he fell victim to malaria or another illness or was simply weak from the earlier attack. Whatever the case, Caravaggio collapsed with fever and died July 18, 1610, at age thirty-eight. He never knew that a full pardon had been granted to him in Rome.

THE FICKLE FINGER OF FATE

During Caravaggio's lifetime and immediately after his death, his fame prompted artists around Europe to imitate his realism and chiaroscuro technique. Eventually tastes shifted, and by the nineteenth century he was all but forgotten. His paintings were destroyed or dispersed, languishing in private collections or moldering in attics.

In the mid-twentieth century Caravaggio's reputation began to revive. The price of his canvases rose along with his reputation, and soon the hunt was on to find lost works by the artist. In the early 1990s *The Taking of Christ*, a masterpiece from 1602, was found hanging on the wall of a Jesuit house in Dublin, covered in a layer of soot and labeled as a work by a minor follower. Today Caravaggio is appreciated for his striking realism and depth of emotion, as well as for a life that resembles more a character in *The Sopranos* than an artistic hero.

THE MEANING BEHIND BEHEADING

It's not surprising that violence plays a role in Caravaggio's art, but it's bizarre that the artist picked decapitation as a major theme. No fewer than twelve paintings show figures either beheaded or on their way to losing their heads. Psychologically minded academics have had a field day with this peculiarity, most taking as their starting point Freud's equation: decapitation = castration. By contrast, in alchemy, which Caravaggio studied, beheading signifies the separation of the soul from the physical realm, so perhaps he was expressing a sense of alienation and a search for wholeness. Or maybe he was just reacting to the times. After all, government-sanctioned hangings, beheadings, quarterings, and clubbings were daily fare in seventeenth-century Rome.

YOU WANT ME TO DO WHAT?

Caravaggio was devoted to naturalism, and one early biographer declared that he "thought Nature the only subject fit for his brush." But sometimes he took realism too far. *The Raising of Lazarus* (1609) is the most extreme case. The commission was to depict the New Testament account of Christ returning Lazarus to life after three days in the grave,

so, in the spirit of getting things right, Caravaggio ordered a recently buried corpse to be dug up. He paid two workmen to be his models and instructed them to pose holding the body. Overcome by the stench, they dropped the cadaver, prompting Caravaggio to draw his dagger and demand them to pick it up again. The workmen didn't doubt he would use the dagger, so they dutifully lifted the body. Surely there must have been an easier way.

HE WHO DIES LAST GETS THE LAST WORD

Caravaggio had a gift for making enemies. One was Giovanni Baglione, a Roman artist remembered today for his fussy, melodramatic frescoes. Baglione landed some commissions that Caravaggio wanted, and Caravaggio reacted in a typically immoderate way, ranting about his rival. So Baglione sued for slander.

The trial opened in August 1603. Baglione claimed Caravaggio had written scurrilous verses about him and distributed them around Rome. Caravaggio denied writing the poems but didn't refute his dislike for Baglione's work. He described Baglione's *Resurrection* as "clumsy" and said, "I consider it the worst he's ever done." Adding fuel to the fire, he added, "I don't know of any artist who thinks that Baglione is a good painter."

The trial ended inconclusively after the intervention of some of Caravaggio's patrons. The furious Baglione, who lived some thirty years longer than Caravaggio, eventually got his revenge in his book *The Lives of Painters, Sculptors, and Architects* (1642), in which he repeated every nasty rumor he had ever heard about the defunct Caravaggio.

REMBRANDT VAN RIJN

JULY 15, 1606?–OCTOBER 4, 1669

ASTROLOGICAL SIGN:
POSSIBLE LEO

NATIONALITY:
DUTCH

STANDOUT WORK:
THE NIGHT WATCH (1642)

MEDIUM:
OIL ON CANVAS

ARTISTIC STYLE:
BAROQUE

SEE IT YOURSELF:
RIJKSMUSEUM, AMSTERDAM, THE NETHERLANDS

"OF COURSE YOU WILL SAY THAT I OUGHT TO BE PRACTICAL AND OUGHT TO TRY AND PAINT THE WAY THEY WANT ME TO PAINT. WELL, I WILL TELL YOU A SECRET. I HAVE TRIED AND I HAVE TRIED VERY HARD, BUT I CAN'T DO IT. I JUST CAN'T DO IT! AND THAT IS WHY I AM JUST A LITTLE CRAZY."

QUOTABLE

Rembrandt had little use for Italian art. He ignored Raphael, turned up his nose at Leonardo, and shook off the influence of Michelangelo. He even refused to make the traditional artist's pilgrimage to Rome.

Yet he did adopt one practice from the Italian greats: He signed his name, simply, Rembrandt. Like Raphael, Leonardo, and Michelangelo before him (or Cher, Prince, and Madonna after him), he was known by one name alone. That's one heck of an ego.

Fortunately, Rembrandt had the artistic chops to back it up. His dramatic histories and forceful portraits challenged and captivated seventeenth-century audiences, at least until his aesthetic and Dutch taste parted ways. Spoiler alert: Rembrandt's story does not have a happy ending. But even if he died alone and in penury, he sure had one heck of a ride.

DIRTY NAILS AND ALL

Rembrandt was the eighth of nine children born to the van Rijns of Leiden, a family of millers. He must have been a bright child because, at about age fourteen, his family enrolled him at Leiden University. But the young boy had different plans, and in the early 1620s he pursued an artist's apprenticeship. Soon after completing his training, he moved to Amsterdam, a port city throbbing with the business of fur traders, spice importers, and slave brokers. At the height of the Dutch golden age, burghers enjoyed the fruits of their labors by commissioning portraits of themselves, their families, and their civic organizations. Artists flourished, and Rembrandt faced significant competition. Luckily, his style found favor by capturing not only the personal appearance of his patrons but a sense of their personality as well.

In his best portraits, Rembrandt added drama to the scene. In *The Anatomy Lesson of Dr. Tulp*, a group portrait of a well-known local physician and several surgeons, Rembrandt shows the good doctor demonstrating how arm tendons function. As he lectures, the surgeons peer intently at the flayed human appendage, their faces full of concentration and fascination.

The Dutch also enjoyed history paintings of biblical, historical, or mythological events, which usually contained some sort of moral. Such works often combined Caravaggio-esque drama with splendor—the women were busty and beautiful, the men chiseled and courageous, and the settings luxurious and exotic. Rembrandt demolished many of these conventions by simplifying his compositions, eliminating extraneous elements and making the characters

look like ordinary people. In *Samson and Delilah* of 1628, the blue-robed temptress looks like an ordinary tavern girl, complete with a double chin. The rare touch of luxe, her satin brocade gown, is countered by her dirty toenails.

MILITIA UNIT: IMPOSSIBLE

Rembrandt's star was on the rise throughout the 1630s. Commissions rolled in, and students lined up for classes. Things only got better in 1634 when he married the young and relatively wealthy Saskia Uylenburgh. Rembrandt immediately began sketching and painting his wife—as herself, as the Roman goddess Flora, and once, oddly, as a prostitute sitting on the knee of the biblical prodigal son, whom he painted as a self-portrait. With Saskia's dowry, combined with his booming artistic reputation, Rembrandt took out a mortgage on a large house.

To top it all off, Rembrandt received a major commission to paint a group portrait of an Amsterdam militia unit. Because the Netherlands defended its cities with these volunteer guards, militias symbolized Dutch independence and pride. In 1641, Amsterdam's six militia companies commissioned portraits for their new headquarters, and Rembrandt was asked to portray the company of Capt. Frans Banning Cocq.

Imagine comparing a group photo of corporate stockholders with a dramatic still from an action movie. That's how different Rembrandt's portrait was from the other five. Now known as *The Night Watch*, the work is alive with action and energy. The captain is shown gesturing his men forward, thrusting the company into motion. A drummer strikes up a beat, the standard-bearer raises his flag, and the troops lift their muskets and pikes. The patrons expected a static scene, and instead Rembrandt gave them this pulse-pounding mini-drama. He had gambled that he could transform his subject but still satisfy the commission, and his bet paid off. Dutch audiences were wowed.

His moment of triumph was sorely diminished, however, when Saskia was found to be suffering from tuberculosis. She died in June 1642, soon after *The Night Watch* was completed, leaving Rembrandt with a baby boy, Titus, less than one year old.

MAIDS MAKE THE MAN

Rembrandt may have tried to remain faithful to his wife's memory, but the presence of Geertge Dircx, his housekeeper, proved too tempting, and

within a few years the two were lovers. Then his eye fell on his new maid, the lovely Hendrickje Stoffels. He gave Geertge the boot while a pregnant Hendrickje was dragged before the church council for living in sin.

The decade was disastrous, and by the early 1650s popular taste had shifted. Unable to keep up with the mortgage, Rembrandt took out personal loans with patrons and Amsterdam businessmen. He transferred some of his possessions into Titus's name and even held a weeklong sale of his possessions, but it wasn't enough. Facing bankruptcy, Rembrandt watched as auditors inventoried all his possessions and sold them to repay creditors. The house was auctioned, and Rembrandt, fifteen-year-old Titus, Hendrickje, and new baby Cornelia moved to a rented house in a less-than-attractive neighborhood.

> REMBRANDT HAD A THING FOR SELF-PORTRAITS: THROUGHOUT HIS LIFETIME, HE DREW, PAINTED, AND ETCHED HIS OWN LIKENESS MORE THAN EIGHTY TIMES.

NEVER OVERESTIMATE YOUR AUDIENCE

If nothing else, Rembrandt had faith in himself. He believed he could get everything back with one massive gamble. The opportunity arose in 1661, when he received the civic commission to create a painting for the new town hall. The subject—*The Conspiracy of the Batavians Under Claudius Civilis*—was especially dear to the city. According to legend, in AD 69 the Batavians, a Germanic tribe believed to be the ancestors of the Dutch, rebelled against Roman oppression. In the seventeenth century, the episode was evoked as a parallel to the Netherlands' recent struggle against Spain. Popular prints depicted the feast at which the Batavians swore an oath of loyalty and declared their rebellion against Rome; most painters showed the Batavians standing around a table and shaking hands to seal the deal.

Rembrandt's approach couldn't have been more different. His Batavians aren't sophisticated proto-Dutchmen, but rather barbarians dressed in rough and wild regalia. Civilis's stern expression and battle-worn face are made grimmer by the scar of his missing left eye, a detail Rembrandt found in ancient histories. Most shocking? Instead of politely shaking hands, the conspirators cross their raised swords with Civilis's.

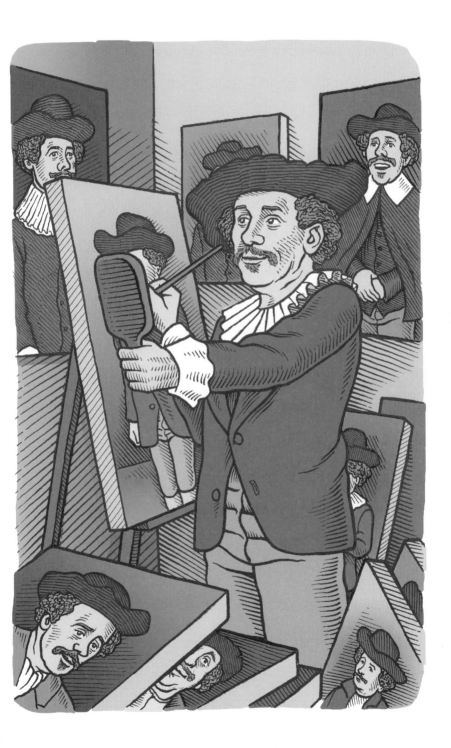

"Oh, er, my," said the Dutch. They expected an inspiring depiction of their forerunners but were met with an alcohol-fueled call to insurrection. Rembrandt believed he could wow his audience by transforming the subject, just as he had done with *The Night Watch*, but this time he was wrong. Officials requested that the work be removed.

DEATH OF AN OLD MASTER

The 1660s were terrible years of plague and death. The disease claimed the life of his beloved Hendrickje in 1662. Then Titus, who was working as an art dealer and his father's promoter, died in 1668, only eight months after his marriage. Despite personal misery, during his last years Rembrandt created many of his most enduring masterworks. He died October 4, 1669, alone except for his daughter, Cornelia. He was buried in a rented grave.

The next centuries would be equally grim for his reputation, with critics condemning his "vulgar" style. It wasn't until the nineteenth century that Romantic artists rediscovered Rembrandt and began to celebrate him as a prototypical artistic genius. The Impressionists and Post-Impressionists applauded his work and imitated his "rough" use of paint; Vincent van Gogh said of one of Rembrandt's late paintings, "I should be happy to give ten years of my life if I could go on sitting in front of this picture for ten days with only a dry crust of bread." Today, Rembrandt is considered to be the ultimate Old Master.

THE DAY WATCH?

The Night Watch is a terrible title for Rembrandt's most famous painting. Amsterdam's militias didn't guard the city at night. In his lifetime, the painting was known by the clunkier—albeit more correct—title *The Company of Captain Frans Banning Cocq*. Why the name change? By the nineteenth century, the already heavy shadows of the painting had darkened under layers of yellowing varnish and centuries of dirt. Audiences interpreted the scene as having taken place at night and gave the work its current title. A thorough cleaning after World War II removed much of the grime, and the resulting, much brighter painting more correctly shows Rembrandt's intended impression.

MY SUBJECT, MYSELF

If you thought Albrecht Dürer had a thing for self-portraits, Rembrandt put him to shame, drawing, painting, and etching his own likeness more than eighty times. Through these detailed and often startling works, we watch the artist age, his hair growing longer, shorter, and longer again; his eyes changing from sharp to tired to rheumy; his nose bulging wider and wider until the skin is pitted and the veins are broken. Sometimes he experiments with different facial expressions, from surprise to anger to shock. Other times he presents himself as a character—a beggar or a withered St. Paul. But most often he is unmistakably himself, an artist, holding a palette or standing before a canvas. In 1669, with both Hendrickje and Titus dead, Rembrandt depicted himself as Democritus, the ancient Greek philosopher who laughed at the spectacle of human life. The poignancy of the aging artist producing a bitter chuckle at the vanity of ambition makes for a haunting work.

SWEET REVENGE

Geertge Dircx had a right to be mad at Rembrandt: He'd thrown her out like last week's milk. So in 1649 she sued him for breach of promise. Eager to prevent a scandal, Rembrandt offered her money, but still she demanded a trial. The judges weren't going to force the artist to marry Geertge, but they demanded he increase his yearly payments to her. Rembrandt was steamed, and so he conspired with her brother, to whom Geertge had given power of attorney, to have her declared of unsound mind. She was thrown into a house of correction, a sorry workhouse where prostitutes and vagabonds were held alongside epileptics and the genuinely insane. Inmates were subjected to a rigorous schedule of demanding work, relentless sermons, and endless Scripture readings.

Geertge was finally released in 1656 after five years of incarceration, managing to regain control of her affairs from her treacherous brother. By then, Rembrandt's finances were in a disastrous state, and he was in no position to pay her. Before she could join the list of Rembrandt's creditors, she died. Pity she didn't live to see the artist humiliated and bankrupt—she might have enjoyed it most.

JOHANNES (JAN) VERMEER

OCTOBER 31, 1632 (DATE OF BAPTISM)–DECEMBER 15, 1675

ASTROLOGICAL SIGN:
SCORPIO

NATIONALITY:
DUTCH

STANDOUT WORK:
GIRL WITH A PEARL EARRING (CA. 1665–67)

MEDIUM:
OIL ON CANVAS

ARTISTIC STYLE:
BAROQUE

SEE IT YOURSELF:
THE MAURITSHUIS MUSEUM, THE HAGUE, THE NETHERLANDS

We expect art to have a message, yet the works of Johannes (Jan) Vermeer confound us. What meaning can we find in a maid pouring milk, a woman reading a letter, a girl practicing her music? We want there to be a story, and so we search in vain for hints to motive, character, and action. Our expectations are similarly unrealized when studying the life of Vermeer. We want there to be dramatic action and significant moments, but all we have are a few legal documents marking an ordinary life: birth, betrothal, burial.

In the end, we must take Vermeer's life as we take his art. It is what it is. All drama has been lost to time, all messages carefully hidden. A young woman wearing a lustrous pearl earring turns to face us, her lips parted and her expression questioning. Who is she? What is her relationship to the artist? How does she feel? Why did the artist paint her? We just don't know.

A MAN OF CATHOLIC TASTES

Vermeer lived during the Dutch golden age, a period when the art, science, and economic vitality of the Netherlands reached their apex. Artists thrived as a growing middle class with money to spend sought pictures to hang on the walls of their expanding homes. The nominally Protestant Dutch state cultivated an atmosphere of religious tolerance unknown in the rest of Europe.

Vermeer's life was shaped by this unusual religious setting. Other than a notation of his baptism, the first mention of him is a record of his betrothal to Catharina Bolnes in April 1653. In a witnessed statement, Catharina's mother, Maria Thins, refused her consent but allowed the engagement to go forward; in other words, she wouldn't give her approval to the marriage but she wouldn't stop it either. Apparently, Vermeer's staunchly Catholic mother-in-law didn't want her daughter marrying a Protestant. But married they were, and not long after Vermeer registered with the artist's guild in Delft, signifying his status as a professional master.

Maria needn't have worried about the religious practices of her son-in-law, for he became Catholic in everything but name. One of his first known paintings, *St. Praxedis* from 1655, takes as its subject a Roman saint who prepared the bodies of martyred Christians for burial. It's a strange painting, very un-Vermeer-like. The artist seems to be struggling to find his style.

GIRLS, GIRLS, GIRLS

About 1657, Vermeer started to paint works immediately recognizable as his, such as *A Girl Reading a Letter by an Open Window*. All the elements we consider quintessentially Vermeer are here: A woman stands by an open window, her face flooded with light. Vermeer gives us no hints about the meaning of the letter; in fact, X-ray analysis reveals that he removed symbolic items that might have been clues, including a painting of Cupid hanging on the wall, which would have led the viewer to surmise it is a love letter. As the painting is now, the letter could be a romantic plea or the seventeenth-century equivalent of a credit card offer.

Having discovered his favorite subject, Vermeer rarely strayed. He completed more than two dozen paintings that all show, essentially, women standing by windows. The ladies pour milk, examine their jewelry, read letters, play lutes. Sometimes he includes a second woman, usually a maid; rarely do men make their way into the scene. Many times the viewer seems to be in the same room, with the same window to the left, the same chairs with their lion-head finials, the same maps hanging on the wall. The women also wear the same clothes—a fur-trimmed jacket, a blue-stripped bodice— and the same water pitcher and jewelry box sit nearby.

The female preponderance probably has a lot to do with Vermeer's family situation. Women dominated his life. By the early 1660s he and his wife were living in the household of his mother-in-law, and their first five surviving children were daughters. He loved painting these women, and yet there is no sense that Vermeer, to use a contemporary term, objectifies them—his gaze is never lascivious or leering. Take *Girl with a Pearl Earring* from about 1665. Art historians have conjectured that the model was one of Vermeer's daughters, and that seems justified. We sense love, but not desire.

WAR IS HELL

Vermeer was highly regarded in his lifetime—contemporaries refer to him as "celebrated," and he was twice appointed the head of the painter's guild— but he certainly wasn't prolific. He completed no more than three or four paintings a year, totaling fewer than about fifty, and could not have supported his growing family on such limited output. Fortunately, the Vermeers lived rent free with Catharina's mother, who contributed income from various properties and loans. Vermeer also worked as an art dealer.

In 1672, the political stability and economic prosperity of the Netherlands abruptly ended when England and France declared war on the country. The art market collapsed; Vermeer could sell neither his works nor those of others. One of Vermeer's children died, as did his principal patron. Eventually the pressures killed him, too. Testimony by Vermeer's wife describes the anguish of his last days: "Owing to the great burden of his children, having no means of his own, he had lapsed into such decay and decadence . . . and in a day or day-and-a-half had gone from being healthy to being dead." He left enormous debts, ten underage children, and a house full of paintings. His wife was forced to declare bankruptcy.

Vermeer's work was little known until the late 1800s, when he was rescued from obscurity by French art enthusiasts who rediscovered the charm of his works and began widely promoting him; by the early 1900s, Vermeer was widely acknowledged as a master. In 1995–96 an exhibition of his works at the National Gallery of Art in Washington, D.C., attracted 330,000 visitors. Today, audiences celebrate works whose serenity and simplicity reflect the artist's seemingly quiet and simple life.

WHOA, BABY!

Pity Vermeer's wife, Catharina. In roughly twenty years, she bore fifteen children. No wonder, then, that several of the women in Vermeer's paintings appear to be pregnant. It's conjectured that he frequently used his wife as his model, and it sure would have been hard to catch her at a moment when she wasn't expecting.

ONE FAN YOU COULD DO WITHOUT

Adolf Hitler, himself a failed artist, hugely admired Vermeer, and he gave special instructions to his troops to watch out for his paintings, which were then "liberated" from their owners. Toward the end of World War II, the seized Vermeers were shipped to a salt mine in Austria for safe-keeping as part of a massive collection that included works by van Eyck, Leonardo, Dürer, and Rembrandt. As Allied troops approached Berlin, Hitler ordered the demolition of the mine, but

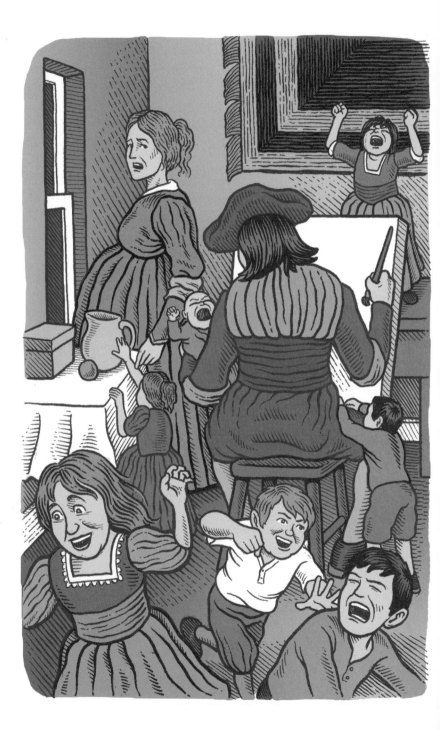

local officials used delays, evasions, and downright sabotage to save the art-works. The U.S. military discovered the mine, safeguarded the masterpieces, and redistributed the works to the museums and individuals from whence they had been stolen.

Among the works in the mine? An intriguing Vermeer titled *The Woman Taken in Adultery*, sold to Reichsmarschall Hermann Goering by a man named Han van Meegeren (see below).

FORGING AHEAD

The popularity and paucity of Vermeer paintings created an ideal situation for the not-so-honest to make a fortune on forgeries. That very idea occurred to Dutch artist Han van Meegeren in the 1930s. He went about his work with care, finding an old canvas, rubbing ink across the surface to imitate cen-turies' worth of dirt, and crafting a plausible provenance, or history of own-ership. His selection of a subject was particularly clever: Instead of imitating Vermeer's mature style, he copied his early religious paintings.

> IT'S NO WONDER THE WOMEN IN JAN VERMEER'S PAINT-INGS APPEAR TO BE PREGNANT: HIS WIFE—AND FREQUENT MODEL—BORE HIM FIFTEEN CHILDREN IN ROUGHLY TWENTY YEARS AND WAS RARELY NOT IN THE FAMILY WAY.

The scheme worked. A Vermeer scholar proclaimed the phony painting "every inch a Vermeer." Emboldened, van Meegeren produced five more "Vermeers" (along with two works by compatriot Pieter de Hooch), earning about $2 million, or some $28 million in today's dollars.

It wasn't until the end of World War II that van Meegeren came under inves-tigation as a Nazi collaborator for his sale of *The Woman Taken in Adultery* to Hermann Goering. Charged with collaborating, van Meegeren put on an extraor-dinary defense: He couldn't be convicted of selling a Vermeer to the Nazis because the painting wasn't really a Vermeer; it was a forgery. Further, in fool-ing Goering, van Meegeren had arranged for the return of some two hundred paintings looted from Dutch collections. The Dutch, perhaps astounded by his audacity, proclaimed van Meegeren a hero. The collaboration charges were dropped, and he was given a one-year sentence for fraud. Meanwhile, art experts were left to explain how they had been hoodwinked for so long.

VANISHING VERMEERS

The skyrocketing value of Vermeer's paintings has made them prime targets for art thieves. In 1974, thieves took *The Guitar Player* from Kenwood House in London. They apparently had political motives, for police received messages ordering them to move two young women serving life sentences in Britain for their involvement with an Irish Republican Army bombing unit. The London *Times* received a strip of canvas cut from the edge of the painting along with a threat that the artwork would be burned on St. Patrick's Day if the women weren't transferred to an Irish prison. The prisoners weren't moved, and no ransom was paid; in the end, police received a phone call directing them to a London churchyard, where they found the work wrapped in an evening paper.

The only Vermeer work still missing is *The Concert*, which was stolen from the Isabella Stewart Gardner Museum in Boston in 1990. Thieves dressed in local police uniforms convinced museum guards to let them in; they then bound and gagged the museum staff, destroyed all the security tapes, and spent the next two hours removing more than a dozen works including the Vermeer, two Rembrandts, a Manet, and an ancient Chinese bronze beaker. As of this writing, the whereabouts of these paintings are still unknown, even though a $5 million reward awaits anyone who helps track them down.

FRANCISCO GOYA

MARCH 30, 1746–APRIL 16, 1828

ASTROLOGICAL SIGN:
ARIES

NATIONALITY:
SPANISH

STANDOUT WORK:
THE THIRD OF MAY, 1808 (1814–15)

MEDIUM:
OIL ON CANVAS

ARTISTIC STYLE:
ROMANTIC

SEE IT YOURSELF:
MUSEO DEL PRADO, MADRID

"THE SLEEP OF REASON BRINGS FORTH MONSTERS."

QUOTABLE

The theme of war is as old as art itself. Ancient works present war as honorable, even glorious, and when artists of the late eighteenth and early nineteenth centuries turned to the subject, they followed this tradition. Of course, most of them had never seen a battlefield.

Not Francisco José de Goya y Lucientes. Goya lived in occupied Madrid, toured battlefields, and witnessed the aftermath of executions and reprisals. He responded by creating art that, for the first time, portrayed war as ugly, muddy, bloody, and unfair. Goya painted war's bitter truth. It was a strange fate for an artist who began as an adequate Rococo painter seeking success at the Spanish royal court.

WHAT DREAMS MAY COME

There weren't many opportunities to get ahead in Spain in the mid-1700s, but art offered one way to advance socially—if you were good enough. Goya decided he had what it took. After training in his hometown of Zaragoza, he moved to Madrid in 1774 and worked his way up to court artist. For nearly twenty years, he painted conventionally pretty rococo portraits and country scenes. . . . Then he got sick.

We don't know what nearly killed Goya in the winter of 1792–93. He heard ringing in his ears, endured debilitating vertigo, and suffered from fainting fits and semi-blindness. His sickness has been attributed to various causes—Ménière's disease, botulism, polio, hepatitis—but we really don't know the cause. He was left completely deaf, and his life would never be the same.

Nor would his art. Goya soon began a series of engravings known as *Los Caprichos*. The most famous shows a man slumped asleep at a desk as menacing bats and owls swarm in and out of darkness; the caption reads, "El sueño de la razón produce monstruos" (The sleep of reason brings forth monsters).

The *Caprichos* are a motley bunch, part fantasy, part satire, and the public found them baffling and potentially dangerous, what with the Inquisition ready to jump on any perceived blasphemy. Goya had three hundred sets of *Los Caprichos* printed, but only twenty-seven sold.

GUERILLA TACTICS

The king named Goya First Royal Painter in 1799, but the monarchy's days were numbered. In 1807, Napoleon convinced Carlos to let him move 100,000 troops into Spain on the pretext of invading Portugal. Then Crown

Prince Ferdinand, who combined gross stupidity with raging paranoia, attempted a coup against his father. Terrified, Carlos first abdicated but then changed his mind. Napoleon offered to negotiate if all parties would come to France. Carlos, not the sharpest knife in the drawer, agreed, and in April 1808 the Bourbons obligingly packed their bags. With the royal family in his custody, Napoleon announced he was giving the Spanish crown to his brother Joseph.

One member of the royal family, a thirteen-year-old prince, remained in Madrid, so Napoleon ordered him moved to France. On the morning of May 2, passersby noticed French soldiers bundling the prince into a carriage. Suddenly the locals realized what was happening, and violence broke out across the city. The next day, the French began reprisals, rounding up real and imagined rebels and staging mass executions. From there, it was a steady slide into war.

Spain might possibly have benefited from Napoleon's rule, particularly his liberal constitution, but the Spanish wanted nothing of it or of Napoleon's brother Joseph, whom they nicknamed Pepe Bottelas ("Joe Bottles") for his love of wine. The Spanish army was ill-prepared to fight the superior French, but no matter—the real threat was small, self-organized bands that relentlessly harassed the invaders and then escaped into the hills. These *guerrilloros* fought throughout Spain in the *guerrilla*, or "little war," tormenting the French and lending their name to a new type of conflict. War raged for six long years.

I AM THE EGGPLANT

Goya's loyalties were torn: He supported the new constitution and had little sympathy for the loutish Fernando, but his patriotism ran deep. He certainly wasn't among those who flocked to the court of King José, but it would have been dangerous to publicly demonstrate resistance. So he painted portraits of members of the French circle and accepted a royal decoration invented by Joseph, the Order of Spain, known derisively for its color as "The Eggplant."

He also completed several patriotic works such as *The Water Carrier* and *The Knife Grinder*, which show his compatriot's indomitable spirit, while working on a series of engravings that were much less gung-ho. Known as the *Desastres de la Guerra* (Disasters of War), the engravings expose the horrors of battle: A peasant hefts an axe over a screaming French soldier; refugees trudge along a road; mangled bodies hang from tree limbs. There is nothing patriotic about these images—the Spanish are shown to be as brutal as the French. Goya seems to have decided the series was too dark

and too dangerous to exhibit, so he hid it away. The *Desastres de la Guerra* weren't published until 1863, thirty-five years after Goya's death.

Eventually the French were defeated, and in 1814 Fernando returned in triumph to Madrid. (Carlos had died during the war.) He promptly rejected the liberal constitution, enforced his absolute rule, and mercilessly punished French collaborators. Goya needed to secure his position: Fernando would surely be wary since Goya had accepted that "eggplant" honor. So he sought a commission to commemorate the events of May 2–3.

These works became Goya's celebration of the Spanish spirit. The first, *The Second of May, 1808*, is the lesser known of the two; it depicts one of the spontaneous conflicts that broke out on that day in Madrid. The more famous painting, *The Third of May, 1808*, is Goya's masterpiece, completed in 1814–15. To the right, a line of French soldiers stand aiming their rifles at a cluster of Spanish partisans. The Spaniards, grouped on the left, hide their eyes, clench their hands, or stare at their executioners in despair; in the center, one throws open his arms and faces the French with wide-eyed defiance. Nothing like this scene had ever been painted. Yes, you can see influences—the arms-out position of the central Spaniard evokes the crucified Christ, for example—but never before had art been so honest about war.

Were the paintings hung in a prominent place to serve as a constant reminder of the cost of conflict? Nope. Fernando was unimpressed, and the paintings drop out of the records. They weren't even displayed until 1872.

I'M OUTTA HERE

At least Goya was safe and could return to work as a court artist. From 1819 to 1823, he worked on the series known today as the *Black Paintings*, applied directly onto the walls of his country house. These are huge, strange, haunting images. In the best known, *Saturn Devouring His Son*, the naked god, his eyes wide in madness, bites down on his offspring's bloody limbs. Some critics have suggested that Goya himself was a little mad in these years, but evidence in his letters contradicts this notion.

Fernando's disastrous policies nearly ruined Spain, and finally Goya had had enough. Using the excuse that he needed to visit a French hot spring for his health, he applied for a passport and arrived in Bordeaux in 1824. He spoke no French, but it didn't matter—he was deaf, after all. He was cared for by his housekeeper/lover Leocadia and her daughter Rosario, who may have been their

daughter (facts are inconclusive). Goya died two weeks after suffering a stroke in April 1828, at the age of eighty-two. Although he left no immediate followers, he influenced later artists, notably those of the twentieth century—Modernists who appreciated his willingness to confront the horrors of the modern world and Social Realists who believed art should expose injustice.

Even today we don't know quite what to do with Goya: How do you reconcile the court painter with the satirist of *Los Caprichos?* the realist of *The Third of May?* the fantasist of *Saturn Devouring His Son?* He doesn't fit into any artistic categories or schools, nor does his art fit well in museums, where its brutal realism hangs uneasily between the still lifes and landscapes.

WOMAN OF MYSTERY #1

Goya met Maria Theresa de Silva y Silva, Duchess of Alba, when he was forty and she was twenty-four. She was in her prime: beautiful, willful, charming, spoiled, and intelligent. Goya fell under her spell, as did, it seems, everyone who met her.

So how well did the duchess and the artist know each other? Impossible to say. Goya certainly knew who she was, showing her in formal portraits, country scenes, engravings, sketches, and perhaps even in the nude. She has been cited as the model for *The Naked Maja* and *The Clothed Maja*, two paintings that are essentially of the same woman with a faint, intimate smile, lying on a bed and gazing at the viewer. Despite her exposed state in the nude version, the clothed *Maja* is arguably the sexier of the two. Her white dress reveals as much as it conceals, curving over her hips, falling between her legs, and barely containing her chest.

So are these paintings of the duchess? Neither resembles her. Some biographers assert that Maria Theresa posed for the paintings but Goya changed her face to avoid compromising her reputation. Others say a duchess would never have posed nude for a working-class artist, and, furthermore, the whole "affair" is wishful thinking. We'll never know for sure, but it's tantalizing to imagine the enigmatic Goya having a rousing love affair with this apparently irresistible woman.

WOMAN OF MYSTERY #2

We know next to nothing about Goya's wife, Josefa Bayeu y Subías. Her brothers were artists who presumably introduced her to Goya, and the two married in 1771. It is said she endured twenty pregnancies and suffered repeated miscarriages, but only one child, a son, survived into adulthood. Goya rarely mentioned her in his letters, and we know of none she wrote herself (it's possible she was illiterate). Last known fact: She died during Spain's war with France.

LIFE BEFORE WITE-OUT

Two years into the war with Spain, Goya was asked to paint a portrait of Joseph, the French king. He needed the money, so he reluctantly accepted the commission. He called the work *The Allegory of Madrid* and composed it so that he wouldn't have to actually see the king. He copied Joseph's profile from an engraving and positioned it within a medallion surrounded by frou-frou angels and a beatific maiden symbolizing Madrid.

In 1812, English forces routed Napoleon's army and Joseph Bonaparte fled Madrid, so Goya painted over the erstwhile king's profile and replaced it with the word *Constitución*, in honor of the document that promised basic freedoms to Spaniards. Ah, but then Joseph came back, and Goya returned him to his oval. José I finally left for good in 1813, and Goya had one of his assistants put *Constitución* back in.

IN THE WINTER OF 1792–93, GOYA SUFFERED DEBILITATING VERTIGO, FAINTING FITS, AND SEMI-BLINDNESS— TRUE-LIFE MONSTERS THAT APPEARED IN HIS ART, ESPECIALLY THE GROUP OF ETCHINGS KNOWN AS *LOS CAPRICHOS.*

But wait, there's more. In 1814, Fernando returned to the city and immediately annulled the constitution. Taking its place in the oval was his profile, painted by Fernando's favorite court artist. There it stayed until 1843, when the city of Madrid, with no fond memories of the dear-departed monarch, had him painted out and the words *Libro de la Constitución* put in his place. Even that was too partisan to last, and in 1872 new words filled the oval—Dos de Mayo (the Second of May). And so the painting remains to this day.

THE VENUS DE MILO
(DISCOVERED 1820)

She is the second-most popular lady in the Louvre—only the *Mona Lisa* attracts more attention. This ancient statue depicts a beautiful woman, nude from the waist up and with clinging draperies covering her hips and legs. Her arms are broken off near the shoulders.

The so-called Venus de Milo is believed to represent Aphrodite, who was called Venus by the ancient Romans. The statue was discovered in 1820, at the height of the Neoclassical movement. Antiquities were all the rage, and Europeans visiting Greece had a habit of prying loose ancient marbles and hauling them home as souvenirs. So when French sailor Olivier Voutier had shore leave on the Aegean island of Melos, he decided to go treasure hunting near the ruins of the ancient theater. He and a local farmer dug up the statue of Venus along with several other carved stones.

Voutier tried to convince his captain to sail immediately to Constantinople to get permission from the French ambassador to buy the statue, but when the captain refused, Voutier lost interest. However, another French naval officer on the scene, Jules Dumont d'Urville, headed for Constantinople in Voutier's stead. Permission granted, d'Urville returned to Melos to find the statue in a rowboat in the middle of the harbor; a Turkish official had seized it and made a deal with a Russian captain to ship it to Constantinople. After lengthy negotiations with the islanders, d'Urville arranged to buy the statue, retrieving it from the Russians. Later, Turkish authorities, who were outraged to have such a prize slip through their fingers, ordered the island's leading citizens to be publicly whipped.

Meanwhile, the statue arrived in Paris safe and sound. At the time, the emerging discipline of art history was dominated by the ideas of German scholar Johann Joachim Winckelmann (1717–1768), whose evolutionary the-

ory declared that Greek art had reached its height during the Classical period (510–323 BCE) and declined during the Hellenistic period (323–146 BCE). When museum experts saw the beauty of the *Venus de Milo*, they immediately declared it to be the work of a Classical master. Imagine their shock when they learned that among the recovered bits of marble was a carved base that fit the statue perfectly. Its inscription read: "[Alex]andros son of Menides, citizen of Antioch on the Maeander made this statue." Well, problem was that Alexandros was hardly a master and Antioch on the Maeander didn't exist during the Classical period—it was a Hellenistic colony. Since the inscription contradicted Winckelmann's beloved theory, curators decided that the base didn't really fit the statue. When Venus was displayed, the base was nowhere to be found—and hasn't been seen since, despite nearly two centuries of searching.

The statue has a sort of simple beauty—chipped, battered, broken, yet elegant. It would have presented a very different image in its prime, however, when it stood in a niche in a gymnasium. The Greeks painted their statues with bright colors and decorated them with jewelry. Serene Venus would have been downright gaudy.

The masterpiece known as the *Venus de Milo* started life as an incidental sculpture by an unknown artist on a small island. Only today, with so much Greek heritage lost, do we treasure it as a sublime image of feminine beauty. ■

JACQUES-LOUIS DAVID

AUGUST 30, 1748–DECEMBER 29, 1825

ASTROLOGICAL SIGN:
VIRGO

NATIONALITY:
FRENCH

STANDOUT WORK:
DEATH OF MARAT (1793)

MEDIUM:
OIL ON CANVAS

ARTISTIC STYLE:
NEOCLASSICAL

SEE IT YOURSELF:
ROYAL MUSEUMS OF FINE ARTS OF BELGIUM, BRUSSELS

QUOTABLE *"I DEMAND THAT YOU ASSASSINATE ME."*

*I*t's pretty darn remarkable Jacques-Louis David managed to die of old age in his own bed. If any artist ever played high-stakes politics it was David, and in his day, political missteps could cost you your head. Literally.

David started out as the golden boy of the French Academy and a favorite of the aristocracy. Then he transformed himself into a radical Republican, designing propaganda spectacles and signing death warrants. After barely escaping the Terror, he fell under the spell of Napoleon and devoted himself to promoting the emperor's reign. It was only in his old age, with France back under royal control, that David withdrew from the fray. Along the way, he sought to develop art infused with republican values, a style that came to be known as Neoclassical. Ultimately, he wasn't much of a politician, but he knew how to create an image, and it is his image of the French Revolution that we all know today.

GIVE THAT MAN A PRIZE!

Rococo was just about the silliest art movement in Western history. A typical Rococo painting features busty goddesses grasped by muscular gods, surrounded by pudgy cherubs, and supported by pouffy clouds. Yet it became the unofficial art style of the French monarchy during the reign of the Sun King, Louis XIV (1643–1715), and gained popularity throughout much of the 1700s.

David learned to paint the frilly stuff and was actually pretty good at it. He expressed an early interest in art and in 1766 entered the state-sponsored Royal Academy of Painting and Sculpture. The highest achievement for academy students was the annual Prix de Rome, entitling the winner to an all-expense-paid trip to Italy; David won in 1774, although it did take him four tries. He wanted the prize for the prestige, not for the opportunity to see the art of Rome. "The antique will not seduce me," he told friends. Famous last words.

FAREWELL, CHERUBS—HELLO REVOLUTION

Confrontation with the works of ancient Roman artists and Renaissance masters came as a physical blow to David—he actually collapsed in aesthetic shock. Upon returning to Paris in 1780, he struggled to incorporate what he had learned. As important as Michelangelo-esque nudes in Caravaggio-esque poses was a new tone, one of austerity, even severity, combined with an emphasis on patriotic duty and sacrifice. Two of his early

masterpieces, *Oath of the Horatii* of 1784 and *The Death of Socrates* of 1787, typify this approach.

David was becoming a favorite of the aristocracy, who begged him to paint their portraits, when wider events drew him into their spiral. In the summer of 1798, Louis XVI convened the Estates-General, a sort of French parliament, to try to restructure the state. When real reform was blocked, the middle classes and peasants, known as the Third Estate, split off and formed the National Assembly to represent "the people." The king tried to regain control by locking the doors of the assembly room, but representatives merely headed to a nearby indoor tennis court, where they swore an oath not to disband until they had given France a constitution.

David may or may not have witnessed the famous Tennis Court Oath, but he was asked to commemorate the event with a monumental painting. He started preliminary sketches, but events moved faster than art; by the time he began to paint the canvas, several of the main participants had been exiled or executed.

It would be nice to think David became a revolutionary out of principle, but his real motives were less noble. He held a long-simmering grudge against the leaders of the French Academy, who had declined to appoint him director of the academy in Rome and then refused to hold an exhibit to commemorate the premature death of one of his students. At first, David saw the Revolution as an excuse to attack the academy, and he denounced the institution as "despotic." He eventually triumphed: In 1793, the academy was shut down.

RUBOUT IN THE TUB

Involvement with revolutionaries was intoxicating, and David quickly transformed into a radical true believer. Observers described him as "delirious" with revolutionary fervor. In 1792, he was elected to the National Convention, and in early 1793 he voted for the death of Louis XVI. He put his artistic powers to revolutionary purposes, designing propaganda spectacles, and he also painted a series of works commemorating the deaths of republican "martyrs." The most famous, *Marat Breathing His Last*, is better known today as *The Death of Marat*.

Jean-Paul Marat was a radical journalist who founded the newspaper *The Friend of the People*, which served as a forum to denounce the per-

ceived enemies of the people—all of whom ended up at the guillotine. In 1793, Charlotte Corday, a dedicated young revolutionary, became outraged by the Reign of Terror and decided to stop its best-known proponent: Marat. Armed with a butcher knife, she headed for his house. On that fateful day Marat, who suffered from a miserable skin condition, was reposing in a cool bath, which helped relieve his terrible itching. Corday entered on the pretext of supplying names of counter-revolutionary traitors. She handed him a sheet of paper, took out her knife, and stabbed the partially submerged Marat to death. She was seized and guillotined four days later.

The day before the murder, David had visited Marat in his fateful bathtub, and he had even defended Marat when political opponents had lobbied for the journalist's execution, shouting, "I demand that you assassinate me. I too am a virtuous man!" National Convention members asked David to commemorate the assassination, and the resulting painting shows Marat sitting in his sheet-draped bath, his upper body slumped to the side as his blood tints the bathwater. Of course, the painting was more image-making than reality. Marat appears as a young Roman martyr, not a middle-aged grouch with a skin condition.

Meanwhile, the body count rose. In ten months, the Reign of Terror claimed nearly 40,000 lives. Finally, its mastermind, Maximilien Robespierre, watched his support collapse, and in July 1794 he and his followers were seized, tried, and executed. David was thrown into prison, where he immediately claimed he had been duped by Robespierre's powerful personality. (Way to be loyal to your friends.) After a year and a half in and out of jail, he was released and granted amnesty in October 1795.

THE EMPEROR AND I

David resolved to stay out of politics, and for a while he did. Then in 1797 he attended a dinner party held in honor of rising military star Napoleon Bonaparte, whose devastating charisma caused David to gush, "Bonaparte is my hero!" As the Little General's power rose, he relied on David for portraits, such as the 1800 *Bonaparte Crossing the St. Bernard Pass*, in which the blue-and-gold-clad hero sits astride a rearing horse. David took significant liberties with the painting—Napoleon had actually rode on a mule—to create a magnificent scene of power and grandeur. His next major task was an enormous canvas celebrating Napoleon's coronation as emperor, which he completed in 1806. The coronation was a high point not only for Napoleon

but also for David. After that, things sort of went downhill. In 1812 Napoleon invaded Russia, dooming not only his troops but his entire rule. When only 20,000 of the original 600,000 troops returned, the emperor's enemies seized the opportunity to attack. Napoleon was defeated, and the Bourbon kings returned to the throne.

David tried to keep a low profile, except that Napoleon wasn't done yet. He escaped from exile, rallied his troops, and triumphantly returned to Paris. David rushed to pay his respects. The Battle of Waterloo forced the former emperor into permanent exile, the Bourbons returned yet again, and David fled Paris.

A GRUDGE IS A GRUDGE

The artist settled in Brussels. He was given several opportunities to return to France, with the king making it known that if he apologized he would be welcomed back. David replied with some dignity, "Never speak to me again of things I ought to do to get back. I do not have to do anything; what I ought to have done for my country I have already done."

David continued to paint until his health failed in 1825; he died in the arms of his son on December 29. His family hoped he could be buried in his beloved France, but in a final act of petty revenge, the government refused, and David was laid to rest in Brussels.

After David's death, his family tried to sell *The Death of Marat*, which had sat rolled up in his studio for nearly three decades. (The painting had been returned to him upon the fall of Robespierre, and David had had enough sense to keep it under wraps.) But by the mid-nineteenth century Marat was perceived as a villain, and Corday, his assassin, a heroine, so no one was much interested. Finally, in 1886, the Royal Museum of Fine Arts in Belgium accepted the painting as a gift, and the work remains there today.

AS GIDDY AS A TEENAGER, JACQUES-LOUIS DAVID GUSHED, "BONAPARTE IS MY HERO!" AND PROCEEDED TO PAINT THE EMPEROR LARGER, HANDSOMER, AND GRANDER THAN LIFE.

"GROSS DAVID WITH THE SWOLN CHEEK"

That's how the Scottish essayist Thomas Carlyle referred to the French artist—a nasty comment but a true one. During a student duel, his opponent's blade pierced David's cheek. The result was a benign tumor that distorted his face and twisted his mouth. It made speech extremely difficult, and David's orations before the National Convention were said to be nearly incom

prehensible. More than one art historian has made a connection between David's garbled verbal communications and his crisp visual representations. In the words of one biographer, "It may not be too fanciful to link his increasingly aggressive and biting compositional attacks with his decreasing ability to express himself clearly in words."

I DO, I DON'T, I DO AGAIN

When David returned from Italy in 1780, he was offered a studio and lodgings in the Louvre. David asked the contractor, the successful Monsieur Pécoul, to build him a small alcove for his bed. "Why small?" asked Pécoul, "why not big enough for two?" and proceeded to offer his daughter Charlotte as a companion. David and Charlotte were married in May 1782 and went on to have four children.

At first Charlotte supported the Revolution as much as her husband did, but as David's views grew more extreme, she pulled away. David's support of the king's execution was the final blow to their marriage, and an appalled Charlotte promptly filed for divorce. However, after the downfall of Robespierre and David's imprisonment, Charlotte had a change of heart. She visited her ex in prison and declared herself his "devoted wife." They remarried in November 1796, a newly fond couple, with Madame David backing his every enterprise. She died less than a year after her husband.

LIBERTY'S REVENGE

The famous *Death of Marat* was originally one of two works celebrating Revolutionary martyrs. The first was in honor of Louis Michel Le Pelletier de Saint-Fargeau, a former aristocrat who, opportunely, allied himself with the republicans and voted for the death of the king. On the eve of Louis XVI's date with the guillotine, one of the king's former bodyguards tracked down Le Pelletier and killed him. He was immediately hailed as a Revolutionary martyr. David decided to paint Le Pelletier at the moment of death and quickly completed a work that showed Le Pelletier as a Roman warrior giving up his life for his nation.

So why have you never seen this painting? It no longer exists. Le Pelletier had a young daughter named Suzanne, and after his death she was adopted by the French nation and rechristened, bless her heart, "Liberty." Little Liberty didn't have Dad's devotion to the cause—she became a ferocious royalist who dropped "Liberty" at the first opportunity. As an adult, she bought up all prints she could find of the painting and had them destroyed. She then negotiated with David's son for the original painting; he kept raising the price, but the wealthy Suzanne was prepared to pay anything. Finally, the David family gave in, and Suzanne burned *Le Pelletier de Saint-Fargeau on His Deathbed* to ashes. That we know what the painting looked like at all is due to the accidental survival of one torn print and a drawing by one of David's students.

DANTE GABRIEL ROSSETTI

MAY 12, 1828–APRIL 9, 1882

ASTROLOGICAL SIGN:
TAURUS

NATIONALITY:
ENGLISH

STANDOUT WORK:
PROSERPINE (1874)

MEDIUM:
OIL ON CANVAS

ARTISTIC STYLE:
PRE-RAPHAELITE

SEE IT YOURSELF:
TATE GALLERY, LONDON

QUOTABLE

"TO BE AN ARTIST IS JUST THE SAME THING AS TO BE A WHORE, AS FAR AS DEPENDENCE ON THE WHIMS AND FANCIES OF INDIVIDUALS IS CONCERNED."

*I*n the mid-nineteenth century, the English Royal Academy of Arts worshipped the Italian masters so much that it copied them down to the brown tone of their canvases. When young artists had the effrontery to paint grass green, they were reprimanded; in the paintings of Renaissance painter Raphael, grass is always a dirty brown. The academicians never considered that the masters wouldn't have recognized their own canvases because of all the dirt and varnish piled on their surfaces.

Dante Gabriel Rossetti, thought it was stupid, all of it—the repetition of tired themes, the insistence on dull colors, the preference for the old over the beautiful. He celebrated beauty—the beauty of lovely women, the beauty of Romantic poetry, and the beauty of the medieval past. So he created an art style all about beauty, full of gorgeous women in stunning settings. And his grass is always green.

BREAKING WITH CONVENTION

With a name like Gabriel Charles Dante, how could you not grow up to be an artist? Dante Gabriel, as he came to be known, was named by his father Gabriele, an Italian expatriate who had fled his homeland in the 1820s. Rossetti senior became a professor of Italian at King's College, London, but his true passion was an exhaustive commentary on Dante's *Divine Comedy*.

Rossetti showed early interest in art, and at age thirteen he started on a Royal Academy–approved curriculum. He immediately rebelled against the course of instruction, which required endless drawings of classical models and tedious exercises in perspective. (The result was a weak grasp of the basics— Rossetti's perspective is usually wonky and he never understood anatomy.) By 1848, he was fed up with academy instruction and decided to look for one-on-one tutoring. He wrote a glowing letter to Ford Madox Brown, an aspiring artist seven years his senior. Brown had been little noticed, and when he received a letter praising him to the skies, he decided it was a cruel hoax. He grabbed his heavy walking stick and set out for the Rossetti home, demanding of the aspiring artist, "What do you mean by it?" Rossetti managed to convince Brown that he meant what he said, and the two became life-long friends.

BROTHERHOOD OF THE PENIS

Rossetti also befriended two academy students, William Holman Hunt and John Everett Millais. One night the trio got particularly fired-up over a book of engravings of early Italian Renaissance frescoes. In a burst of enthusiasm,

they decided to form an artistic society and call themselves the Pre-Raphaelite Brotherhood. They didn't actually have anything against Raphael; they merely rejected the uninspired rehashing of Renaissance themes. Nor did they intend to imitate medieval art. Rather, according to Hunt, they sought to "sympathize with what is direct and serious and heartfelt in previous art, to the exclusion of what is conventional and self-parodying and learned by rote." The result was an emphasis on painting directly from nature and a hyper-focused style in which every detail is painstakingly rendered.

Four other men were invited to join, bringing their number to the magic seven. They pledged to sign their paintings with "P.R.B." and imagined audiences breathlessly pondering the initials' significance. (To maintain an aura of secrecy, they suggested telling outsiders that P.R.B. stood for "please ring bell" or "penis rather better.")

Rossetti, Millais, and Hunt exhibited the first Pre-Raphaelite canvases at the 1849 academy exhibition, but to their disappointment, no one noticed they had begun an artistic revolution. They finally got the attention they craved in the 1850 show, but not in the way they had imagined. Pre-Raphaelite paintings were labeled, among other things, revolting, atrocious, disagreeable, preposterous, and ugly. The reception the next year was even more devastating. The movement was rescued only when the leading art critic of the day, John Ruskin, wrote a glowing review of P.R.B. art in the *Times*, and the tide finally turned.

Rossetti never got over the early condemnation, and in the mid-1850s he decided not to exhibit publicly. He liked to mock the process of marketing artwork as prostitution, although no one cared less than Rossetti about what patrons wanted. For all his talk that "to be an artist is just the same thing as to be a whore, as far as dependence on the whims and fancies of individuals is concerned," Rossetti always painted exactly what he liked: beautiful women.

FOR THE LOVE OF LIZZIE

By 1853 the brotherhood had pretty much disbanded, with members dropping out or moving on, although Rossetti found new kindred spirits in the young artists William Morris and Edward Burne-Jones. He found another kindred spirit in the object of his affections, Elizabeth (Lizzie) Siddal, a stunning beauty from London's lower classes who had been spotted by a P.R.B. companion working in a milliner's shop. Soon she was modeling

exclusively for Rossetti and spending her days (and nights) at his flat.

Lizzie had tuberculosis when the two met and was never completely healthy. She dropped hints about marriage, but commitment-phobic Rossetti always devised an excuse or delay, particularly when his roving eye was caught by another beauty. After a decade of dallying, and after Siddal had suffered a particularly severe flare up of TB, the two were wed on May 23, 1860. Their marriage prompted a period of great artistic productivity, with Rossetti concentrating particularly on poetry. Unfortunately, Siddal enjoyed no such happiness. In May 1861 she suffered a stillbirth and never fully recovered. She began taking copious amounts of laudanum, an alcoholic tincture of opium, and died of an overdose on February 11, 1863. The death was ruled accidental, but rumors flew that she had left a suicide note reading, "My life is so miserable that I wish for no more of it."

Devastated by guilt, Rossetti blamed himself for spending too much time on his work. And so at her funeral, he placed all his poems into her casket.

UM, ABOUT THOSE POEMS . . .

Ah, dramatic gestures. As Rossetti's grief receded, he began regretting his decision, and in 1870 he sought permission to exhume Lizzie's coffin. The poems, which had to be disentangled from the corpse's hair, appeared later that year in his first book, *House of Life*, which was published to general acclaim—much of it manufactured by Rossetti, who prevailed on friendly critics to write anonymous reviews.

Rossetti also fell in love again. His new passion was Jane Morris—Mrs. Jane Morris, the wife of his friend William Morris, the poet, architect, and decorator. Morris tacitly approved of the affair. In the summer of 1871, he installed his wife and their two small children in a country house and set off for Iceland; six days later, Rossetti arrived.

The new-found couple existed in a blissful dream world. Between long walks in the country and—presumably—long sessions in bed, Jane modeled for Rossetti. Her most memorable pose was as the young goddess Proserpine, who was kidnapped by Pluto, god of the dead, and henceforth forced to spend six months of the year with him in the Underworld because she had eaten six seeds of a pomegranate fruit. Rossetti shows the goddess in a rippling blue robe, holding the fateful fruit in her hand. She is the quintessential Pre-Raphaelite beauty, all drooping hair, sad eyes, and full lips. For

Rossetti, the myth symbolized the torment of a woman (Jane) bound to husband she didn't want (William).

A CRITICAL RX

At the end of his summer idyll, Rossetti returned to London deeply depressed. He had long suffered from insomnia, and now it was back with a vengeance. He turned to his favorite sleep aid, chloral hydrate, and started downing massive doses several times a day. And since the drug nauseated him, he chased it with whiskey. He had no idea how dangerous the combination was, creating a Pre-Raphaelite Mickey Finn that induces not only sleep but psychosis as well.

Soon after, in the literary scandal of the year, Rossetti was publicly attacked in an article titled "The Fleshly School of Poetry: Mr. D. G. Rossetti," by Thomas Maitland, a pseudonym for Robert Buchanan, an unsuccessful poet. Buchanan criticized Rossetti for the eroticism and sensuality of his poetry and called his work "simply nasty." Rossetti went off the deep end and became convinced that everyone, from people on the street to birds in the trees, conspired to destroy him. In June 1872, he attempted suicide by swallowing an entire bottle of laudanum.

> A FEW YEARS AFTER HIS WIFE WAS BURIED WITH THE POEMS HE'D WRITTEN FOR HER, GABRIEL ROSSETTI HAD HER CORPSE EXHUMED—AND THE POEMS UNTANGLED FROM HER HAIR—SO THAT HE COULD PUBLISH THEM IN HIS FIRST BOOK.

Despite surviving the breakdown, Rossetti never completely recovered from his persecution delusions and gradually became a recluse. He still painted, eventually completing two versions of Proserpine, but the chloral hydrate was killing him. By 1881, he was suffering from delusions and bouts of paralysis. Under a nurse's care, he was moved to a health resort at Birchington-on-Sea, where he died on April 9, 1882. His death prompted an enormous interest in his work, and two major memorial exhibits were held in the following years, presenting the public with the first opportunity to see his paintings since the 1850s.

Rossetti strongly influenced the Symbolist poets and artists of the late 1800s and Modern poets such as William Butler Yeats, but new art move-

ments condemned him to obscurity. It wasn't until the late twentieth century that his work again found favor. Popular culture discovered the work of the Pre-Raphaelites, and today Lizzie Siddal and Jane Morris look out from endless coffee-table books and calendars.

PICTURE-PERFECT PROFESSOR

The flighty, irresponsible Rossetti seems a strange choice as a teacher, but turns out he was an excellent one. In 1854, a group of London philanthropists created the first institution in England intended to provide extended education to the lower classes, and they convinced Rossetti to offer a course in figure painting. Students were captivated by his charm and awed by his prowess, and Rossetti basked in their adoration. He taught for nearly eight years, one of the longest commitments of his life. One student recalled, "He could inspire and even thrill us; we loved him so, and were happy to render him the smallest service."

THE DROWNING OF LIZZIE

Lizzy Siddal's beauty appealed to all members of the Pre-Raphaelite Brotherhood. In 1851, John Everett Millais asked her to pose for his painting *The Death of Ophelia*, which shows Hamlet's love lying partially submerged in a stream. Committed to painting only from nature, Millais had Lizzie pose fully clothed in a bathtub full of water. He placed lamps beneath the tub to keep the water warm, but during one session, the lamps burned out and Lizzie was left soaking for hours in chilly water. She caught a terrible cold; when her father threatened to sue, Millais settled the matter amicably by agreeing to pay her medical bills. The resulting work was the hit of the 1852 academy exhibition and has been called "the supreme achievement of Pre-Raphaelitism."

WOMBATS IN THE BELFRY

One advantage of Tudor House, the home in London where Rossetti moved after Lizzie's death, was the size of its garden, which allowed him to indulge in his fondness for exotic animals. Over time he assembled a veritable zoo, including a kangaroo, zebu, armadillo, chameleon, mole, woodchuck, marmot, Japanese salamander, talking parrot, raven, wood owl, jackdaw, and parakeet. At one point he bought an enormous white bull because, he claimed, it had eyes like Jane Morris's.

By far Rossetti's favorite animal was an Australian marsupial called a wombat, which lived in the house and slept on the dining room table. When the poor creature died in 1869, Rossetti drew a satirical self-portrait weeping over its body and invited friends to its funeral.

THE JOVIAL CAMPAIGN

In 1857, Rossetti enlisted the help of two new friends—the young Oxford students William Morris and Edward Burne-Jones—to paint a series of murals about the life of King Arthur on the walls of a building at the college. The trio dubbed their effort the "Jovial Campaign" and set to work modeling for one another, dumping water on each other's heads, and running up a shocking bill at a local hotel. When completed, spectators declared the murals a masterpiece, but within only a few years the paintings faded into an incomprehensible muddle. Unfortunately, the jovial campaigners' knowledge of proper techniques had been rather limited, dooming their work to an early demise.

ÉDOUARD MANET

JANUARY 23, 1832–APRIL 30, 1883

ASTROLOGICAL SIGN:
AQUARIUS

NATIONALITY:
FRENCH

STANDOUT WORK:
OLYMPIA (1863)

MEDIUM:
OIL ON CANVAS

ARTISTIC STYLE:
IMPRESSIONIST

SEE IT YOURSELF:
MUSÉE D'ORSAY, PARIS

QUOTABLE

"FAIRE VRAI; LAISSER DIRE."
(DO WHAT'S TRUE; LET THEM TALK.)

T he problem with Édouard Manet's Olympia was that she was naked. Not *nude*, mind you. Nude wouldn't have been a problem. So what's the difference? Nudes have no clothes to put on, like Adam and Eve in the Garden of Eden; nudes don't know shame, and so they aren't objects of sexual desire but are instead physical representations of eternal ideals. (Yeah, right.) *Naked*, on the other hand, well, that implies clothing has been deliberately removed. So Olympia is definitely naked.

And for good reason. Manet's Olympia is a high-class prostitute. She sits on her luxurious bed receiving flowers from one of her many clients and confronts the viewer with a startlingly direct gaze. With her "Well, what do you want?" expression, it's little wonder that the image shocked Parisians, who declared it a threat to public morality. Despite the lambasting, Manet went on painting, determined to triumph on his own terms.

BOURGEOIS VS. BOHEMIAN

Édouard was the eldest of three sons of a relatively wealthy bourgeois family. He attended the best schools but showed no interest in the legal career his father, Auguste, had planned for him. Instead he talked about studying art. Auguste reacted with dismay—his son wanted to become an artist, one of those bohemians who spend all their time in cafés in the company of loose women, *sacré bleu!*—but eventually he sucked it up.

The young Manet undertook his artistic training, showing remarkable independence from the start. He knew right away what he would and would not paint, rejecting the subjects demanded by the Academy, notably great events from the Bible, myth, and history. He wanted to depict modern life: ordinary men and women attending the opera, enjoying a picnic, or flirting at a bar. What Manet didn't discard was artistic tradition. Many Impressionists wanted nothing to do with Michelangelo or Raphael & Co. But Manet revered his predecessors and honored the masters by transforming their compositions—not that the Academy understood his form of reverence. Take his first masterpiece, *Le Déjeuner sur l'herbe* (The Luncheon on the Grass), of 1862. The work, which shows two men sitting with a naked woman in a rural glade, directly quotes a drawing by Raphael of two river gods and a water nymph. Manet's transformation creates a strikingly modern scene populated not by classical figures but by Parisian bohemians and (seemingly) a prostitute.

The next year Manet married longtime love Suzanne Leenhoff and submitted *Le Déjeuner* to the Academy-sponsored Salon, then the sole path to artistic success in France. Succeed there, and commissions were guaranteed; fail there, and your artistic career was over.

REFUSED, BUT NOT REFUSE

The 1863 Salon went down in history not for the works it accepted but for those it rejected. Along with *Le Dejeuner*, the jury turned down three thousand works. Paris erupted at the news, and so Emperor Napoleon III announced a compromise: He ordered a second exhibition to display the rejected paintings. The Salon des Refusés attracted huge crowds eager to see if the banned artists were geniuses or hacks. The consensus? Hacks. The exhibition hall echoed with shrieks of laughter. Critics singled out *Le Déjeuner* for particular condemnation, finding the painting baffling and obscene.

If the Academy expected Manet to be chastened, they were wrong, and he soon started work on *Olympia*. In this composition, he played with several artistic precedents, most significantly a work by the late Renaissance artist Titian, whose *Venus of Urbino* of 1583 includes a nude in the same pose. The contrast between the two paintings is startling: Titian's Venus is relaxed, open, and inviting, whereas Manet's Olympia is tense and direct. Where Venus's hand rests negligently against her pubic area, Olympia's splayed fingers protect her sex. Venus looks ready to melt in your embrace; Olympia looks ready to steal your credit card. Surprisingly, the painting was accepted for the 1865 Salon, but critics were horrified. They claimed the work was pornographic and warned parents to keep their young daughters away.

At least Manet got sympathy from fellow artists. By the end of the decade, a group of innovative painters were gathering regularly at a Parisian café, including Edgar Degas, Claude Monet, Pierre-Auguste Renoir, and Camille Pissarro. Manet was a favorite of the group—cheerful, genial, and generous, a dazzling conversationalist and wit.

SALON, SALOON—WHAT'S THE DIFF?

Artistic innovation gave way to world events. In the summer of 1870, France declared war on Prussia and immediately had its butt handed to it on a plate by superior Prussian troops. As enemy forces bore down on the capital,

Manet sent his family out of harm's way and volunteered for the National Guard. The siege of Paris began in September. Nights grew colder, food supplies dwindled, and smallpox raged through the city. Paris surrendered on January 28, 1871. That summer Manet returned to his studio with misgivings. He was nearly forty years old, had been a professional artist for almost two decades, and had barely sold a painting. It was hard to take up his brush and continue to challenge convention.

Enter art dealer Paul Durand-Ruel, who walked into Manet's studio and began snapping up canvases, marking the beginning of a remarkable run. Manet's portrait *Le Bon Bock* (The Good Pint), showing a red-faced, twinkling-eyed habitué of his café hangout, became the hit of the 1873 Salon. So in 1874, when many of Manet's friends decided to hold an independent exhibit in defiance of the Salon that had so often rejected them—what became the first Impressionist show—Manet declined to join them. "I will enter the Salon through the main door," he said, declaring his intention to change the Academy from the inside.

OLD AND IMPRESSIONABLE

In the late 1870s, Manet frequently suffered from numbness and pain in his legs. He passed off the symptoms as rheumatism, but he soon recognized the illness for what it was: the final stage of syphilis. He fought the disease as best he could, taking long trips to the country and undergoing hydrotherapy treatments. He painted as long as he was able. His last masterpiece, *A Bar at the Folies-Bergère*, encompassed all he had ever attempted in art. It depicts a waitress in a popular night club standing before a marble counter, an enormous mirror behind her reflecting the glittering chandeliers and chattering crowd. For all its modernity, the painting still honors artistic masterworks by including traditional symbols such as roses and oranges, thus making a modern Venus of a simple waitress.

One last triumph remained. In December 1883, Manet was named to the Legion of Honor, France's highest civil award. It was recognition a long time in coming, and it couldn't have come much later. In spring 1884, gangrene developed in his leg, which was amputated in a desperate attempt to save his life. He died eleven days later.

At his death, Manet was hailed as the founder of Impressionism, a term he never liked. Ultimately, his greatest artistic contribution was to make

contemporary life a fit subject for art. Ultimately his love-hate struggle with the Salon became increasingly irrelevant. The independent Impressionist exhibitions broke the Academy's stranglehold on French art, and within a few decades the venerable institution as Manet knew it had ceased to exist.

WOUNDED BY A NASTY REVIEW, EDOUARD MANET CHALLENGED HIS CRITIC TO A DUEL WITH SWORDS— BUT NEITHER THE ARTIST NOR HIS FOE HAD ANY IDEA WHAT THEY WERE DOING.

I DEMAND A DUEL!

By 1870, Manet should have been accustomed to attacks by the press, but a casually insulting review by critic Edmond Duranty pushed him over the edge. On encountering his old friend from the Café Guerbois, Manet struck him in the face and demanded the satisfaction of a duel.

For some reason, Manet's biggest concern the night before the fight was a comfortable pair of shoes to do battle in, so he went out and bought a new pair of boots. The next morning, he told his wife he wanted to do some outdoor sketching and headed for the nearby Saint-Germain forest. The men elected to fight with swords, even though neither of them had any fencing experience. They tore at each other with such enthusiasm and utter lack of skill that they quickly bent their swords. Duranty was slightly wounded in the chest, and, honor satisfied, the duel ended with a handshake.

Strangely, Manet then offered Duranty his pair of brand-new boots, but the critic declined since his feet were bigger than Manet's. The two went their separate ways, full of stories of their derring-do. "I would have killed him if my sword had been straight," claimed Duranty.

MADAME MANET

When Manet and his brothers reached their teens, their father decided it would be good for them to learn to play the piano, so he found a teacher: the blonde Dutchwoman Suzanne Leenhoff. The nineteen-year-old Édouard fell for Suzanne's

plump prettiness, and before long she was pregnant. Marriage was out of the question—Auguste would cut off his son without a cent—so Suzanne passed off baby Léon as her brother.

Suzanne's appeal faded over the years, but Manet continued to take care of her, and the two married in late 1863, one year after his father's death, much to the surprise of his friends, who had never met her. Even after the wedding, Suzanne remained on the margins of Manet's social life, although the letters he wrote to her during the Franco-Prussian war express touching devotion.

Manet's marriage never stopped him from ogling beautiful women. One day he followed a pretty young lady down a Paris street, unaware that Suzanne was sitting nearby. Upon realizing that his wife had seen him, he joined her and said, with great presence of mind, "I thought she was you."

THE OTHER MADAME MANET

Berthe Morisot, the daughter of a high-ranking civil servant, took painting lessons as a girl, but such was her talent that by her early twenties she was exhibiting at the Salon. She and Manet met at the Louvre in the late 1860s, and soon she was a regular at his studio. Theirs was an intense relationship. Manet's portraits capture Morisot's dark, delicate beauty and convey a strong connection with his subject. Morisot's letters reveal her reliance on Manet's approval; they also show a woman jealous of his other models and highly critical of Suzanne. So how far did their relationship go? Probably not far. Morisot was a lady, and it's unlikely she would have compromised herself with an affair.

Although Morisot's artistic career took off after her inclusion in the Impressionist shows, she grew increasingly depressed by her single status. Manet was taken, but his younger brother Eugène was not. Even though Eugène was a bon vivant with no occupation, thirty-four-year-old Morisot was quickly reaching old-maid status, and suitors were evaporating. Édouard promoted the match, and Berthe and Eugène married in December 1875. It seems to have been a contented relationship, although Berthe was devastated when Édouard died, writing, "I had somehow imagined he was immortal."

JAMES McNEILL WHISTLER

JULY 11, 1834–JULY 17, 1903

ASTROLOGICAL SIGN:
CANCER

NATIONALITY:
AMERICAN

STANDOUT WORK:
*ARRANGEMENT IN GREY AND BLACK NO. 1
(PORTRAIT OF THE ARTIST'S MOTHER)* (1871)

MEDIUM:
OIL ON CANVAS

ARTISTIC STYLE:
AESTHETIC MOVEMENT

SEE IT YOURSELF:
MUSÉE D'ORSAY, PARIS

*"ART SHOULD BE INDEPENDENT OF ALL CLAP-TRAP—
SHOULD STAND ALONE AND APPEAL TO THE
ARTISTIC SENSE OF EYE OR EAR, WITHOUT
CONFOUNDING THIS WITH EMOTIONS ENTIRELY
FOREIGN TO IT, AS DEVOTION, PITY, LOVE,
PATRIOTISM, AND THE LIKE."*

QUOTABLE

There were two ways to turn James McNeill Whistler into your enemy: Ignore him, or pay attention to him. You just couldn't win. Life-long friends and complete strangers alike were equally prone to incur his wrath. And as someone who titled his memoirs *The Gentle Art of Making Enemies*, Whistler wasn't the least bit gentle about it. He preferred to conduct his quarrels in the full glare of the press and had a nasty habit of dragging his opponents to court.

Whistler's biggest fight was with the entire culture of art in Victorian England and its insistence on finding meaning and morals in paintings. Ironically, his most famous painting, *Arrangement in Grey and Black No. 1*—popularly known as *Portrait of the Artist's Mother*—has been saddled with the most Victorian of meanings: It is an icon of the cult of motherhood.

Man, that would have driven Whistler nuts.

THE AGGRAVATED ARTIST AS A YOUNG MAN

Whistler was the son of George Washington Whistler, a railroad engineer, and Anna McNeill, a devout Episcopalian. In 1842 the family packed up and left Massachusetts for Russia, where George Whistler was invited to help build the St. Petersburg-to-Moscow Railway. A precocious draftsman, young James began art training, but ill health forced him to spend several months of the year in England. After George's sudden death, Anna collected her two sons and returned to the United States, thus ending James's artistic training, an endeavor she considered expensive, uncertain, and ungodly. The family's military background provided an alternate career path, and James was soon enrolled at West Point. He muddled through for a few years, but the rigid discipline made him miserable; a failed chemistry exam was the last straw. Whistler liked to say, "If silicon had been a gas, I would have been a general."

The next year, Whistler took off for Europe despite his mother's objections. In the late 1850s he bounced between Paris and London, becoming close friends with the proto-Impressionists and the Pre-Raphaelites and rejecting mainstream academic art. He completed many portraits such as *The White Girl*, which shows a young woman dressed in white (natch) and standing in front of a white curtain. Whistler entered the painting in the 1863 Paris Salon, where it was unceremoniously rejected—along with a whopping three thousand other paintings. To accommodate the horde of

rejected works, French emperor Napoleon III sanctioned the Salon des Refusés, the setting where Édouard Manet had his first succès de scandale for *Le Déjeuner sur l'herbe* (Luncheon on the Grass). Whistler's *White Girl* received almost as much attention as Manet's pastoral scene—not surprising, since the two works are stylistic cousins. Both feature a "rough" painting style and a contemporary setting that were new (and a bit scandalous) for the time.

MOTHER DEAREST

Back in America, the Civil War raged and Southern fortunes failed. In despair over living in a reunited United States, Whistler's fiercely Confederate mother hopped a ship to England. Her son, meanwhile, was enjoying a bohemian lifestyle, complete with all-night whiskey parties and a live-in girlfriend. Imagine his shock upon learning that Mother Anna intended to move in. Despite the dampening effect on his social life, Whistler enjoyed his mother's coddling. She took over the housekeeping, managed his studio, and invited his friends over for dinner, during which she lectured about the evils of drink to such notable alcoholics as Dante Gabriel Rossetti.

One day when his model failed to show up for work, Whistler turned to his mother. Initially he positioned her standing, but the frail woman was unable to hold the pose, so he directed her to sit, propping her feet on a footstool. Anna was dressed in her usual black dress, with a white lace-trimmed cap on her head; as a result, the painting is strikingly monochromatic, all tones of black, gray, and white.

With this work, Whistler discovered his mature style. First, he picked one or two colors and worked only in tones of those hues. Second, he provided no story for his paintings—he simply depicted a scene and a character. Whistler didn't want his paintings to evoke feeling; instead he called for art to be independent of "clap-trap" such as "emotions entirely foreign to it, as devotion, pity, love, patriotism and the like." To drive home the point, he titled his paintings with musically inspired names like "symphony" or "nocturne," emphasizing that, just as a symphony doesn't tell a story, neither does his art.

A MOVEMENT—AND A LAWSUIT—IS BORN

Whistler's approach fit into a wider trend taking shape in Europe, one that called for "art for art's sake" and came to be known as the Aesthetic Move-

ment. Aesthetic artists were deplored by Victorian critics, who insisted that art provide some sort of edifying lesson. One of the most prominent opponents of Aestheticism was John Ruskin, the supporter of the Pre-Raphaelites. Ruskin objected especially to Whistler's work titled *Nocturne in Black and Gold: The Falling Rocket*, which was painted at a Thames pleasure garden known for its fireworks displays. In an 1877 review, Ruskin sniped, "[I] never expected to hear a coxcomb ask two hundred guineas for flinging a pot of paint in the public's face." Well!

Whistler promptly charged Ruskin with libel.

He also turned *Whistler v. Ruskin* into a debate over art itself. Artists and critics were paraded before the jury and asked to weigh in on the purpose of painting and the meaning of beauty. Ruskin's attorney belittled Whistler's artistic abilities; after learning it took Whistler two days to complete *Nocturne*, he asked, "The labor of two days is that for which you ask two hundred guineas?" Whistler retorted, "No, I ask it for knowledge I have gained in the work of a lifetime."

The jury found Ruskin guilty of libel but awarded Whistler only one farthing (a quarter of a penny). A popular editorial cartoon of the era showed the judge admonishing both parties: "Naughty critic, to use such language! Silly painter, to go to the law about it!"

MAN ABOUT TOWN

The trial ushered in Whistler's most prominent period. He began hosting Sunday breakfasts, serving up American-style pancakes and scrambled eggs to such English notables as writer Oscar Wilde and Lillie Langtry, the British royal mistress. However, the easily offended Whistler could never sustain friendships for long. Out of jealousy over the attention Wilde received for his lectures, in 1885 Whistler held his own, known simply as the "Ten O'Clock," in which he attacked Wilde's popularization of Aestheticism. Wilde's riposte appeared in a newspaper review, and the whole dispute disintegrated into a series of increasingly nasty letters to the editor.

Yet despite all the haranguing and his contentious nature, Whistler was able to find one source of happiness. After several long love affairs with various models, in the mid-1880s he grew close to Beatrice Godwin, wife of architect E. W. Godwin. When Godwin died in 1886, and the socially mandated Victorian mourning period had passed, Whistler and Beatrice married.

She brought a stability to his life unknown since the years Anna had ruled the roost. Unfortunately, their happy life was shattered in 1894 when Beatrice was diagnosed with cancer. After enduring two years of terrible pain, she died. Friends reported that the artist suddenly seemed old. He battled on, picking a public fight with his former student Walter Sickert and taking patrons to court, but it soon became increasingly difficult to rouse that fighting spirit, and Whistler died July 17, 1903.

LINGERING IMAGE

The portrait of Whistler's mother endured the vicissitudes of his career. During a rough patch in the 1870s, he used it as security on a loan and was unable to reclaim it until 1888. He was still able to exhibit the work, however, and it appeared in the 1883 Paris Salon and twice in the United States. In 1891 the painting was purchased by the French government for the Luxembourg Museum.

Had *Arrangement in Grey and Black* stayed on a wall in a Paris museum, it would have remained largely unnoticed in the United States. However, Alfred Barr, founding director of New York's Museum of Modern Art, hit upon the idea of exhibiting the work in America during the Great Depression. (Maybe he figured anxious Americans needed their mommies.) The museum promoted the painting as representing the dignity and patience of motherhood, and American audiences embraced it as depicting a universal everymother. The painting toured twelve cities and attracted thousands of viewers, usually described as "reverent pilgrims" (Boy Scouts were particularly encouraged to visit). Over the next decades, it found endless uses in popular culture, from a poster advertising war bonds to covers for *Newsweek* and *The New Yorker*. The image remains popular today and can be found on Mother's Day cards worldwide.

Yet Whistler would have been outraged by the painting's interpretation as an icon. It's easy to imagine him firing off nasty letters to the editor and starting lawsuits contesting others' interpretations of his art. In the end, the irascible artist accomplished something he had never intended: He created a painting loaded with emotion—despite himself.

ON WIT AND SELFISHNESS

The friendship of such noted wits as Oscar Wilde and Whistler was bound to result in numerous quips. One was the result of an article in *Punch* magazine that described them discussing actresses. Wilde immediately shot off a telegram to Whistler that read, "*Punch* too ridiculous. When you and I are together we never talk about anything except ourselves." Whistler shot back, "No, no, Oscar, you forget. When you and I are together, we never talk about anything except me."

THE ORIGINAL ODD COUPLE, WHISTLER WAS A PARTY ANIMAL WHO LOVED TO INDULGE IN ALL-NIGHT WHISKEY-FUELED REVELRIES; HIS MOTHER, ANNA, WAS A WET BLANKET WHO LECTURED HER SON'S FRIENDS ON THE EVILS OF ALCOHOL.

THE PEACOCK ROOM PERTURBATION

While artists of the era such as William Morris spent significant time on interior decoration, Whistler finished only one such project—much to his wealthy client's displeasure. F. R. Leyland asked Whistler to advise on the color scheme for his dining room, which he wanted to design around Whistler's painting *Rose and Silver: The Princess from the Land of Porcelain*. Whistler transformed the project into a complete redecoration of the room, which he made resplendent with peacock designs in rich blue and gold.

Whistler's friends loved the room, as did the society papers, but the owner was less than pleased. Not only was Leyland irritated that Whistler was entertaining the press in his dining room, but he was particularly annoyed that the artist had exceeded the original commission, and he refused to pay the increased fee. Whistler compromised on a smaller fee, but he commemorated the dispute by including a scene of two peacocks fighting, giving the more aggressive peacock white breast feathers, in imitation of Leyland's white ruffled shirts.

Fortunately, the aggrieved patron kept the room intact. In 1904 American collector Charles Lang Freer purchased the room, which was painstakingly dismantled and reassembled in his Detroit home. Today, the Peacock Room is in the Smithsonian's Freer Gallery of Art in Washington, D.C.

THE VALPARAISO ADVENTURE

The year 1865 was one of the strangest in Whistler's life. It began when John O'Leary, an old friend from Paris, was arrested for his involvement in the Irish Republican Brotherhood, an organization seeking to overthrow British rule in Ireland. Whistler seems to have feared that O'Leary would implicate him, perhaps for obtaining financial support for the Irish cause from U.S. sympathizers—although no evidence of such efforts by Whistler have been found.

Whistler boarded a ship for, of all places, South America and spent several months in Valparaiso, Chile. When he decided England was safe again he returned, managing to get in a brawl on the way with a black Haitian man who offended him "as a Southerner" for daring to dine with him. His troubles didn't end when he arrived in London: Met at the station by the outraged husband of a woman he had seduced en route to Chile, Whistler received a thorough thrashing.

EDGAR DEGAS

JULY 19, 1834–SEPTEMBER 27, 1917

ASTROLOGICAL SIGN:
CANCER

NATIONALITY:
FRENCH

STANDOUT WORK:
THE DANCE CLASS (1874)

MEDIUM:
OIL ON CANVAS

ARTISTIC STYLE:
IMPRESSIONIST

SEE IT YOURSELF:
MUSÉE D'ORSAY, PARIS

"NO ART IS LESS SPONTANEOUS THAN MINE."

QUOTABLE

*I*n the 1870s, all the avant-garde artists in Paris were obsessed with plein-air painting—painting outdoors, directly from nature. Camille Pissarro and Alfred Sisley embraced the fad; Claude Monet spent his time wandering around the countryside with an easel; and even the consummate urban-dweller Edouard Manet could occasionally be found in gardens, palette in hand.

Edgar Degas wanted nothing to do with it. He had zero interest in plein-air painting, zero interest in landscapes, zero interest in capturing atmospheric effects. "If I were in the government, I would have a brigade of gendarmes for keeping an eye on people who paint landscapes after nature," he groused. His good friend Manet introduced him to new acquaintances by explaining, "He paints cafés from nature!"

Degas dismissed many of the defining aspects of Impressionism, a term he hated, yet he helped create the movement by organizing the groundbreaking exhibitions that brought the group to public notice. He might not have wanted to be an Impressionist, but that's how we remember him today.

GOTTA DANCE

Hilaire-Germain-Edgar Degas was born to a family who couldn't make up its mind about their name. Some of its more ambitious members liked to call themselves De Gas, giving the family aristocratic status. Nice try. The real spelling was the more pedestrian Degas. They did have wealth and power, however; his father's family managed a bank, and his mother's family controlled a cotton-export empire in New Orleans. The young Edgar was groomed for a law career, but he switched his interest to art, studying at the École des Beaux-Arts and setting out to become a traditional academic painter.

So who put him on the path to Impressionism? Édouard Manet, that's who. The two met in the Louvre in 1861 and became fast friends. Manet's rebellious career was well under way, and Degas was a first-hand observer of the attacks on the older artist's paintings, such as *Olympia*.

Like the rest of his generation, Degas' life was interrupted by the Franco-Prussian War. He joined the National Guard and spent the war guarding the French capital's fortifications. The next spring, eager to forget the dark days of war and civil unrest, Parisians threw themselves into the pursuit of pleasure, and Degas became a regular at the Opéra, where society men brought their looking glasses to ogle the pretty dancers. He was as fascinated with

the glamorous productions as he was with the dirty, crowded backstage, particularly the dance classes full of preteen and teenage girls known as *petits rats* ("little rats").

When he took up the theme of dance, Degas discovered his own style. *The Dance Lesson* of 1874–75 shows an elderly instructor leaning against a tall stick and watching several girls rehearse; around them other students stretch, yawn, and scratch. Degas loved the contrast between the elegance of a dancer at work and the reality of the dancer at rest, slumped, bow-legged, tired. In a style that would become typical, he depicts a deep sense of space; the scene is dramatically cropped, with some dancers cut off at canvas edge. Also typical is the way the painting conveys a feeling of immediacy, as if this scene were a real one Degas witnessed; it was, in fact, carefully constructed, with dancers having posed individually in his studio. "No art is less spontaneous than mine," Degas admitted.

FIRST AND LAST IMPRESSIONS

After an 1872–73 trip to New Orleans, Degas returned to find his friends Monet, Pissarro, Renoir, Sisley, and Morisot deep in discussions about breaking away from the state-sponsored Salon. Degas immediately threw in his lot with the rebels, somewhat to their surprise, for he had exhibited six times at the Salon and was building an impressive list of collectors. However, Degas had developed a deep dislike—almost a loathing—of the arts establishment. He believed that playing the academy game meant selling out, so he became a driving force behind the first independent exhibit. When it opened in April 1874, curious audiences filled the studio and laughed out loud. They attacked the artists as intransigent lunatics, honestly unable to understand art that didn't tell a story, have a moral, or reproduce the world in ways to which they were accustomed. Degas was particularly singled out for his "poor" drawing ability and "bizarre" compositions.

That didn't stop the group, who were soon labeled Impressionists. Degas helped organize six of their seven exhibitions over the next twelve years, despite frequent squabbles over who would and wouldn't be allowed to participate. At the sixth exhibit, in 1881, he displayed one of his most unusual works: a sculpture called *Little Dancer of Fourteen Years*.

Degas had modeled the figure of the *petit rat* Marie Van Goethen as a two-thirds life-size figure in wax. She stands with one leg before the other,

a dancer's fourth position, with her feet turned out, her hands clasped behind her back, and her chin thrust forward. He dressed the figure in a real bodice, gauze tutu, and satin ribbon, all sewn for him by a doll maker, and placed real hair on her head. Then he smeared all these objects with a thin layer of hot wax, which hardened them into shape but still revealed their texture. Audiences were baffled but transfixed: nothing like it had ever been seen. To them, "sculpture" meant ancient precedent, marble or bronze, and fine finish, not this bizarre mixture of media and bony prepubescent girl. Some critics denounced the girl as "bestial" and condemned Degas for cultivating ugliness; others declared it "the only truly modern attempt . . . in sculpture."

The last Impressionist exhibit was held in 1886, by which time Impressionist paintings were being widely collected across Europe and North America. By the 1890s Degas' eyesight had greatly deteriorated, and by 1908 he was blind. He also lost some of his hearing, which at least spared him from the thunder of German guns outside Paris in 1914. When Degas died in 1917, at age eighty-three, academy officials spoke at his funeral.

Through all the upheavals of modern art, Degas' work remained popular. His strange sculpture of a young ballerina dramatically influenced twentieth-century sculptors, who embraced its incorporation of multiple textures and mediums. In the 1920s, the original wax figure was used to make a mold from which twenty-eight bronze casts were made, despite debate over whether Degas would have approved of his work being "mass produced." Nevertheless, the bronzes have been hugely popular, selling at recent auctions for more than $10 million.

WHO MISPLACED THE "PLACE"?

For nearly fifty years, one of Degas' masterpieces, *Place de la Concorde*, was known to art history students only as a black-and-white reproduction. The original painting had been lost in World War II, and no one knew what had become of it. No one, that is, except select Soviet art officials. At the end of the war, official Soviet policy called for the seizure of German-held artworks. Degas' painting

ended up in storage at the Hermitage Museum in St. Petersburg, but officials denied any knowledge of its whereabouts.

It took the collapse of the Soviet Union to bring the painting to light. Pressure from Germany and other Western nations finally forced Russian museums to open their archives, and in 1995 *Place de la Concorde* was seen publicly for the first time since World War II. Discussions were held with the heirs of the original owners to return the painting, but today the work remains at the Hermitage.

A MARRIAGE OF THE MIND

Mary Cassatt, the daughter of a wealthy Pittsburgh businessman, met Degas in 1877, and the two quickly formed a bond, making prints together and sketching each other at work. Theirs was a long and complex relationship; periodically, Degas would make a biting comment that would alienate Cassatt, and they wouldn't speak for months, until some painting would bring them back together. Naturally rumors flew that they were more than just friends, but Cassatt was too morally fastidious and socially conscious to become an artist's mistress. For Degas' part, he told a friend, "I would have married her, but I could never have made love to her." It's a bizarre statement, but perhaps it points to a marriage of the mind that neither party could imagine complicating with sex.

NOT THAT THERE'S ANYTHING WRONG WITH IT

Other than his long friendship with Mary Cassatt, Degas had no extended relationships with women. We know of no girlfriends or lovers, and he never married. The reason has been hotly debated, even during Degas' lifetime, when curious friends liked to conjecture about his sex life (or lack thereof). It's been proposed that he was misogynistic, homosexual, and/or impotent.

Degas had a simple explanation for his refusal to marry. "What would I want a wife for?" he once said. "Imagine having someone around who at the end of a grueling day in the studio said, 'That's a nice painting, dear.'"

EDGAR DEGAS · 115

LOOK AWAY!

Degas couldn't stand women who were past their prime yet insisted on wearing clothes appropriate for young girls. At one dinner party, he was seated next to an older woman attired in a gown with bare shoulders and a plunging neckline. The horrified Degas couldn't drag his eyes from the sight. Apparently, the lady noticed his scrutiny. Suddenly confronting him, she demanded, "Are you staring at me?" "Good lord, Madame," he replied, "I wish I had the choice."

HORRIFIED BY THE REVEALING DÉCOLLETAGE OF AN ELDERLY DINNER PARTY GUEST, EDGAR DEGAS COULD NOT HELP BUT STARE. "GOOD LORD, MADAME, I WISH I HAD THE CHOICE."

KODAK MOMENTS

Degas developed a fascination with photography in the 1890s and immediately coerced everyone he knew to pose for him. A family friend describes one social evening that was ruined by Degas' obsession: "He went back and forth in front of [his models]; he ran from one corner of the salon to the other with an expression of infinite happiness; he moved lamps, changed reflectors, tried to light our legs by putting a lamp on the floor." Degas' victims had to hold their designated poses without moving for two minutes, so that by evening's end everyone was sick of the camera—except the artist. "At eleven-thirty everybody left, Degas carrying his camera, as proud as a child carrying a rifle."

PAUL CÉZANNE

JANUARY 19, 1839–OCTOBER 22, 1906

ASTROLOGICAL SIGN:
CAPRICORN

NATIONALITY:
FRENCH

STANDOUT WORK:
CARD PLAYERS (1890–92)

MEDIUM:
OIL ON CANVAS

ARTISTIC STYLE:
POST-IMPRESSIONIST

SEE IT YOURSELF:
THE LOUVRE, PARIS; THE BARNES FOUNDATION, MERION,
PENNSYLVANIA; AND THE MUSÉE D'ORSAY, PARIS

QUOTABLE ➤ *"THE WORLD DOESN'T UNDERSTAND ME,
AND I DON'T UNDERSTAND THE WORLD."*

*I*n 1870s Paris, if you headed to the Café Guerbois about five o'clock in the afternoon, you would likely find the charming Édouard Manet engaged in clever conversation with the witty Edgar Degas and the dapper Claude Monet. Sometimes another artist joined the group, but only to sit in the corner and glower over his drink. Whereas Manet and company had cast off their work clothes for evening wear, the newcomer arrived in a paint-stained smock, with his trousers held up by a string. While they chatted about art, the sullen artist maintained a menacing silence.

Without warning, he would slam down his drink, shout "L'esprit m'emmerde!" ("Wit bores the crap out of me!"), and storm out. The others would shrug and continue drinking. That's Paul Cézanne for you, they'd say. Acts like he was raised in a barn. It's a wonder why they tolerated him. Even fellow avant-garde artists were usually baffled by his art. But every now and then Cézanne's canvases revealed his unique artistic vision, and ultimately he created paintings that amazed them all.

But he was still a jerk.

THE ALIENATING ARTIST

A psychologist could probably trace many of Cézanne's personal problems to his domineering father. Louis-Auguste Cézanne had the arrogance—and the stinginess—of a self-made man; a petty tyrant, he belittled his wife and demanded absolute obedience from his children. It took all the courage Paul could muster to tell him that he wanted to study art in Paris—Louis-Auguste had intended him to work at the bank he had founded in south France. It took three years of arguments, but in 1891 Louis-Auguste finally gave in, perhaps realizing that his stammering heir lacked even the barest business instincts.

Cézanne arrived in the French capital and met future Impressionists Édouard Manet and Camille Pissarro. However, he really had zero social graces (see above) and was intimidated by the men's witty chatter—he always suspected they were making fun of him. Along with his colleagues, he repeatedly had his work rejected from the Paris Salons, although in his case you can understand the jury's reluctance. Cézanne's early work is dark and strange, reverberating with violent undercurrents. Nevertheless, every year he trundled through the Paris streets in a ritual of protest, pushing a wheelbarrow full of canvases.

LOVE (AND ART) ON THE RUN

About age thirty, Cézanne began an affair with Marie-Hortense Fiquet, a seamstress. How Hortense got Cézanne into bed remains a mystery. He had previously exhibited a certain alarm—verging on terror—toward the opposite sex. Nevertheless, Hortense moved in, and in January 1872 they had a son, also named Paul. Cézanne insisted on keeping her a secret from his father, for he was convinced Louis-Auguste would immediately stop the cash flow. He struggled to eke out support for three on an allowance for one; in fact, money was so tight the family was forced to take a tiny flat across the street from the Paris wine market, where wine barrels rattled across the cobblestone streets at all hours.

Thankfully, Pissarro invited the trio to join him in the small village of Pontoise, where he was living cheaply. Pissarro introduced Cézanne to plein-air painting, and the two worked side by side. Pissarro's influence can be seen in the bright colors and light brushwork of one of Cézanne's first masterpieces, *The Suicide's House*. Despite this use of Impressionist techniques, the painting still displays Cézanne's characteristic solidity: He is more interested in reproducing the three-dimensional forms of houses than in capturing the effects of sunlight.

In 1874 Cézanne was back in Paris for the opening of the first Impressionist exhibit. Pissarro insisted that Cézanne be included, although other artists saw him as a liability. Along with *The Suicide's House*, he displayed *A Modern Olympia*, a parody of Edouard Manet's *Olympia*. Colleagues saw it as a deliberate provocation, and many questioned Cézanne's talent. He would exhibit with the group only one other time.

By the late 1870s, Paul and Hortense had been together ten years, but his father still didn't know about her. When Cézanne headed south in the winter of 1878, he established Hortense and their son in Marseilles while he stayed with his parents. The next few weeks resemble a farce—except for Cézanne, it wasn't funny. The nearly forty-year-old artist spent his days tromping the eighteen miles between his girlfriend's and his father's houses. Since Paul was living at home, Louis-Auguste cut his allowance, forcing him to borrow money from friends to support Hortense; Papa Cézanne even talked of making Paul get a job. (Horrors!) Then a letter arrived from Paris mentioning "Madame Cézanne and little Paul," which Louis-Auguste saw since he routinely opened all the mail. He confronted his son, who denied everything. Another letter arrived, this one addressed to Hortense from her

father. Louis-Auguste again confronted Paul, who again denied it. Then, out of the blue, Louis-Auguste offered Paul three hundred francs. He had read the letter, in which Hortense's ill father begged her to visit; Louis-Auguste wanted the money to be used to pay for her journey. After all, he was a father, too (and he was probably tired of this game with his son). Soon, Hortense was acknowledged by the family, and, in 1886, the couple officially wed. Louis-Auguste died that fall, leaving Cézanne a sizable inheritance.

THE DISCREET CHARMS OF REFINED SAVAGERY

By the 1890s, Cézanne was living primarily in Provence. He worked slowly and painfully, often scraping all the paint from his canvases and starting over; sometimes he would erupt with rage and attack them with a palette knife. Friends found tattered canvases hanging in trees because Cézanne had thrown them out the window.

He painted series of the same motif over and over—whether landscape, portrait, or still life—trying to realize his vision. He produced three versions of *The Card Players* in the early 1890s as well as multiple paintings of women bathing, Mont Ste.-Victoire, and fruit. Apples provided a means to explore the depiction of volume on a flat surface without relying on traditional perspective techniques. His use of color to convey three-dimensionality was unprecedented in art, but since he ignored conventional perspective, his paintings sometimes appear awkward. Tables seem ready to topple out of the frame and tablecloths float ominously. This effect is not due to faulty technique—Cézanne knew exactly what he was doing. It was just his way of seeking a new depiction of depth and space in painting.

Since Cézanne was still being rejected by the Salon and had broken away from the Impressionists, few people knew his later work. The tide turned in 1895, when the art dealer Ambrose Vollard organized a one-man show of Cézanne's work. But first he had to find the artist, combing villages and wandering the Paris streets before finally tracking down Hortense, who put him touch with her itinerant husband. The exhibition of nearly 150 canvases attracted some hostile attention (one female attendee shouted to her husband, "How could you punish me like this?") but garnered positive reviews. Former Impressionist colleagues were amazed. Pissarro wrote, "My enthusiasm is nothing compared to Renoir's. Even Degas has succumbed to the charm of this refined savage."

IF AT FIRST YOU DON'T SUCCEED,
WAIT FOR YOUR EPITAPH

The appreciation of the next generation of artists was even greater. Some tried to befriend the artist, a risky proposition since he treated admirers with suspicion. Once, when introduced to an old friend's son, the young man stammered his appreciation. Cézanne slammed his fist on the table and shouted, "Don't you make fun of me, young man!" But then, just as suddenly, his manner changed and he said contritely, "You mustn't hold it against me—how can I believe that you see something in my painting . . . when all those fools who write nonsense about me have never been able to perceive anything?"

Cézanne spent his days tramping around Provence or working in his isolated studio. One day in October 1906 he set out as usual, burdened by a knapsack full of supplies. A heavy rainstorm hit and he slipped and fell on the road. He got to his feet and turned to head home, but his strength gave

GLOWERING IN THE CORNER, DRESSED IN A PAINT-STAINED SMOCK AND WITH HIS TROUSERS HELD UP BY A STRING, CÉZANNE WOULD SLAM DOWN HIS DRINK, SHOUT "L'ESPRIT M'EMMERDE!" ("WIT BORES THE CRAP OUT OF ME!"), AND STORM OUT.

out and he collapsed. A passing laundry-cart driver spotted him lying half-conscious and brought him home. Pneumonia set in, and before Hortense and Paul could arrive from Paris, Cézanne died.

French artists mourned the loss of this unique visionary, and future painters found in him a wealth of inspiration. Henri Matisse adapted Cézanne's use of color, and Pablo Picasso expanded on his depiction of volume and form. Picasso later cited Cézanne as a major influence, saying, "My one and only master . . . Cézanne was like the father of us all."

NO, REALLY, THANKS FOR THE HELP

Once when Cézanne was painting along the Seine, a passerby stopped to look at his work. He mistook the bright colors and heavy lines for the inexperienced daubings of an amateur and, turning toward him, offered kindly, "You are painting."

"Certainly, but so little," said Cézanne, always frustrated by what he was able to achieve.

"Oh, I can see that," said the stranger. "Here, I'm a former pupil of Corot [an Academy favorite], and if you'll allow me, with a few deft touches I'll straighten all this out for you."

The man took a brush and began to tone down Cézanne's brilliant colors and harsh lines. When he was done, Cézanne looked at his altered canvas, picked up his palette knife, and scraped off everything the man had added. Then he let out a terrible fart, turned to the gentleman, and said, "What a relief."

HANDS OFF!

Cézanne abhorred being touched. He refused to shake hands with other artists and resisted most physical contact. The phobia grew stronger as he aged, sometimes reaching bizarre extremes. Once as he and artist Émile Bernard walked together on a rough hillside, Cézanne stumbled and nearly slid down the hill. Bernard grabbed his arm and stopped him from falling, but as soon as Cézanne regained his balance, he shook off Bernard's help and stomped away in a fury. When Bernard caught up with him, Cézanne shouted, "I allow no one to touch me!"

Later than evening, Cézanne made a special trip to Bernard's house to inquire about the younger man's health and make idle chat. Bernard understood—it was Cézanne's way of apologizing.

BE THE APPLE!

One of the reasons Cézanne liked painting still lifes was because human beings were so much more trouble. He demanded that his models sit perfectly still, without talking, for hours on end. When painting a portrait of dealer Ambrose Vollard, Cézanne insisted Vollard sit on a kitchen chair atop a rickety packing case from 8 A.M. until 11:30 P.M., without a break. One day Vollard dozed off and lost his balance—the dealer, the chair, and the packing case all crashed to the floor. "Does an apple move?" Cézanne shouted.

Henceforth Vollard drank massive amounts of black coffee before his sittings, but after more than one hundred sessions Cézanne abandoned the project. When Vollard asked if the artist was happy with the work, Cézanne's only reply was, "The front of the shirt isn't bad."

ANYTHING FOR AN ADMIRER

The young Cézanne had a terrible time finding anyone who appreciated his art, let alone wanted to own it. One day, while walking along a Paris street and carrying a painting under his arm, a stranger noticed it and asked to see it. Cézanne propped the landscape against a wall. The young man was delighted by the green of the trees—he said he could almost smell their freshness. Thrilled, Cézanne said, "If you like it, you can have it." The stranger protested that he didn't have money, but Cézanne insisted he take the painting anyway, and then he rushed off to tell Monet and Renoir the good news: He had "sold" his first painting!

AUGUSTE RODIN

NOVEMBER 12, 1840–NOVEMBER 17, 1917

ASTROLOGICAL SIGN:
SCORPIO

NATIONALITY:
FRENCH

STANDOUT WORK:
THE THINKER (1880)

MEDIUM:
CAST BRONZE

ARTISTIC STYLE:
POST-IMPRESSIONIST

SEE IT YOURSELF:
TWENTY-ONE BRONZE CASTINGS ARE ON DISPLAY AROUND
THE WORLD, INCLUDING AT THE MUSÉE RODIN IN PARIS;
RODIN'S TOMB IN MENDON, FRANCE; THE DETROIT INSTITUTE
OF ART; AND THE CITY MUSEUM OF NAGOYA, JAPAN

QUOTABLE ➤ *"WHAT ABOUT CATHEDRALS—
ARE THEY EVER FINISHED?"*

The last thing you'd call Auguste Rodin was "intellectual." Genius, yes. Man of reason, no. So it's ironic that his most famous work, *The Thinker*, has been adopted as the universal symbol for philosophy and intellectualism. Rodin preferred a life of action to one of contemplation, and he intended the work to represent an artist like himself. With *The Thinker*, he depicts the monumental effort of artistic creation, the effort to which he devoted his life.

THE DELINQUENT GENIUS

Rodin's creative impulses surfaced early. Born to a working-class family in Paris and christened François-Auguste-René Rodin, he doodled his way through school, ending up a spectacularly bad student. When he dropped out at age fourteen, he had difficulty reading and could barely count, but he shrugged off his lack of education and declared, "Spelling mistakes are no worse than the drawing mistakes that everyone else makes."

Reluctantly supporting his son's talent, Rodin's father allowed him to enroll in 1854 in the École Impériale Spéciale de Dessin et Mathématiques, a state-sponsored institution that trained decorative artists in design. After two years of study, Rodin decided to seek entrance at the more prestigious École des Beaux-Arts, but he failed the entrance exam—three times. (Oof.) He was disappointed at the time but over the years adopted a "you-can't-fire-me-because-I-quit" attitude. In any case, his father soon tired of footing the bill for this artistic nonsense and insisted his son get a real job. Rodin started working as an artist's assistant in various studios and factories. After ten years employed by others, he finally held his first exhibition in Brussels in 1871.

SEE YOU . . . IN *HELL*

In 1875 Rodin splurged on a trip to Italy to see the masterpieces of the Renaissance. Fired up after studying Michelangelo, he attempted his first full-size nude—and walked straight into his first scandal. Titled *The Age of Bronze*, the sculpture of magnificently muscled male stands in a pose reminiscent of Michelangelo's 1516 *Dying Slave*. In a period when sculpture aspired to neoclassical ideals of form over realistic depictions of the human body, the figure was shockingly lifelike—so lifelike that critics accused Rodin of casting from a live model rather than shaping the nude by hand.

Rodin was devastated. It took a government inquiry to put the controversy to rest.

The kerfuffle nevertheless brought Rodin to the attention of the French Ministry of Fine Arts. First they purchased *The Age of Bronze* in 1880. Then they presented him with a major commission, the design of a monumental doorway for a proposed museum of the decorative arts. Rodin turned for inspiration to Dante's *Divine Comedy*, the fourteenth-century epic poem that describes the poet's imagined journey through Hell, Purgatory, and Heaven. He focused on the Inferno portion of the tale, which details the eternal sufferings of the damned. He called his work *The Gates of Hell*.

Rodin began the project with enthusiasm, sketching plans and modeling figures. He decided on the size of the work (15 feet tall by 12 feet wide) and the general approach (straining nudes emerging from the surface of the doors) before executing his designs. And then . . . bupkis.

Rodin simply couldn't bear to finish, and *The Gates of Hell* was never assembled during his lifetime. Over the years, the ministry routinely asked what had happened to their doorway, only giving up when plans for the decorative arts museum were shelved. Rodin's response? "What about cathedrals—are they ever finished?"

WHEN ONE DOOR CLOSES . . .

The doorway was far from an artistic dead end. Au contraire. It provided Rodin with a wellspring of inspiration for works including *The Thinker*, which began as a depiction of Dante. He initially envisioned the poet as a cloaked, standing figure, but his instinct was always for the conceptual over the allegorical. Instead of sculpting an historic individual, Rodin decided to design a nonspecific artist in the process of creation. He positioned the figure, then titled *The Poet*, jutting out from the top of the doorframe, not only pondering the suffering of souls in hell but also imagining the entire work into being. In Rodin's words, "He is no dreamer. He's a creator."

Rodin then decided to separate the work from the doors and exhibit it on its own. The figure became even less allegorical, with Rodin renaming it *The Thinker*. Lacking context, the sculpture becomes anonymous and, in the original meaning of the word, abstract.

Several other figures from *The Gates of Hell* also took on independent lives. *The Kiss* began as a depiction of Paolo and Francesca, the two famous

lovers from canto V of the *Inferno*. *The Three Shades* originally stood atop the doorway as Rodin's interpretation of Dante's inscription on the entrance to hell, "Abandon hope, all ye who enter here."

While continuing to tinker with *The Gates of Hell*, Rodin eventually moved on to new projects and new controversies. A series of commissions for public monuments exposed his work to a wider audience but also provoked criticism. His monument to French author Honoré de Balzac prompted a storm of outrage, with critics labeling it an obese monster, a shapeless lump, and a giant fetus. Nevertheless, Rodin's popularity grew until, by the turn of the century, he had become a society darling. Women found him irresistible and treated him like a natural wonder, an artistic genius who was all Romantic impulse and tousled hair. Rodin didn't mind, particularly when they paid handsome commissions for sculpted portrait busts.

In his noncommissioned work, Rodin created increasingly fragmentary figures. He sculpted dozens of versions of disembodied arms, legs, and heads, drawing inspiration from the remains of Greek and broken Roman sculptures. *Armless Meditation* (1894) lacks, well, arms. *The Walking Man* (1907) has neither arms nor head, and *Arched Torso of a Woman* (1910) lacks all extremities. He liked his work to remain partially unfinished, leaving in place the rough seams from casting plaster and the impressions of fingerprints. By 1911, the French viewed him as national treasure. The government purchased his Paris home, the Hôtel Biron, to develop it as a museum; in exchange, Rodin donated all his work to the state. The outbreak of World War I forced him to withdraw to his country house in Meudon, southwest of Paris, to endure coal shortages, food rationing, and the threat of German troops. He continued to work steadily until weakened by a stroke in July 1916. Rodin died in Meudon, surrounded by his supporters, in November 1917.

Rodin's work remained popular after his death, although what interested later generations was not his skill in modeling the human body but his fascination with the fragmentary and nonallegorical. Twentieth-century sculpture quickly became so abstract that it abandoned the human form altogether. Rodin would have been amazed at his legacy.

LOVE, RODIN-STYLE

Rodin met Rose Beuret, an uneducated seamstress, in 1864. While serving as his model, she became pregnant; their son was born in 1866, although Rodin never legally acknowledged paternity. For the rest of their lives, Beuret remained slavishly attached to the artist: She cleaned his house, cooked his food, and slept in his bed.

Beuret's devotion didn't stop Rodin from pursuing other women, particularly Camille Claudel. When the two met in 1882, Rodin was an established artist, and Claudel was a young, aspiring student. He found her skill, intelligence, and fierce ambition powerfully attractive. Soon they were working side by side and living as lovers in a country love nest. When apart, they wrote each other racy letters. A typical Rodin note reads, "Have mercy upon me, naughty girl. I can't take it any longer." A typical Claudel response: "I go to bed naked to make me think you're here."

But the passion couldn't last. Claudel worried that Rodin would get credit for her achievements. Then she got pregnant and, determined to persevere as an artist, had an abortion. Rodin felt betrayed. He refused to give up the good life with Beuret, enraging Claudel. Most seriously, Claudel's mental health began to fail. She broke with Rodin in 1898 and soon fell victim to schizophrenia. In 1913, Claudel's family had her committed to a mental asylum, where she died in 1943.

> AFTER MORE THAN FORTY YEARS AND NUMEROUS INFIDELITIES, AUGUSTE RODIN FINALLY AGREED TO MARRY HIS LONG-TIME MISTRESS, ROSE BEURET. BED-RIDDEN AT THEIR WEDDING, BEURET DIED TWO WEEKS LATER.

The faithful Beuret, meanwhile, stood by her man. Most found her a baffling figure, seemingly unable to comprehend Rodin's wealth and fame and apparently content to be treated as a servant. As the two neared death, their friends decided their relationship should be formalized and convinced Rodin at long last to marry her. They wed on January 29, 1917, in the midst of a freezing war-time winter. Beuret had little opportunity to enjoy her new marital status. Bed-ridden at their wedding, she died two weeks later.

NOT CUT FOR THE CLOTH

Rodin was one of five children, three of whom died in early childhood. His relationship with his surviving sibling, older sister Maria, was understandably close. After an unhappy love affair as a young adult, Maria decided to devote her life to the church and entered a convent as a novice. Shortly before taking her vows, she succumbed to smallpox, dying on December 8, 1862.

Devastated, Rodin decided to take up his sister's calling. He entered the Order of the Holy Sacrament and took the name Brother Augustin. The prior of the community quickly realized the young man lacked the vocation for a life of abstinence and self-denial. He encouraged Rodin to sketch and model, gradually drawing the artist out of his grief. A grateful Rodin soon returned to his studio. We are left to wonder what havoc this passionate man would have wreaked on a monastery.

AN ICON IS BORN

Contemporary artists have drawn much inspiration from *The Thinker*. Keith Tyson's 2001 *The Thinker (After Rodin)* is a twelve-foot-tall black hexagon housing a bank of computers that runs an artificial intelligence program; set to operate for 33,000 years, the only output is an LED display counting the seconds up to 76.5 years, the average human lifespan. The artist says he likes the idea that you know the machine is thinking but not what it is thinking about.

Several contemporary versions have a scatological vein. Miguel Calderón created his *Thinker* in 1971 out of stacks of toilet-paper rolls. Cody Choi's 1996–97 exhibition *The Thinker* consisted of seven life-size sculptures formed from 2,500 rolls of toilet paper soaked in 20,000 bottles' worth of Pepto-Bismol. That's a lot of Pepto.

WHAT DEADLINE?

Rodin worked at his own pace and resented anyone who expected him to create on a schedule. *The Monument to Balzac*, for example, took years longer than anyone antici-pated. Commissioned in 1891 by the Société de Gens de Lettres, it was supposed to be completed in May 1893. In October 1894, the society got so fed up that they demanded that the work be delivered in twenty-four hours. Rodin replied, "Don't they understand that great art does not keep delivery dates?" He didn't display *Balzac* until 1898.

AN ICON IS BORN

It didn't take long for *The Thinker* to be adopted as a satirical symbol. As early as 1907, a French cartoonist created a caricature for a magazine cover that showed Rodin in the form of his own sculpture. Cartoonists for the *New Yorker* have also been fans, returning repeatedly to the figure. In a 1998 car-toon, a man is shown hunched over in *The Thinker's* iconic pose at the edge of the bed; his naked partner sits up beside him, saying, "Believe me, you're just thinking about it too much."

CLAUDE MONET

NOVEMBER 14, 1840–DECEMBER 5, 1926

ASTROLOGICAL SIGN:
SCORPIO

NATIONALITY:
FRENCH

STANDOUT WORK:
WATERLILIES (1920–26)

MEDIUM:
OIL ON CANVAS

ARTISTIC STYLE:
IMPRESSIONIST

SEE IT YOURSELF:
THE ORANGERIE, PARIS

QUOTABLE *"I WANT TO PAINT THE AIR."*

Claude Monet had little interest in giving titles to his paintings; he was content with descriptors like "View of the Village." The monotony of these generics frustrated Edmond Renoir, brother of the artist Pierre-Auguste Renoir, as he prepared the catalogue for the first avant-garde exhibit in 1874. When he asked Monet what he should call a painting of a sunrise, Monet replied, "Why don't you just call it 'Impression'?" And thus the painting was recorded as *Impression: Sunrise.*

The name caught on. Critics loved it, of course, because of the comedic opportunities it presented. Louis Leroy, in particular, noted derisively: "I was just telling myself that, since I was impressed, there had to be some impression in it . . . and what freedom, what ease of workmanship! Wallpaper in its embryonic state is more finished than that."

For his part, Monet generally liked the term, for it captured what he was trying to do: record an "impression" of an instant in time.

LIGHT, PAINTER, ACTION!

Oscar-Claude Monet, son of a shop owner from the French port city of Le Havre, showed remarkable early talent for creating clever caricatures. By the time he quit school at age seventeen, he was earning a good living off his drawings, saving two thousand francs, which he dedicated to building his artistic career. At nineteen, he headed for Paris, where he spent two years studying before being called up for military service. Given his scholarly underachievement, he rather surprisingly enlisted in a crack cavalry regiment that trained in Algeria, but within a year he came down with typhoid and was sent home.

In 1862 Monet was back in Paris, this time at the academy of Charles Gleyre, who taught traditional painting methods, none of which interested Monet. He was already dedicated to plein-air painting, work done outdoors directly from nature, and was well on the way to developing his own style. (Of course, plein-air painting had its risks. Monet was once seriously injured in the leg by a stray discus.) He found kindred spirits in fellow students Camille Pissarro, Pierre-Auguste Renoir, Alfred Sisley, and Frédéric Bazille, and one afternoon in 1863, the five artists abandoned Gleyre's atelier and headed for the countryside to paint. That was the end of Monet's artistic education.

The year 1865 was a good one for Monet. He met the lovely Camille Doncieux and had a landscape accepted at the Salon, the state's fomal

exhibition. A scant two years later, however, his ambitious Salon submission called *Women in the Garden* was rejected outright, and Camille was pregnant. Monet's father, furious that his son had fathered a child, cut off his allowance and demanded that he return to Le Havre. Camille was left alone in Paris to have the baby. Over time, Papa Monet softened enough to pay his son a pittance, but it wasn't enough to support Camille and baby Jean, so friends were regularly asked for loans.

When his 1869 Salon submissions were rejected, Monet grew so depressed he threw himself into the Seine River. He immediately regretted his rash action. Fortunately, he was a good swimmer.

DRAFT-DODGER MAKES AN IMPRESSION

In the summer of 1869, war with Prussia loomed. As a veteran, Monet faced compulsory conscription, a duty he was desperate to avoid. First, he got hitched, since married men were called up last, and then, when war broke out, he moved his family to London, where they remained for more than a year. They returned to France in the fall of 1871, settling in the small town of Argenteuil, outside Paris. Monet was seeking to free himself from artistic conventions and to paint exactly what he saw, not what he "knew" was there. Academy artists were taught to paint objects in their natural colors (brown bark, blue ocean) and to ignore the effects of light that change colors as perceived by the human eye. Monet reversed this notion. "Try to forget what objects you have before you, a tree, a house, a field," he advised. "Merely think, here is a little square of blue, here is an oblong of pink, here a streak of yellow, and paint it just as it looks to you." He also sought to create a sense of instantaneity, to show a scene as it was at one moment in time.

> AN ARTIST WITH AN EYE FOR THE LADIES, CLAUDE MONET DECLARED, "I ONLY SLEEP WITH DUCHESSES OR MAIDS. PREFERABLY DUCHESSES' MAIDS. ANYTHING IN BETWEEN TURNS ME RIGHT OFF."

After years of rejection by the Salon, Monet latched onto the idea of an independent exhibition, working with Edgar Degas to make the show a reality in 1873. Critics seized on his painting's title to label the entire group "Impressionist" and brutally attacked the works on display. One critic exam-

ined a Paris streetscape called *Boulevard des Capucines*, imagining a dialogue with the artist: "Will you kindly tell me what all those little black dribbles at the bottom of the picture mean?" the critic asks. "Why, they are pedestrians," explains the artist. "And that's what I look like when I walk along the Boulevard des Capucines? Good Heavens! Are you trying to make fun of me?"

THE IMPORTANCE OF BEING ERNEST—AND ALICE

In 1876, Monet met Ernest Hoschedé, a wealthy new patron and owner of one of the first Paris department stores, and the two families became close. When the economy suddenly took a nosedive, commissions ran out, and the Monets were plunged into debt. Even harder hit was Hoschedé: His business failed, and he ran off to Belgium, leaving behind his wife, Alice, and their four children. Monet invited Alice and the kids to live with Camille and their two children in a new house in the remote village of Vétheuil.

Tragically, Camille developed cervical cancer and suffered constant pain. Alice nursed her, kept the household, and tended the children, two of whom were babies. At some point, she also became Monet's lover, although it's impossible to know whether it was before or after Camille's death, in September 1879. Monet painted his wife on her deathbed, although he later described with dismay the way his painter's mind automatically analyzed the colors of her sick face. So desperately poor was the Monet-Hoschedé ménage that Monet had to beg one of his patrons to retrieve Camille's favorite golden locket from a Paris pawnshop.

That winter would be the lowest point of Monet's life. In time, the economy rebounded and patrons returned. In 1883, the couple and their children moved to a house set within a large garden in the village of Giverny, where Monet spent the rest of his life.

MAKING HAY

In autumn 1890, Monet used the haystacks in local fields as a motif to capture what he liked to call the "envelope" of light and atmosphere. In the end, he completed twenty-five paintings depicting different seasons and times of day, thus composing his first series, the paintings for which today he is best known. There are haystacks in pale winter light, haystacks in spring fog, and haystacks in summer sunsets. When exhibited together in

May 1891, the paintings dramatically impacted audiences, who finally understood what Monet had been attempting all along. (Some of the artist's friends were less understanding; Pissarro, for example, thought Monet was simply repeating himself.) The success of the haystacks convinced Monet to undertake more series—of poplars, of Rouen cathedral, and of London's Houses of Parliament. He would carry multiple canvases, each noted on the back with the time of day it depicted, and work on them in turn.

In 1891, Ernest Hoschedé died, and the next summer Claude and Alice quietly married. She continued to run the house like clockwork in deference to her husband's artistic sensibilities; Monet went into the sulks if his dinner or lunch were delayed by dawdling children. When Alice died in 1911, one of her daughters took over the housekeeping. Monet didn't even allow World War I to disrupt his routine, although the German front line was fewer than forty miles from Giverny.

HAD ENOUGH OF HAY?

Increasingly, Monet concentrated on one theme: the water lilies in his garden, the subject of some 250 canvases. During the first world war, he began his most ambitious works: enormous, curved canvases, more than $6^1/_2$ feet tall and almost 14 feet tall. After the war, with his close friend Prime Minister Georges Clemenceau, Monet arranged for France to build two oval-shaped rooms in the Musée de l'Orangerie in Paris especially for these works. By the time the water lilies were installed in 1927, they were an anachronism. Modernism was ascendant and Impressionism was an art of the past. Contemporary artists derided the works as "pretty." Monet died at Giverny in December 1926 at age eighty-six, little aware of how much art had changed.

Yet the dip in his reputation was short-lived. Today, Monet is one of the most beloved artists of all time—less intimidating than Leonardo da Vinci and saner than Vincent van Gogh. His paintings have been translated into every conceivable consumer item: You can play with the limited edition Waterlily Barbie, entertain your infant with Baby Monet videos, and create your own Impressionist water lilies with a paint-by-numbers kit.

I ONLY HAVE EYES FOR BLUE

In the early 1900s, Monet started to notice he was having trouble with his vision. He was well aware of Edgar Degas' blindness and feared the same fate for himself. Fortunately, he was diagnosed with cataracts, a treatable ailment; however, in the early twentieth century cataract surgery was far more dangerous than it is today, and Monet put it off until 1920. When he was finally able to return to the studio, Monet viewed his own paintings with shock. Before his surgery, the yellowish-brown cataract had shifted his perception until the blue portion of the spectrum was almost completely invisible. To compensate, Monet had been painting everything in tones of red and yellow. After the surgery, blues came flooding back, to the point that he couldn't see reds. It took several months for Monet's vision to return to normal.

Many joked that the artist painted in an Impressionist blur because he was nearly blind. Not so. Monet's paintings were as "unfocused" in his thirties as in his seventies. But the cataract did change the way he saw the world. Paul Cézanne said famously that Monet was "only an eye—but, my God, what an eye!"

MAID MAN

While studying art in Paris, Monet wowed all the female models with his handsome features, well-cut clothes, and fashionable lace cuffs. "Sorry," the artist told them, "I only sleep with duchesses or maids. Preferably duchesses' maids. Anything in between turns me right off."

THE HONORABLE MONSIEUR MONET

Monet didn't hesitate to effect distinguished airs to advance his interests. In 1877, he wanted to paint the Gare Saint-Lazare train station and decided the light would be best if the train for Rouen was delayed a half hour. Unfortunately, railways don't usually adjust their schedules for impoverished artists. Renoir describes what happened next:

> He put on his best clothes, ruffled the lace at his wrists, and twirling his gold-headed cane went off to the office of the Western Railway, where he sent in his card to the director. . . . He announced the purpose of his visit. "I have decided to paint your station. For some time I've been hesitating between your station and the Gare du Nord, but I think yours has more character." He was given permission to do what he wanted. The trains were all halted; the platform cleared; the engines were crammed with coal so as to give out all the smoke Monet desired. Monet established himself in the station as a tyrant and painted amid respectful awe. He finally departed with half-a-dozen or so pictures, while the entire personnel, the Director of the Company at their head, bowed him out.

Impressed by his grand manner, the Western Railway staff had no idea they were dealing with an artistic outcast, an "intransigent" constantly rejected by the official Salon. Renoir concluded with amazement, "I wouldn't have even dared to paint in the front window of the corner grocer!"

HENRI ROUSSEAU

MAY 21, 1844–SEPTEMBER 2, 1910

ASTROLOGICAL SIGN:
GEMINI

NATIONALITY:
FRENCH

STANDOUT WORK:
THE SLEEPING GYPSY (1897)

MEDIUM:
OIL ON CANVAS

ARTISTIC STYLE:
NAÏVE

SEE IT YOURSELF:
MUSEUM OF MODERN ART, NEW YORK

QUOTABLE *"I MUST LEARN TO DRAW."*

Far from where the École des Beaux-Arts taught "official" French art, far away from the cafés where the avant-garde rebelled against convention, Henri Rousseau toiled away at his art. His Paris apartment might have been on the other side of the world, so distant was he from current artistic thought. Paul Gauguin, living in isolation on the island of Tahiti, was more in the mainstream than Rousseau.

Rousseau was that most unusual of creatures: a self-taught artist who amazed the world with his raw talent. Even though he never took an art class and began painting only in his forties, his dynamic works astounded audiences. In the end, he would influence such revolutionary artists as Pablo Picasso and convince the world that his unique artistic vision deserved a place on museum walls.

A CUSTOMS AGENT WHO DEFIED CUSTOM

Henri Rousseau was born in 1844 in Laval, a provincial town in northern France. In 1863, he joined the staff of a local law office and then did his military service. Future admirers liked to romanticize his army career as a series of adventures in exotic locales, but in fact he spent four undistinguished years at regional training posts. Upon his discharge in 1868, he moved to Paris, where he worked as a bailiff's clerk and married Clémence Boitard, a seamstress.

The Franco-Prussian war brought hardship on the young couple. Their first child died during the food and fuel shortages of the siege of Paris. After the war, Rousseau obtained a job with the Octroi, the Parisian customs service, and friends called him Le Douanier ("the customs agent").

What set Rousseau apart from his petite bourgeoisie neighbors was his creative energy. An enthusiastic amateur violinist, in 1885 he won a diploma from the French music academy for his waltz "Clémence." He also wrote several plays, including *A Visit to the 1889 World's Fair* and *The Revenge of a Russian Orphan* (apparently as melodramatic as it sounds).

But what interested Rousseau most was painting, and so he bought himself paints and canvases and set to work without any training whatsoever. Enormously confident in his abilities, he exhibited four canvases at the Salon des Indépendants in 1886. This new forum had been established a year before by artists including Georges Seurat in an attempt to

break the chokehold of the government's official Salon. Rather than jurying shows, the Indépendants allowed anyone to exhibit for a small annual fee.

JUNGLE PRIMITIVE

In the 1890s, Rousseau hit upon his most important theme: the jungle. His painting called *Surprise!* depicts a tiger baring its teeth and surrounded by sharply pointed leaves, rippling grasses, and looming trees. To create his jungle scenes, Rousseau spent hours at the Jardin des Plantes, the botanical garden in Paris, which contained stuffed wild animals and greenhouses full of tropical plants. He eventually painted dozens of jungle scenes, many with animals straight out of the garden's exhibit cases. The primal energy emanating from these canvases sometimes alarmed even Rousseau, who claimed he needed to open the studio windows to let it escape.

Rousseau's most famous painting is unusual among his works—so unusual, in fact, that it was rumored to be a forgery. *The Sleeping Gypsy* (1897) depicts a black woman dressed in a colorfully striped gown lying asleep on the ground. A lion with a bright mane and a pert tail leans over and sniffs her. The desolate landscape of distant hills and bare ground contrasts strangely with Rousseau's usual jungles; no other of his works is as stark. But the horizontal planes of color and limited details create a powerful impression.

In 1888, Clémence died, leaving Rousseau to care for their teenage daughter, the only of their eight children to survive into adulthood. He retired from the customs service in 1893 with a small pension, which he supplemented with violin lessons. In 1899, he married a widow named Joséphine Noury. He tried to earn a living from his paintings by entering government competitions but never had any luck. Fortunately, his Paris neighbors paid him small sums to create portraits of family members. The stiffness and "primitiveness" of these works is profound but strangely compelling. Although they failed to capture likenesses—Rousseau is at his most awkward portraying faces—they succeeded in conveying a sense of the subject's personality, often through details such as a favorite toy or treasured possession.

AN OUTSIDER ON THE INSIDE

Rousseau would have languished in obscurity had not the avant-garde sud-

denly "discovered" him around the turn of the century. Pablo Picasso happened to see one of Rousseau's canvases lying in a heap in a junk shop; when he expressed interest, the store owner offered it cheap, saying, "You can paint over it!" Before long, Picasso and his bohemian friends were visiting Rousseau in his modest studio. They thrilled to the artist's "naïveté" and his "primitive" style and prized his vision as free from academic conventions and uninfluenced by any school or movement. (It's doubtful Rousseau viewed their paintings with similar regard. He always expressed admiration for academic art and seems to have found modernist painting incomprehensible.)

In 1910 at the Indépendants, Rousseau exhibited his largest canvas, a jungle painting titled *The Dream*, to the appreciation of his young friends. Sadly, he had little time to enjoy his newfound fame. He died that fall from complications from an infected leg wound. Friends donated money to erect an elaborate tomb for him that featured a poem by Guillaume Apollinaire inscribed by the artist Constantin Brancusi.

Rousseau influenced movements as diverse as Cubism and Surrealism. Most significant is the development of an entirely new type of art that became known as Naïve, or Outsider, Art. Henceforth, critics would be on the lookout for unknown geniuses, hoping another Rousseau is working away unobserved.

PRIMITIVE, BUT NOT SO SIMPLE

Lest you leave with the idea that Rousseau was pure of spirit and charmingly naïve, you should know about his criminal record. His first run-in with the law happened when he was a young man just out of school. He took a job at a lawyer's office, where he apparently stole some cash and a large quantity of stamps. He served a short prison sentence in 1864 and then volunteered for the military to get out of jail.

His second criminal encounter occurred many years later, in 1907, when he was involved in an elaborate case of bank fraud. A

bank clerk friend hatched the scheme, which involved Rousseau opening an account under a false name and obtaining forged bank certificates.

The crime was quickly uncovered, and Rousseau was hauled to jail. At trial, he played up his "naïve" reputation, with his attorney emphasizing his client's "simpleness" and insisting he had been manipulated. The jury didn't completely believe the story—they imposed a fine and a suspended sentence.

ALTHOUGH HENRI ROUSSEAU IS AN ARTIST KNOWN AS A CHARMINGLY NAÏVE "PRIMITIVE," HIS RAP SHEET INCLUDED JAIL TIME FOR THEFT AND BANK FRAUD.

WHAT AM I DOING HERE?

The avant-garde appreciation of Rousseau peaked in November 1908, when Pablo Picasso hosted a banquet in his studio in Rousseau's honor. The guests formed a Who's Who of Paris bohemia, including artist Georges Braque, poets Max Jacob and Guillaume Apollinaire, and writer Gertrude Stein, her lover, Alice B. Toklas, and Stein's collector brother, Leo. Unfortunately, the evening's feasting portion was a flop, since Picasso had mistakenly ordered the food for the next day; his girlfriend and Toklas scrambled to find the ingredients to make paella. Luckily, plenty of alcohol was on hand, and events went on long into the night.

After Apollinaire read a poem about the guest of honor, Rousseau stood to express his thanks. Turning to Picasso, he said, "We two are the greatest painters of our time: you in the Egyptian style, and I in the modern style."

No one had any idea what he was talking about.

TIME'S UP—HANDS DOWN

The artist Fernand Léger once took Rousseau to an exhibition of the works of Jacques-Louis David, one of the quintessential academic artists. Rousseau was particularly struck by David's execution of hands, a part of the body Rousseau found particularly difficult to paint. He said to Léger, "I must learn to draw." Léger noted in an article after the artist's death, "That was his mistake. Fortunately he never had the time to take drawing lessons."

OPEN WINDOW

Stories by Henri Rousseau's avant-garde friends paint a picture of a man inclined to let his imagination get the better of him. The poet Guillaume Apollinaire once claimed that "sometimes, when painting a fantastic subject, [Rousseau] would become terrified and, all atremble, would be obliged to open the window." It seems that only after the powerful spirits he'd evoked were allowed to escape could the artist continue with his work.

VINCENT VAN GOGH

MARCH 30, 1853–JULY 29, 1890

ASTROLOGICAL SIGN:
ARIES

NATIONALITY:
DUTCH

STANDOUT WORK:
STARRY NIGHT (1889)

MEDIUM:
OIL ON CANVAS

ARTISTIC STYLE:
POST-IMPRESSIONIST

SEE IT YOURSELF:
MUSEUM OF MODERN ART, NEW YORK

"I CANNOT HELP IT THAT MY PICTURES DO NOT SELL. NEVERTHELESS, THE TIME WILL COME WHEN PEOPLE WILL SEE THAT THEY ARE WORTH MORE THAN THE PRICE OF THE PAINT."

QUOTABLE

It's hard to understate the unrelieved misery that was Vincent van Gogh's life. He staggered from one disaster to another—lost jobs, failed careers, troubled relationships. In his entire artistic career, he sold only one painting. In the end, he killed himself.

Yet today his art elicits tremendous acclaim worldwide.

It's also hard to reconcile the despairing man with his exuberant creations. In a painfully short career—only eight years—van Gogh revolutionized art. His colors seem to leap off the canvas. Brilliant blues, glowing greens, luminous yellows—van Gogh's palette never ceases to astound.

MISSIONARY POSITION

Vincent Willem van Gogh was the eldest surviving son of the Calvinist pastor Theodorus van Gogh and his wife, Anna Cornelia. Of their five other children, Vincent was closest to his brother Theo. He showed early interest in art—selling it, not painting it—and at age fifteen took a position with the dealers Goupil and Co. at a branch run by one of his uncles. In 1873 his employers transferred him to the London branch, but soon they found him distracted by religious fervor inspired by the evangelism movement sweeping England. He was then transferred to Paris, where he took to preaching to annoyed customers rather than selling them art. In March 1876, he was fired.

Van Gogh took his dismissal with unseemly enthusiasm and returned to England to undertake mission work. When he visited his parents for Christmas, however, they insisted he stay in the Netherlands and enter divinity school. To pass the entrance exam, he would have to study higher Latin and Greek. Vincent rebelled. What did dead languages have to do with serving the poor? The family enrolled him in an evangelical academy, which he attended a few months before the faculty declared his explosive temper unsuitable for a missionary. "Whatever," said van Gogh, and he set off to be a missionary anyway. Moving to a desperately poor coal-mining community, he lived like the miners to whom he preached, eating scraps and dressing in rags. Without the little money Theo sent to him, he would have starved.

THE MAKING OF AN ARTIST

Although barely aware of it himself, van Gogh's passions began to shift during the two years spent with the miners. He developed a distaste for organized religion, which did little to help the poorest of the poor. He also began

drawing compulsively and spent hours copying prints sent by Theo. In 1880, the twenty-seven-year-old renounced a life of religion and embraced one of art.

He was still the same person, though—just as unwilling to follow convention—and a stint at an arts academy ended in failure. He returned to his parent's house in the country, where he startled his father's parishioners with his bedraggled appearance and odd behavior. "We cannot change the fact that he's eccentric," sighed his father.

Van Gogh came of age as an artist during this time, although his somber early work is hard to reconcile with his later, vivid masterpieces. He preferred to paint the most downtrodden of peasants and chose determinedly dull colors—browns, grays, dirty greens, and blacks. His restless spirit eventually tired of country life, so, on the spur of the moment, he hopped a train for Paris in March 1886. Soon after arriving, he attended the last Impressionist exhibit. He was amazed by the colors of the Impressionist palette—their brilliance and purity was like nothing he had ever seen—and soon his own canvases glowed with bright colors infused with light. As influential as the older Impressionists were younger artists such as Georges Seurat and Paul Gauguin. In the spirit of the times, van Gogh organized an exhibition that, although ignored by critics, attracted the attention of other artists.

HEADING SOUTH

The bohemian's life was wearing thin. After two years in Paris, van Gogh's health was failing due to the consumption of vast quantities of brandy and long nights spent at the Moulin Rouge. He needed to get out of the city and recuperate. In one of his sudden fits of inspiration, he envisioned a "Studio of the South" in southern France, where like-minded artists could work without the pressures of the capital. He picked the small town of Arles as the ideal location—no one really knows why—and set off in February 1888.

Provincial Arles didn't know what to make of the odd Dutchman. Van Gogh was horribly lonely. He didn't speak the Provençal dialect and could barely communicate with his neighbors. He had nothing to do but paint. In fifteen months, he completed some two hundred canvases. The brilliant light of Provence fired his imagination, and soon he was painting in his immediately recognizable, mature style characterized by pure pigments applied with thick brushstrokes.

Still obsessed with his Studio of the South, van Gogh pestered Gauguin to visit. Gauguin had also turned to art as a second career, having starting out as a stockbroker, and, although initially inspired by Pissarro and Impressionism, by 1888 he was moving away from the direct recording of nature to an approach intended to represent the working of his imagination. He had only tepid interest in Vincent's artists' community but did want to cultivate the relationship of Theo, now an important dealer, and so he journeyed to Arles. Van Gogh greeted his arrival with delight; he had spent the preceding weeks painting still lifes of sunflowers for the walls of Gauguin's room.

> IN THE EXTREMES OF HIS MADNESS, VINCENT VAN GOGH ATE PAINT DIRECTLY FROM THE TUBE.

CRAZY IN PROVENCE

Gauguin had anticipated a master-pupil relationship, and for the first few weeks, he got it. Van Gogh seems to have followed Gauguin around like a puppy. But before long van Gogh's stubbornness resurfaced, and intense arguments broke out about art and the proper source of inspiration. (Van Gogh said nature; Gauguin, imagination.) Gauguin's surliness didn't help matters. With only the neighborhood café-slash-brothel for diversion, the tension grew. Gauguin unexpectedly declared he was returning to Paris. Van Gogh snapped.

We don't really know what happened during those two days before Christmas 1888. Gauguin's account is self-serving, to say the least, and van Gogh never wrote about the events. After (possibly) threatening Gauguin with a razor, van Gogh severed part of his earlobe (not, as myth would have it, his entire ear) and headed to the brothel to present it to his favorite prostitute. The next morning, the police followed a trail of blood to van Gogh's room and found the artist lying unconscious in bed. Gauguin sent for Theo, and Vincent was hospitalized, hovering close to death from blood loss while Gauguin beat a hasty retreat for Paris. The two men would never meet again.

Van Gogh would never be the same. He was released in January but relapsed in February. Realizing how unstable his mental state was, he vol-

unteered to be committed to a mental institution in nearby Saint-Rémy. He spent several months lapsing in and out of insanity. Sometimes he was able to work, paintings irises in the asylum's garden and the night sky full of stars. Other times, he was the hopeless victim of delusions and hallucinations. Gradually, his condition improved, and in May 1889, after a year in confinement, he left Provence.

LUST FOR LIFE—AFTER DEATH

Theo settled his brother in a small town about twenty miles north of Paris, where Vincent obsessively painted the surrounding landscape, particularly wheat fields blazing under the summer sun. Many find these paintings, particularly *Crows over Wheat Fields*, terrifyingly oppressive. On July 27, 1890, the innkeeper found van Gogh lying in his room in a pool of blood: He had shot himself, apparently while in one of the wheat fields. Poor, bungling Vincent—the bullet had missed his heart but was lodged in his side. It took two days for him to die.

And so the world learned of the death of an artist they had only just begun to notice. Theo had entered Vincent's paintings at the Salon des Indépendants in 1888, 1889, and 1890, where they received small but glowing praise. He even sold a painting, his first and only one.

Instead, van Gogh was acclaimed as the prototypical "mad" artist destroyed by an indifferent society. By the early twentieth century, the public was gobbling up publications of his letters and novelizations of his life, particularly Irving Stone's 1934 *Lust for Life*. (The book was made into an Oscar-winning movie in 1956, directed by Vincent Minnelli and starring Kirk Douglas.) Meanwhile, artists continued to be inspired by him. The Fauves, including Henri Matisse, celebrated his dynamic use of color, as did the Abstract Expressionists fifty years later.

In the late twentieth century, van Gogh's reputation was secured when his paintings sold at auction for vast sums. One of his last works, *Portrait of Dr. Gachet*, commanded a record-breaking $82.5 million in 1990. Today his paintings are found at museums around the world, as well as on throw pillows, silk ties, coffee mugs, and tote bags. As a defender of the nonelite classes, van Gogh may have appreciated the irony of his art's afterlife as kitsch.

COLORS TO DIE FOR

We can thank the Industrial Revolution for the brilliance of van Gogh's paintings. In the nineteenth century, chemical research resulted in the development of some twenty new pigments, many of which were much brighter and more stable than those previously available. Van Gogh took advantage of all of these innovations, writing Theo that it was false economy to try to make do with the older, cheaper paints.

Unfortunately, many of these pigments might have contributed to his ill health. The brilliant Emerald Green, with its concentrated copper/arsenic base, is highly toxic and was sold as an insecticide to kill rats as well as a paint. It's been theorized that van Gogh's neurological symptoms were caused by arsenic poisoning, although the lead in flake white and the mercury in vermilion could also have played a role—particularly when you consider that, in the extremes of his madness, van Gogh ate paint directly from the tube.

DIAGNOSIS: GENIUS

So what was wrong with Vincent van Gogh? In addition to the paint-poisoning hypothesis, numerous diagnoses have been proposed, including schizophrenia, syphilis, and porphyria. Two of the most convincing theories are that he suffered from bipolar disorder, which could account for his periods of mania followed by deep depression, and temporal lobe epilepsy, which could explain his hallucinations and seizure-like episodes. Any of these conditions would have been exacerbated by malnutrition and alcohol abuse; it seems during his time in Arles, the artist survived on absinthe, black coffee, and pipe tobacco. Whatever van Gogh's sickness, twenty-first-century medicine probably could have cured him, which leads to the unanswerable question: What would a cure have done to van Gogh's magnificent art?

FIND A GIRL, SETTLE DOWN

Poor van Gogh couldn't catch a break, especially when it came to women. His first passion was for the daughter of his London land-lady, but when he finally got up the courage to propose, she announced she was engaged to someone else.

His second infatuation was with his cousin, the recently widowed Kee Vos-Stricker. Van Gogh spent the summer of 1881 in Etten liv-ing with his parents and Kee. Seven years older, she was kind and sympathetic, and van Gogh became obsessed. He proposed, but she declined decisively. So he proceeded to stalk her, following her to Amsterdam and pestering his aunt and uncle. One night, he stuck his hand in the flame of a lamp, declaring he would keep it there until they allowed him to see his cousin; he passed out from the pain before his uncle could blow out the flame.

Van Gogh was finally distracted by a new love, although this one was no less inappropriate. Clasina Maria Hoornik (known as "Sien") was a pregnant, alcoholic prostitute with a young daughter. Van Gogh resolved to "rescue" the unfortunate woman and took her into his house. His family was disgusted with the relationship, particularly because Sien returned to her old profession after the baby was born. He finally left her in 1883.

Henceforth, van Gogh's relationships with women were purely, ahem, professional. He wrote to Theo from Arles that he made it a practice to visit the local brothel once every other week—strictly for his health.

UKIYO-E AND THE INFLUENCE OF HOKUSAI

For centuries, European artists considered non-Western art unworthy of notice. That attitude of cultural superiority changed in the mid-nineteenth century when the art of Japan reached Paris. Japanese art had been largely unknown until then because, beginning in 1639, Japan strictly limited contact with foreign "barbarians" (cultural superiority cuts both ways, after all). In 1853, the United States ended Japan's isolation by sailing four warships into Edo (now Tokyo) Harbor. Japanese art soon flooded into Europe.

Ukiyo-e, or colored prints made from woodblocks, were then the most popular form of art in Japan, and Katsushika Hokusai (1760–1849) was the most famous ukiyo-e artist. Working under the name Gakyo Rojin Manji, which translates as "The Old Man Mad About Art," he lived to the ripe old age of eighty-nine. On his deathbed he exclaimed, "If I had another five years, even, I could have become a real painter."

Hokusai created thousands of prints depicting landscapes, scenes from Japanese theater, and well-known personalities including beautiful courtesans and bulky sumo wrestlers. His popularity ensured that his was some of the first Japanese art seen in the West. The Impressionists and Post-Impressionists had never seen anything like the flat panes of color and delicate lines in prints such as *Great Wave off Kanagawa*, and they immediately started imitating Japanese effects. Claude Monet, for example, acquired an enviable collection of prints and grew particularly interested in Japanese gardening, basing the famous bridge in his garden at Giverny on Japanese models. Monet was also inspired by the Hokusai's series, such as his Thirty-Six Views of Fuji, painting his own series of haystacks and church facades.

Vincent van Gogh was also dramatically influenced by Japanese prints, buying them in quantities he (or, rather, his brother Theo) could ill afford.

In the winter of 1887–88, he toyed with the idea of journeying to Japan, another impractical pipe dream for an impoverished artist. Instead he consoled himself with the idea that by traveling to Arles, he was going to the "Japan of France." He wrote to Theo on his arrival, "Here I feel myself to be in Japan."

Van Gogh re-created Japanese prints and evoked Japanese art in several paintings, particularly *Branches of Almond Tree in Bloom, Saint-Rémy*, completed while he was in the mental asylum. Gnarled greenish brown branches twist and cross a vivid turquoise sky, with pale blossoms adding a touch of delicacy.

For some artists and craftsmen, imitation became a style in itself, known as *japonisme*, from which Art Nouveau drew its sinuous lines and fields of color. The most significant impact of the Japanese influx, however, was that it made non-Western art an acceptable source of inspiration for Western artists. ■

GEORGES SEURAT

DECEMBER 2, 1859–MARCH 29, 1891

ASTROLOGICAL SIGN:
SAGITTARIUS

NATIONALITY:
FRENCH

STANDOUT WORK:
*SUNDAY AFTERNOON ON THE ISLAND OF
LA GRANDE JATTE* (1886)

MEDIUM:
OIL ON CANVAS

ARTISTIC STYLE:
POST-IMPRESSIONIST

SEE IT YOURSELF:
ART INSTITUTE OF CHICAGO, CHICAGO

*"THEY SEE POETRY IN WHAT I HAVE DONE.
NO, I APPLY MY METHOD AND THAT IS ALL
THERE IS TO IT."*

QUOTABLE

By the 1880s, it seemed science could improve anything. Modern engineering and cutting-edge research were transforming cities, eliminating diseases, and reinventing industry. So why not art?

Most artists had limited interest in the brave new world of nineteenth-century science, but not Georges Seurat. Convinced he could use science to remake art, he created a new approach to painting, one we today call Pointillism.

It turns out Seurat's science was wrong, and Pointillism doesn't really work the way he intended. But no matter—the scientist/artist still produced a masterpiece with his renowned *Sunday Afternoon on the Island of La Grande Jatte*, a masterwork of light and color that took on a strange after-life in the footlights of the Great White Way.

ADVENTURES IN LIVING COLOR

Georges-Pierre Seurat was the only son of a canny, one-armed bailiff who made enough money on his investments to support his son's pursuit of an artistic career. In 1878, Seurat entered the prestigious École des Beaux-Arts and trained as a traditional history painter. The school had responded to the challenge of Impressionism by clinging ever more tightly to classicism, but even the staid Seurat found the teaching irrelevant, so he taught himself by sketching endlessly at the Louvre.

By 1883, the science of color obsessed him. New investigations of light, vision, and color perception were widely known among the scientific community but were only beginning to be noticed by artists. One theorist described the phenomenon that occurs when you look at a bright color intently (say, red) and then look at a piece of white paper: You briefly see its opposite (pale blue). (Try it—it works.) Another proposed that if you divide a color into either related or opposing tints and place them next to one another, they will combine in the eye to form more vibrant hues.

Very well then, said Seurat, and he set about creating art based on those principles. In its loose brushwork and bright colors, *Bathing Place, Asnières*, his first major painting, resembles Impressionist works by Camille Pissarro or Claude Monet. However, his intentions couldn't have been more different. Seurat wasn't interested in capturing a fleeting impression of a scene; rather, he was attempting to reproduce the vivid colors of natural light. Frankly, he had no interest in the subjects of his paintings, once comment-

ing that he could have painted a history scene like Jacques-Louis David just as well as a modern setting. What mattered was technique.

SUNDAY ON THE ISLAND WITH GEORGE

Seurat exhibited *Bathing Place, Asnières* at the first Salon des Indépen-dants, of which he was a founding member and driving force. He may have been trained by the Academy, but he was savvy enough to realize that insti-tutional art was too hide-bound to accept his innovations. He felt strongly that their Salon needed to occur regularly, so he helped organize the Soci-ety of Independent Artists to sponsor a yearly exhibition.

Soon after, Seurat began work on a new composition, one depicting the pleasure spot on the island of La Grande Jatte, where Parisians of all classes picnicked on weekend afternoons. Seurat decided on a complex composition showing numerous figures dressed in their summer finery and lounging along the riverside; the final work includes forty-eight people, three dogs, and one monkey.

It took two years to complete *Sunday Afternoon on the Island of La Grande Jatte*, an astoundingly long time that reflects his academy training. (Most Impressionists could whip out a painting in a few afternoons.) The size of the canvas was also straight out of the École des Beaux-Arts, meas-uring more than 6 1/2 by 10 feet. But most unusual was Seurat's technique. After covering the canvas with light washes of color for each major section, he then applied small dabs or strokes of paint to build up details.

Seurat placed colors next to one another believing that observers would perceive them as blending, that is, that a dab of yellow next to a dab of blue would merge in our eyes to be perceived as green. His theory was essen-tially sound, and in fact it forms the basis of contemporary color printing. However, Seurat didn't realize that the dots must be incredibly small for the effect to really work; his clearly visible dabs are just too big to blend.

At the end of the day, Seurat's science is pretty much bunk, but it doesn't matter when standing in front of his paintings, which seem to shim-mer and glow as the colors vibrate against one another.

THE GREAT DOT DIVIDE

Artists able to see *La Grande Jatte* in progress were amazed by the technique and quickly imitated it. Pissarro was particularly inspired and began paint-

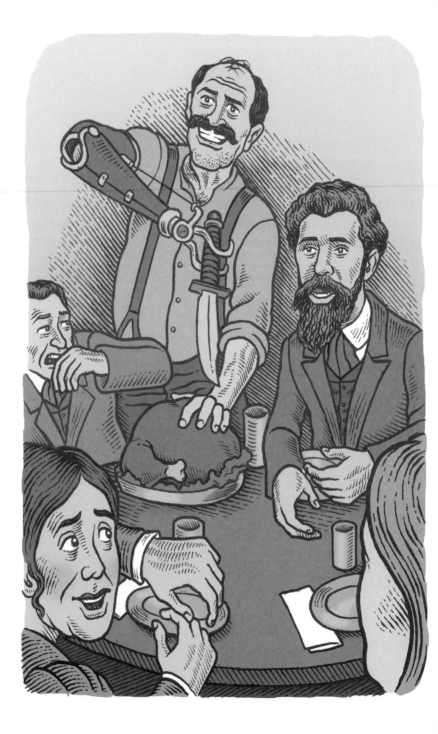

ing using the "divisionist" technique. (The term *Pointillism* came later.) When discussions started in 1886 about another Impressionist show, Pissarro insisted that Seurat be included, to the annoyance of artists like Monet and Renior, who found Seurat's almost mechanical brushstrokes antithetical to the spirit of Impressionism. Pissarro won his point, and Seurat's painting was included in the show.

Critical reaction was mostly bafflement—they didn't know how to "see" such a painting. Even many who applauded Seurat's talent deplored his technique, which they said resulted in lifeless, mannered works. Seurat and his "Neo-Impressionist" friends shrugged off the criticism, although Seurat was apparently stung enough by the charge of "lifelessness" that his next painting featured three nudes.

COMING FROM A FAMILY OF ECCENTRICS, GEORGES SEURAT THOUGHT NOTHING OF HIS FATHER'S ODD PENCHANT FOR SCREWING KNIVES AND FORKS TO THE END OF HIS ARTIFICIAL ARM TO CARVE THEIR TUESDAY NIGHT DINNERS.

A LASTING IMPRESSION

Seurat was officially hailed as the leader of the new generation of avant-garde artists, and his opinions carried great weight at artistic discussions in Paris cafés. But on any other topic, you could expect silence; he had nothing to say about politics, music, or literature. Even his closest companions felt like they never really got to know him. He was uncommunicative, liked to work alone, and never indulged in chitchat. Most friends didn't even know he lived with a young model, Madeleine Knobloch, who bore him two sons.

After *La Grande Jatte*, Seurat divided his efforts between small landscapes and increasingly abstract Pointillist works of theaters and circuses. What would he have done next? Moved toward greater abstraction? Become increasingly ornamental and graphic? Stuck with Pointillism or moved on? We'll never know. On March 30, 1891, Seurat died after a brief illness, probably meningitis. He was only thirty-two.

Seurat's art remained a touchstone into the following century, with Cubists citing him as an influence. *Sunday Afternoon on the Island of La*

Grand Jatte has been particularly popular among American audiences. It was purchased in 1924 by the Bartlett family of Illinois, who donated it to the Art Institute of Chicago, where it hangs today as an internationally recognized icon.

SEURAT SCISSORHANDS

Seurat's acquaintances found him amiable, if withdrawn, but his father was downright weird. Only artist Paul Signac, Seurat's good friend, ever met his family, eventually becoming a frequent guest at dinner on Tuesdays, the one night of the week when Georges' father came into the city from his country cottage. Tuesdays, according to Signac, were "the day this husband had chosen for discharging his conjugal duties." He went on to describe some of Seurat *père*'s defining characteristics:

> He had an artificial arm . . . as the result of some accident, while hunting, I believe. At the table he screwed knives and forks to the end of this arm and proceeded to carve with speed, and even efficiency, mutton, filet, small game, and fowl. He positively juggled these sharp, steel-edged weapons, and when I sat near him I feared for my eyes. Georges paid no attention to these acrobatic feats.

Thankfully, Georges managed to keep his father away from his canvases.

GROUNDED FOR LIFE

The city of Chicago takes understandable pride in *La Grande Jatte*, claiming it as a resident since the 1920s. Rarely has the enormous painting left the Windy City, and for good reason: The one time the Art Institute of Chicago lent the painting, it was nearly burned to bits.

The Museum of Modern Art had arranged to borrow the painting in 1958 for a Seurat retrospective. The exhibition was a huge success, but then disaster struck. Workmen installing a new air-conditioning system had left combustible materials lying around, and around lunchtime on April 15, the materials burst into flames. As firemen rushed into the building, frantic curators carried out priceless works of art.

The fire was indeed serious. An electrician was killed and numerous firefighters and visitors were injured. Some paintings were damaged or destroyed, including one of Monet's eighteen-foot-long water lily canvases. Fortunately, *La Grande Jatte* survived unscathed. Horrified Chicago museum officials reluctantly agreed to allow the painting to remain for the rest of the exhibition but on its return vowed never again to let the painting leave the city. So if you want to see *La Grande Jatte*, you'll have to buy a ticket to the Midwest. It's not going anywhere.

IF WE CAN MAKE IT THERE . . .

Many paintings have played a part in popular culture, but only *La Grande Jatte* has provided the basis for a blockbuster Broadway musical. "Sunday in the Park with George" debuted in 1984, with music and lyrics by Steven Sondheim and a book by James Lapine. Starring Mandy Patinkin and Bernadette Peters, the play became a huge hit, winning two Tony awards, numerous Drama Desk awards, and the 1985 Pulitzer Prize. It gives voices to all the figures in the canvas, depicting them as real people trapped in the painting forever. Only at the end do the figures concede that their torture has some benefits: "There are worse things than sweating by a river / When you're sweating in a picture / that was painted by a genius."

GUSTAV KLIMT

JULY 14, 1862–FEBRUARY 6, 1918

ASTROLOGICAL SIGN:
CANCER

NATIONALITY:
AUSTRIAN

STANDOUT WORK:
THE KISS (1907–8)

MEDIUM:
OIL ON CANVAS

ARTISTIC STYLE:
ART NOUVEAU (VIENNA SECESSION)

SEE IT YOURSELF:
ÖSTERREICHISCHE GALERIE BELVEDERE, VIENNA, AUSTRIA

QUOTABLE

"THERE'S NOTHING REMARKABLE TO BE SEEN IN ME. I AM A PAINTER, ONE WHO PAINTS EVERY DAY FROM MORNING TILL EVENING."

A cool $135 million. That's how much Gustav Klimt's 1907 *Portrait of Adele Bloch-Bauer* sold for at auction in 2006, setting a new record. For an artist who, in his lifetime, was little known outside his native Austria and is still somewhat obscure, that's a lot of clams.

In his homeland, however, Klimt was famous not only for his glowing, erotic artworks but also for the controversy they sparked. An unlikely rebel, he led the secession from the artistic establishment in Vienna and pioneered a style known for its rich patterns and gleaming gold. We may not know much about him, but we recognize in his art uniquely lush depictions of beauty.

GOLDEN BOY

The son of a gold engraver, Gustav Klimt was the second child and first son of seven children. He and his brother Ernst obtained scholarships to the Austrian School of Applied Arts, where they became close friends with Franz Matsch, another artist. In 1881, the three formed the Company of Artists to promote their work, eventually receiving prestigious commissions and widespread recognition. The style of their early paintings is conventional Neoclassicism, with figures straight out of Michelangelo's frescoes, and people loved it. Klimt seemed on his way to a prosperous career as an establishment artist. Except that just as his style gained wide acceptance, Klimt decided to discard it. The death of Ernst in December 1892 contributed to his move away from convention, as did the break-up of the Company of Artists in 1894. The influence of Impressionist art was another factor. This movement had been slow to reach Austria, but gradually innovative artists such as Klimt adapted the new French uses of color and technique. The Austrian arts establishment dug in its heels, with the state-sponsored Vienna Society of Visual Arts, aka the Artists' House, rejecting Impressionism and all it stood for. Conflict brewed between traditional and progressive artists for several years, with matters coming to a head in 1897. Some twenty members of the Artists' House, including Klimt, resigned and organized the Vienna Secession; Klimt became their most prominent member.

ART'S BAD BOY?

At the same time Klimt was establishing himself as a member of the avant-garde, he was wrestling with a commission received during his more conservative period. In 1892, the Ministry of Education invited the Company of

Artists to paint a series of large allegorical works for the ceiling of the Great Hall of the University of Vienna. Several years of negotiations delayed the start of painting (during which time the Company dissolved), but nevertheless Klimt was asked to paint allegories of Jurisprudence, Philosophy, and Medicine. Upon exhibiting the finished works between 1900 and 1903, Klimt revealed his extraordinary new style: In *Medicine*, for example, a maelstrom of naked figures wails and contorts while Hygieia, the Greek goddess of medicine, gazes imperiously out of the canvas and a snake curls around her arm.

The reaction? Shrieking, wailing, and, the ultimate horror: endless committee meetings. A running battle broke out in the press, an official meeting of the arts commission was held, and the paintings became the subject of parliamentary debate. Klimt attempted to stay above the fray, finally writing the arts commission in 1904 that he wished to withdraw from the contract. But in the popular perception, Klimt was now considered a radical unwilling to concede to public taste.

Such a reputation wasn't altogether a bad thing. Wealthy members of the intelligentsia (often Jewish collectors, who were less committed to the status quo than their Christian neighbors) embraced Klimt and invited the artist to paint portraits of their wives. It didn't seem to bother them that the figures in the paintings bore little resemblance to their spouses. Take that oh-so-famous portrait of Adele Bloch-Bauer. A pale woman with dark hair and flushed cheeks looks out at the viewer with an inscrutable expression (boredom? seduction?). The rest of the work is a swirl of gold and a medley of symbols as Klimt developed a passion for gold paint and liberally applied it to his canvases.

GOLD STANDARD

Women were by far Klimt's favorite subjects. When men make their way into his paintings, their faces are often covered or hidden. In *The Kiss*, his most famous work, a man bends over a woman, his face turned away from the viewer as he presses his lips against her cheek. The woman, her head bent at an unnatural right angle, seems to swoon in his arms. The two are clothed in gold and kneel on a flower-covered ground.

Many recent critics, particularly feminist art historians, have criticized Klimt's portrayal of women as passive objects of male desire; they note that the man in *The Kiss* overpowers the woman, who must cling to him for sup-

port. Yet most audiences interpret the painting simply as representing love and passion in a fantasized golden and flower-covered world.

About 1910, Klimt's style began to evolve away from this heavily ornamented approach. A second portrait of Adele Bloch-Bauer from 1912 lacks the extravagant gold paint; color is more important, with the white-clad Adele set against blocks of blue, green, and pink. Unfortunately, Klimt had little time to develop this new style. The outbreak of World War I limited his artistic output, and then he suffered a stroke on January 11, 1918. Partially paralyzed, he was moved to a hospital, where he came down with pneumonia and died on February 6.

In the years immediately after his death, Klimt's art continued to influence the Art Nouveau movement, but the Modernist reaction against ornamentation soon left Klimt behind. He remained on the edges of popular art, but it wasn't until the 2006 sale of the portrait of Adele Bloch-Bauer that Klimt's name exploded into the mass media ($135 million has a way of getting the world's attention). Not all art experts were pleased. When the painting was heralded by some as worth even more than the vast sum paid, a critic at the London Guardian groused, "Worth more what? Surely not money. Was it the value of the gold if you scrape it off?"

THOROUGHLY MODERN EMILIE

Gustav Klimt never married, although he had numerous affairs and reports variously claim he fathered three, fourteen, twenty, or forty illegitimate children. His longest and closest relationship with a woman might not have even been sexual.

Emilie Flöge met Klimt in the early 1890s when her sister Helene married his brother Ernst. The marriage was cut short by Ernst's untimely death, and Helene returned to her family's house with her young daughter, who had been entrusted to Gustav's guardianship. In 1904, the three Flöge sisters established a fashion house and became Vienna's leading couturiers. By adapting Paris fashions to local tastes and designing their own clothes, the sisters dressed the most elegant—and wealthiest—women in Austria. Klimt contributed to Flöge designs and helped decorate their showroom.

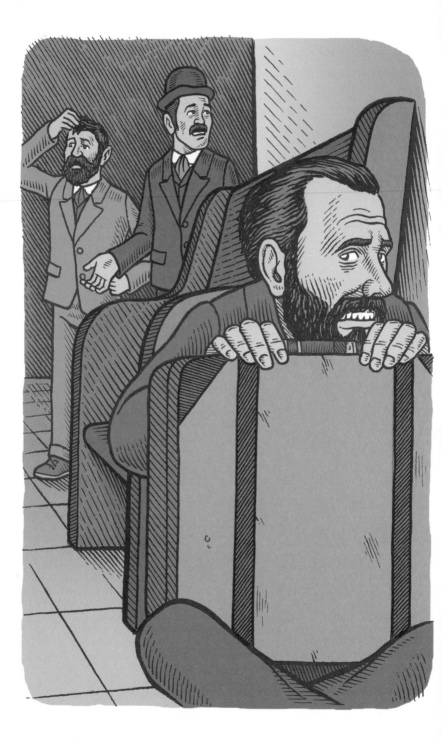

Meanwhile, Emilie and Gustav became inseparable companions. Many biographers and experts doubt they had an affair. Emilie prided herself on her modernity—she built her own business, designed her own clothes, and lived life on her own terms. Klimt seems to have recognized her as an equal. So close were the two that after his stroke, Klimt whispered, "Send for Emilie." Those were the last words he would speak.

TRAVELS WITH GUSTAV

Klimt disliked travel outside Austria and avoided it whenever possible. One friend, Carl Moll, described a trip to Italy that nearly ended before it began. Moll arranged to have friends in Vienna escort Klimt to the station and get him on the right train, while Moll promised to meet Klimt in Florence when he disembarked. The train arrived, and Moll waited at the outer barrier where passengers streamed off the train—but no sign of Klimt. Moll started searching the station, finally finding Klimt sitting alone with his suitcase in a waiting room. When asked what he would have done if Moll hadn't found him, Klimt replied that he would have caught the next train home.

AN INVETERATE TRAVEL-PHOBE, GUSTAV KLIMT WAS SO UNUSED TO DEALING WITH TRAIN STATIONS THAT, WHEN FRIENDS COULD NOT FIND HIM TO ESCORT HIM TO A CONNECTING TRAIN, HE NEARLY GAVE UP AND TOOK THE NEXT TRAIN HOME.

THE LOSS OF PHILOSOPHY

Should you want to see Klimt's controversial paintings for the University of Vienna, you're out of luck. They don't exist anymore. After the brouhaha with the Ministry of Education, the paintings were acquired by private collectors, and when Germany took over Austria in the 1930s, the Nazi government "appropriated" them for the state. Late in the war, the works were moved to Schloss Immerhof, a remote castle, for safekeeping, but as Allied forces moved into the area in 1945, retreating SS troops set fire to the castle rather than allow it to fall into enemy hands. The paintings were destroyed.

Today, all that remains are some preliminary drawings, poor quality black-and-white photos of the three paintings, and one color photo of the figure of Hygieia from *Medicine*. Its brilliant golds and reds hint at the dynamic effects of the three lost artworks.

BREAKFAST CLUB

Klimt disliked being interrupted while working and refused to allow friends to come to his studio. Instead, he arranged visits during breakfast, a practice that became a ritual. Every morning, Klimt walked briskly to the Café Tivoli, where he was a regular. A lavish breakfast was spread before him including, according to one observer, "lashings of whipped cream." Friends were allowed to drop by and chat, but after that the artist returned alone to his studio, where he worked uninterrupted until dinner.

EDVARD MUNCH

DECEMBER 12, 1863–JANUARY 23, 1944

ASTROLOGICAL SIGN:
SAGITTARIUS

NATIONALITY:
NORWEGIAN

STANDOUT WORK:
THE SCREAM (1893)

MEDIUM:
FOUR PAINTED VERSIONS, INCLUDING OIL ON CANVAS AND OIL AND TEMPERA ON CARDBOARD, AS WELL AS A BLACK-AND-WHITE LITHOGRAPH

ARTISTIC STYLE:
EXPRESSIONIST

SEE IT YOURSELF:
TWO AT THE MUNCH MUSEUM IN OSLO, ONE AT THE NATIONAL GALLERY OF NORWAY IN OSLO, AND ONE IN A PRIVATE COLLECTION

"AM I IN HELL?"　　　　　　　**QUOTABLE**

*I*f you thought Vincent van Gogh held the record for Most Miserable Artist, then you don't know Edvard Munch. His life makes van Gogh's look positively gleeful. At least van Gogh had a happy childhood. The amazing thing about Munch is that he survived, and he ultimately found the strength to transform his suffering into expressive art. His most memorable expression of anguish is his painting and lithograph *The Scream*, a primal shriek at the universe.

In the end, the boy who never expected to live to adulthood died an old man of eighty, wealthy, secure, and honored. He never escaped his demons, but by putting them on canvas he bequeathed to the world an art that powerfully expresses human pain.

LOVE AND LOSS

Edvard Munch was the son of Christian Munch, an army doctor who met and married Laura Catherine Bjölstad while stationed in the small town of Løten, Norway, in the 1860s. Their first two children were born there: Sophie in 1862 and Edvard in 1863. The next year, the family moved to Kristiania (now Oslo), where they had three more children, Andreas, Laura, and Inger.

Laura Catherine probably had tuberculosis before she married, and Munch vividly remembered her coughing blood into a handkerchief. She died in 1868 with Edvard and Sophie at her bedside. The loss of his wife reinforced Christian's fatalistic, Calvinist tendencies, which he generously passed along to his children. So terrified of death and damnation was Munch that he would wake in the night afraid he had died—"Am I in hell?" he would ask himself. It didn't help that every winter he fell ill with fevers and bronchitis; when he was thirteen, he began coughing up blood. He pulled through, but a year later his sister Sophie wasn't so lucky. She died of TB at age fifteen.

WHEN LIFE SERVES UP LEMONS, MAKE ART

Munch found few escapes from the miseries of home, where loss was compounded by dire poverty. One pleasure was drawing: He liked to sketch with pieces of charcoal while seated on the hearth. But Christian viewed artists as godless bohemians, and he arranged for his son to train as an engineer. After a year, Munch told his father he wanted to study art. Despite vehement

disapproval, Munch enrolled at the Norwegian art institute. He showed immediate promise and might have mollified his father by painting tradition-ally, perhaps winning scholarships, selling paintings, and paying his own way. But no, Munch allied himself with the most radical artistic elements. He also got involved with a group of bohemians who read Nietzsche and advocated suicide. By 1885 he was having an affair with a married woman and needed a few drinks before breakfast just to quell last night's hangover.

In 1885 he began his first masterpiece, *The Sick Child*, a depiction of his sister Sophie on her deathbed. As he worked, tears flowed down his face; inspired, he took a bottle of paint thinner and sprayed the canvas so that streaks ran down the painting. Munch exhibited the painting in October 1886, hoping audiences would appreciate the work's emotional depth. Instead, it was ridiculed.

The wounded Munch had few sources of comfort. At home, his disap-proving father prayed for his soul while his sister Laura withdrew into fan-tasies and delusions, the first symptoms of her early schizophrenia.

One stroke of good fortune seemed to provide a means of escape when he was awarded a state scholarship to study in Paris, but even the City of Light proved no refuge. In November 1889, his father died, plunging Munch into despair. He wrote in his journal, "I live with the dead." He debated suicide.

ON CANVAS, EVERYONE CAN HEAR YOU SCREAM

Fortunately, Munch did not act on his suicidal thoughts. In a few short years, he received an invitation by the Association of Berlin Artists to do a one-man exhibition. When the show opened in November 1892, the reac-tion was as negative as ever. The association held an emergency meeting and voted to close the exhibit, but its younger members protested, break-ing away to form the Berlin Secession. Munch declared it "the best thing that could have happened to me." He remained in Germany, basking in the approval of new friends.

Munch still painted out of suffering, the subject he knew best, and in 1893 he began work on his most famous artwork. He wrote in his diary about a memory of walking in Kristiania some years before:

I went along the road with two friends—The sun set. Suddenly the sky became blood—and I felt the breath of sadness. I stopped—

leaned against the fence—dead tired. Clouds over the fjord drip-
ping reeking blood. My friends went on but I just stood trembling
with an open wound in my breast. I heard a huge extraordinary
scream pass through nature.

The setting for this experience was Ekeberg, a suburb north of Oslo that was home to the city's slaughterhouse as well as the insane asylum where Munch's sister Laura was incarcerated; the cries of dying animals were echoed by the screams of the insane. Munch painted a fetus- or mummy-like figure with an open mouth, hands clasped to its head. Two oblivious figures walk along a road to the left while the ocean spills out to the right. Above all is a blood-red sky. *The Scream* is an awesome expression of existential horror.

The painting became part of a series known as *The Frieze of Life*. Although intended to depict a universal "life of the soul," the series also functions as autobiography, including depictions of the death of Munch's mother and sister, his own near-death experience, and scenes from various love affairs. It's probably a safe bet Munch had no idea this image would live on in popular culture, appearing on coffee mugs, in slasher films, and on episodes of *The Simpsons*.

IS THAT A GUN IN YOUR HAND OR
ARE YOU JUST HAPPY TO SEE ME?

Munch had always been attractive to women. In fact, friends called him "the most handsome man in Norway." His relationships were typically complicated, a fact reflected in his paintings of women, where they are portrayed either as frail innocents or life-sucking vampires.

The most vampiric of his lovers by far was Tulla Larsen, a twenty-nine-year-old heiress who met Munch in 1898. The two tumbled into a love affair, but when Munch grew tired of her possessiveness and tried to leave her, Larsen stalked him across Europe. He finally got away and they spent almost two years apart, but Larsen tracked him down at his seaside cottage and moved into a house nearby. A letter arrived late one night: Larsen had attempted suicide. Munch found her lying in her bedroom, the picture of health.

Munch launched into his reasoned arguments about why they could never be together, but Larsen either wept or laughed in response (accounts

vary). Then, somehow, Munch ended up with a gun in his hand. His gun? Her gun? No one knows, and neither do we know why Munch picked it up, or whose finger pulled the trigger. What is known is that a shot was fired and a bullet shattered the middle finger of his left hand.

The artist healed, but his hand would always be disfigured.

I WANT TO BE ALONE

The good news: At this stage in Munch's career, no one laughed at his paintings anymore. Honors came, then commissions.

The bad news: Munch had begun to believe strangers were the secret police sent to follow him. He felt himself slipping into the insanity that had claimed his sister Laura. He had bouts of paralysis—a leg would go numb, or an arm. Finally friends rushed him to a hospital outside Copenhagen. Doctors diagnosed alcoholic paralysis, the result of damage to his nervous system from alcohol poisoning. Treatment with hot mud baths and mild electric currents probably had less impact than the enforced quiet and cessation of alcohol, but in any case when Munch was released the next spring, he was sober for the first time in a quarter century and more stable than ever before.

He traveled to Norway and moved into a large house on the coast, rarely straying from home again. His wealth allowed him to support his family in comfort, even though he couldn't stand to be in their company. When Laura died in 1926, Munch couldn't bring himself to openly attend the funeral; he hid behind trees in the cemetery.

World War I brought hardship, but Munch purchased a large property outside Oslo where he raised vegetables and kept chickens. He had a horse as well, named Rousseau, and so fond was he of the animal that it lived a charmed life as Munch's model.

Munch found himself hugely popular in his native land, but official honors and celebrations on his sixtieth and seventieth birthdays left him cold, and he irritably asked journalists seeking interviews to go away.

WHO YOU CALLING A DEGENERATE?

In the late 1930s, stories started trickling out about the art "reforms" that Nazis intended to impose in Germany. The failed art student Adolf Hitler considered all "modern" art (basically anything from Impressionism onward)

"unfinished" and, worse, a source of corruption. In 1937, the Führer authorized the purge from German and Austrian museums of anything remotely modern. A selection of the so-called degenerate art was brought together in June 1937 for the Entartete Kunst ("Degenerate Art") exhibition, known today as the most amazing show of modern art in history. Paintings by Vincent van Gogh, Henri Matisse, Pablo Picasso, and Munch were jammed onto the walls, hung at odd angles to emphasize their "crookedness," and accompanied by printed abuse from Nazi leaders. The show attracted huge crowds—two million in Munich alone.

Declared a "degenerate," Munch feared for his life when German forces invaded Norway in April 1940. Surprisingly, the Nazis instead attempted to win his favor. They invited him to serve on an honorary organization of Norwegian artists; Munch declined and waited for the police to break down his door. He was later ordered to leave his house, but the order was never carried out. Baffled and fearful, Munch continued to paint, concentrating on self-portraits and landscapes. He died on January 23, 1944, about one month after his eightieth birthday.

> THE RED SKY EDVARD MUNCH PAINTED IN *THE SCREAM* MAY HAVE TAKEN ITS HUE FROM THE ERUPTION OF THE KRAKATOA VOLCANO, WHOSE DUST CREATED RED TWILIGHTS THROUGHOUT EUROPE.

But Munch still had a surprise for the world. No one had been allowed in the second floor of his house for years, and when it was opened after his death, friends were astonished. Stacked from floor to ceiling were 1,008 paintings, 4,443 drawings, 15,391 prints, 378 lithographs, 188 etchings, 148 woodcuts, 143 lithographic stones, 155 copper plates, innumerable photographs, and all his journals. He had left the works unconditionally to the city of Oslo, and in 1963 the city opened the Munch Museum to house the collection. It was an astonishing legacy for a man who never expected to survive his childhood.

RED SKY AT NIGHT

That ominous red sky in *The Scream* is usually interpreted as an artistic invention, but it might have been the color of an actual sunset. How? Because of the eruption of the volcano Krakatoa in August 1883, which threw twenty-five cubic kilometers of rock and ash into the sky. The dust that remained in the atmosphere circled the globe, and by November vivid red twilights were reported all over Europe. Munch didn't paint the work until 1893, but his journals make it clear he was drawing on an event from several years earlier. When scientists located the exact vantage point Munch reproduced in his work, they found the view of the sky was toward the southwest, exactly where the Krakatoa twilights were reported.

ROBBERY IS THE SINCEREST FORM OF FLATTERY

The Scream has the dubious distinction of being one of the most stolen paintings in the world. Twice different versions of the work have been robbed from museum walls. The first theft occurred February 12, 1994, the same day the 1994 Winter Olympics opened in Lillehammer, Norway. The painting was stolen from the Norwegian National Gallery by two men who took fifty seconds to climb a ladder, smash a window, and cut the canvas from the wall. A month later, the painting was offered back for a $1 million ransom, but the museum refused to pay. In May an undercover sting operation recovered the work, and it was returned to the National Gallery, where it hangs to this day.

The second heist took place in August 2004 at the Munch Museum. Two masked men walked into the gallery, where one held museum staff, security guards, and stunned visitors at gunpoint while the other yanked *The Scream* and *Madonna*, another Munch painting, from the wall. The two theives fled in a waiting car. Even though three men were convicted of involvement in the crime in early 2006, it wasn't until later that year that the paintings were recovered. They were reinstated in the Munch Museum—after the institution closed for ten months for a $6 million security overhaul.

CHILD ABUSE

Munch loved his paintings, calling them his "children" and resisting efforts to remove them from his grasp. But seeing as his business was selling paintings, this proved just a wee bit of a problem. He took up printmaking for the sole purpose of making works he could sell while retaining the original. But his affection for his paintings didn't mean he cared for them very well. Particularly in his later years, he preferred to paint in outdoor studios, where he surrounded himself with finished works, exposing them to wind, rain, sun, and snow, much to the horror of visitors. Munch shrugged, saying that a year in the sun and rain would allow a painting to "collect itself."

Once a friend found a large oil canvas pierced by a gaping hole. Munch said casually that one of his dogs had run through it. When the visitor protested that Munch shouldn't let his life's work lie around unprotected, he replied, "It does them good to fend for themselves."

HENRI MATISSE

DECEMBER 31, 1869–NOVEMBER 3, 1954

ASTROLOGICAL SIGN:
CAPRICORN

NATIONALITY:
FRENCH

STANDOUT WORK:
THE DANCE (1910)

MEDIUM:
OIL ON CANVAS

ARTISTIC STYLE:
FAUVE

SEE IT YOURSELF:
MUSEUM OF MODERN ART, NEW YORK, AND
THE HERMITAGE, ST. PETERSBURG, RUSSIA

QUOTABLE
*"WHAT I DREAM OF IS AN ART OF BALANCE,
FULL OF PURITY AND SERENITY . . .
SOMETHING LIKE A GOOD ARMCHAIR."*

A raging animal—that's what Henri Matisse's enemies called him. A *fauve*, or "wild beast"—all because of his bright colors and unconventional forms. So in later years, when visitors arrived at his door expecting a maniac with a matted beard, they were surprised to be greeted by a genial gentleman wearing spectacles and a tailored suit. They wrote shocked letters to friends, saying, "Matisse isn't an animal after all!"

Nor, really, is his art all that wild. Matisse sought, above all else, serenity, a refuge from the troubles of the world. Few patrons in his era could perceive that serenity, and others argued that art should challenge viewers. Nevertheless, the joyous paintings of a man labeled a wild beast now bring solace to people worldwide.

SOWING THE SEEDS OF AN ARTIST

Matisse's parents were hard-working folk who ran a general store and seed-supply business in the small town of Bohain, France. They intended their oldest son, Henri, to take over the business when he grew up. When Henri's dreamy disposition ruled out a career as a shopkeeper, his disappointed family sent him to Paris for a year of legal training and, on his return, established him as a law clerk.

Matisse was bored out of his mind. He took to pelting passersby from his window with a peashooter and spit balls. Tension with his father wore down his nerves to the point that he collapsed from strain and ended up in the hospital. There he noticed the patient at the next bed idly copying landscapes in oils. Desperate for distraction, he asked his mother to get him a set of paints. His first attempt at copying a lithograph electrified him: "From the moment I held the box of colors in my hand, I knew this was my life." He enrolled at a local art academy, but what he really wanted was to study in Paris. After a battle with his father, Matisse arrived in the capital in October 1891.

I LOVE YOU THIRD BEST

The first few years were rough, and he had to struggle to establish himself as well as stretch his small allowance to cover things like, well, food. Nevertheless, Matisse quickly mastered the academic technique and received official tributes. He even acquired a pretty girlfriend/model in Camille Joblaud; they had a daughter, Marguerite, in 1894. But just as a staid academic career seemed

within his grasp, Matisse rejected it. He started experimenting with bold colors, strong lines, and contemporary subjects. Camille was horrified—why throw away a sure thing? She left Matisse in the summer of 1897.

And none too soon. That October, on a visit home, he met the spirited Amélie Parayre. Amélie, the daughter of idealists and intellectuals, was on the lookout for a cause, and she found one in Henri. He was smitten, but his recent experience with Camille had made him realize life with an artist had a cost. "Mademoiselle, I love you dearly," he told her, "but I shall always love painting more."

Amélie didn't seem to mind; in fact, after they married she devoted her energy to freeing her husband from domestic cares. Nothing could interfere with his work. Two sons, Jean, born in 1899, and Pierre, born in 1900, were shipped off to grandparents so they wouldn't disrupt the studio; young Marguerite took over household duties her adoptive mother didn't have time to perform because she was busy prepping canvases.

BEAST ON THE LOOSE!

Matisse struggled, meanwhile, to find his artistic voice. He had a breakthrough in 1905 with *Portrait of Mme. Matisse*, which shows Amélie in a reddish-pink dress against blocks of green, red, and lavender, with a green line extending from her forehead to her chin. The green is neither the real color of Amélie's nose (presumably) nor an indicator of an emotion like jealousy. Rather, its sole function is as a color: Matisse was interested in how it interacted with the other colors on the canvas.

He was seeking, ultimately, a new sort of harmony using color, but audiences saw nothing harmonious in the work. At that year's Salon d'Automne, the portrait contrasted strangely with an academic sculpture on display in the same gallery, and a critic noted that the sculpture was "a Donatello among the wild beasts"—*fauves* in French. The comment spread, and soon reviews depicted Matisse as an animal trampling artistic convention.

The mortified artist feared his innovations had doomed him, but in fact they proved an introduction to a new world of avant-garde artists and collectors, including Leo and Gertrude Stein and the Russian Sergei Ivanovich Shchukin, whose generous commission encouraged Matisse to stretch himself artistically. For one painting, Matisse drew on the memory of Catalan fishermen he had seen dancing on the Mediterranean coast. On an undulat-

ing surface against a brilliant sky, he painted five dancers linking hands. The simplicity of *The Dance* gives it a primal energy. Its three colors— blue, green, reddish brown—pulse against one another. Contemporary critics saw the painting as bestial and primitive, and Shchukin nearly backed out of the deal. Only later would *The Dance* become one of Matisse's most recognizable works.

TORN BETWEEN TWO LOVERS

The World War I years were difficult; both Matisse sons were conscripted, and Matisse, then forty-five, tried to enlist but was rejected. During the war, he established himself in the Cimiez, a suburb of Nice on the French Riviera that remained his primary home through the 1920s and 1930s. Amélie grew increasingly ill; life in service to an artist had taken its toll. When Matisse took the commission to paint a new, enormous version of *The Dance* in 1931, she stayed in bed for three years.

Meanwhile, Matisse simply found himself a new caretaker, the sternly efficient Russian emigrée Lydia Delectorskaya. When Amélie gathered the strength to join her husband in Nice, she discovered "that Russian woman" had taken over. Amélie issued an ultimatum: Either Lydia goes, or I go.

A bewildered Matisse remained stubbornly loyal to Delectorskaya. (Outsiders assumed they were sleeping together, but their letters make this seem unlikely.) Henri and Amélie separated in February 1939, with Amélie demanding Matisse hand over half his paintings. She considered them as much her creations as his.

As World War II loomed, Matisse witnessed the German invasion of France and the evils of fascism. Some artists—like Pablo Picasso—chose to depict the anguish of war or confront the Nazi menace. By contrast, Matisse continued creating soothing, decorative works. Some criticized this decision as an abdication of responsibility at a time of war, but he insisted that art should provide solace and "relaxation from fatigue."

CUT IT OUT

It became increasingly difficult to maintain such emotional distance, and Matisse fell ill with duodenal cancer, undergoing risky surgery in 1941. Weakened, he found it difficult to hold a brush, so he started cutting colored paper and placing the pieces onto blank canvases for Delectorskaya to

pin in place. Eventually, the collages became an end in themselves, with Matisse thrilled by the paper's bright, pure colors. He eventually compiled a book of collages, *Jazz*, published in 1947. Later the same year, Matisse tackled a new medium when he was commissioned to design a chapel in Cimiez full of stained glass that would flood the interior with jewel-toned light. Rosaire Chapel was dedicated in June 1951, with even the most conservative nuns agreeing that the work was sublime. However, the strain had weakened Matisse's heart. He continued to sketch until the day before his death on November 3, 1954. Delectorskaya left the Matisse home immediately, and Amélie arrived to take charge of her husband's legacy.

Matisse is now recognized as one of the founders of Modernism, along with Pablo Picasso. They represent the two sides of the Modern impulse: Where Picasso introduced innovations of line and form, Matisse pioneered the free use of color. His influence can be traced to twentieth-century artists who conducted even more radical experiments, such as Mark Rothko, whose nonrepresentational canvases are composed only of fields of color.

Meanwhile Matisse reproductions hang over armchairs and sofas, providing solace and serenity in a troubled world.

HENRI MATISSE WAS SO BORED WORKING AS A LAW CLERK THAT HE TOOK TO HARASSING PASSERSBY FROM HIS WINDOW WITH A PEASHOOTER AND SPITBALLS.

SACRED OR PROFANE

Toward the end of his life, Matisse longed to create something monumental to serve as his legacy, and he was profoundly disappointed when no one requested that he design a museum, state building, or other significant structure. So when the opportunity to create the Rosaire Chapel presented itself, he jumped on it, much to the surprise of friends, who knew him as a life-long atheist. A baffled Pablo Picasso inquired, "Why not paint a brothel, Matisse?" To which the artist replied, "No one asked me."

LADIES AND GENTLEMAN OF THE JURY, I GIVE YOU HENRY HAIRMATTRESS

The paintings of the Cubists and Fauves provoked an out-raged—even violent—reaction when they were first presented to Americans in 1913 at the famous Armory Show. Held at a New York armory building, the exhibition was sponsored by several prominent U.S. artists who felt their fellow citizens needed to see the art that was sweeping Europe. They organized a vast collection of works by leading Impressionists, Post-Impressionists, Symbolists, Cubists, and Fauvists.

The reaction? Shock, horror, and laughter. Audiences were stunned and artists overwhelmed; critics variously described the show as a bomb or an invasion. When it moved on to Chicago, students and faculty at the Art Institute of Chicago were so outraged by Matisse's unconventional use of color and "distortions" of human form that they held a mock trial of "Henry Hairmattress" and burned copies of three paintings. Apparently, the museum got over it. Today its collection contains forty-two works by Matisse.

CLOSING THE BARNES DOOR

Matisse's complex relationship with America took another dramatic turn when he met Albert Barnes, a wealthy and eccentric inventor who developed a passion for art education and accumulated a vast holding of paintings and sculptures. He created the foundation that bears his name in 1922, building a large school/museum in the Philadelphia suburb of Merion, Pennsylvania.

In 1931, Barnes asked Matisse to paint an enormous mural for three large arches in the building's great hall. The work would be larger than anything Matisse had ever attempted, a stunning 47-by-11 feet. Matisse threw himself into the work, constructing rolling ladders and special long-handled brushes to finish the project, a reinterpretation of his earlier *Dance*. When art and artist arrived in Merion in 1933,

Matisse watched the installation in an atmosphere so tense he actually suffered a minor heart attack. He felt relieved when the three works were finally in place, but then Barnes announced he had no intention of letting anyone see them. The paranoid Barnes allowed no one to enter the foundation without his permission, which he refused categorically to the press, collectors, and curators. Matisse was devastated.

Barnes died in 1951, leaving behind a strict will that mandated his collection remain exactly as he left it, complete with his unconventional approach to hanging paintings (he grouped works not by period or artist but by perceived theme), operation (the museum can open to the public only twice a week), and location (the art was never to leave the foundation headquarters). Recent Barnes Foundation board members found these terms so restrictive that they threatened the financial future of the collection, so in 2002 the board began a contentious legal battle to break the will, finally succeeding in 2004. Today, the Barnes is designing a new museum on the Benjamin Franklin Parkway near other Philadelphia cultural institutions. The Matisse murals will be relocated along with the rest of the Barnes's collection.

Somewhere, Albert Barnes is very, very angry.

SPOILS OF WAR

As the Nazis gained power in Germany and started their purge of "degenerate" art, Matisse was among those who came under attack. His work was yanked from museums all over Germany and later auctioned to provide the regime with foreign currency. The most famous of these sales, the Fischer auction, took place on June 30, 1939, in the Swiss city of Lucerne, with paintings by artists from Vincent van Gogh to Pablo Picasso on the block.

The art community was conflicted. Should they rescue this art from destruction or stay away to protest the proceedings? Many museums boycotted the sale, but representatives of the Brussels Museum of Art decided their higher duty was to save the art, and they left with a fabulous cache of Gauguins, Picassos, and Chagalls.

Also in attendance was Pierre Matisse, the artist's son, bidding on behalf of Joseph Pulitzer; Matisse was particularly concerned to retrieve his father's 1908 *Bathers with a Turtle*. The auctioneer, clearly in sympathy with the Nazis, made

slighting comments and sneered at buyers, but at the end of the day, Matisse and Pulitzer left with the painting, purchased for a pittance. Today the work hangs in the Saint Louis Art Museum, a gift of the Pulitzer family.

HEADACHES OVER HONOR

In the early 1920s, Matisse's son Pierre fell in love with one of the students of his school-teacher aunt. His beloved, Clorinde Peretti, was the daughter of a wealthy Corsican family. Pierre followed family custom by formally asking Clorinde's father for her hand in marriage, but the proud papa refused, noting (accurately) that the young man had no visible means of support. So Clorinde ran away from home, and she and Pierre eloped.

The next few months quickly disintegrated into a nightmare. Clorinde had never before lifted a finger and couldn't imagine life without an army of servants. For his part, Pierre expected his wife to pitch in and maybe, oh, cook once in a while. They split after only two months of marriage.

Pierre's life was soon in danger. Arch-conservative Corsicans took honor seriously, and Clorinde's father swore, duty-bound, to seek revenge on the man who had abandoned his daughter. A knife in the back was a real possibility if Pierre remained in France, so the family devised a plan: Send Pierre to New York. He established himself as a dealer there, far away from maddened Corsican fathers, and in time became widely credited for bringing to the American market works by not only his father but other modern masters as well.

PABLO PICASSO

OCTOBER 25, 1881–APRIL 8, 1973

ASTROLOGICAL SIGN:
SCORPIO

NATIONALITY:
SPANISH

STANDOUT WORK:
GUERNICA (1937)

MEDIUM:
OIL ON CANVAS

ARTISTIC STYLE:
MODERN/CUBIST

SEE IT YOURSELF:
MUSEO REINA SOFIA, MADRID

"PAINTING IS NOT THERE MERELY TO DECORATE THE WALLS OF FLATS. IT IS A MEANS OF WAGING OFFENSIVE AND DEFENSIVE WAR AGAINST THE ENEMY."

QUOTABLE

Who *is* this guy? He's larger than life, bigger than big, impossible to get your head around. Try to talk about his art, and you have to decide which Pablo Picasso you're dealing with: the ground-breaking inventor of Cubism, the neoclassical artist of the 1920s, or the political painter of the 1940s?

His personal life is no more coherent. Is the real Picasso the womanizer with the endless stream of lovers? The hard-hearted jerk one former mistress called "morally worthless"? The bitter old man who refused to see his own children? Or the charismatic lover, beloved husband, and loyal friend?

To try to understand Picasso you must view him as you would one of his Cubist portraits. Just as in Cubism you often see both sides of a face in profile, with Picasso you need to see all sides of the artist all at once. It's no easy task, holding this baffling, intimidating man in your mind. But whoever said Cubism was easy?

PARSING PABLO

Picasso was christened with the lofty (and lengthy) name Pablo Diego José Francisco de Paula Juan Nepomuceno María de los Remedios Cipriano de la Santísima Trinidad Clito Ruiz y Picasso—but let's stick with plain ole Pablo. He was raised by a pack of women, including his strong-willed mother, grandmother, four aunts, several cousins, and two sisters, all of whom indulged him to a ridiculous extreme. His father, José Ruiz, was himself an artist of indifferent talent who worked as a curator of a regional museum; he taught his son to draw, and by the time Pablo was twelve he had so outstripped his own talent that Papa handed over his brushes and never painted again. Later, Pablo took to signing his paintings with his mother's name, Picasso, rather than his father's, perhaps as an homage to his mother's primal strength.

By age thirteen, Picasso was enrolled at art school in a class of twenty-year-olds. After stints at academies in Barcelona and Madrid, he moved to Paris. Speaking no French and dead broke, he barely survived, eating little and rooming with friends in miserable apartments. Eventually he could afford his own apartment, which he shared with his new lover, Fernande Olivier, and a menagerie of dogs, cats, mice, and a small ape. (Picasso loved his pets but didn't take particularly good care of them. They had to fend for themselves for food: When an enterprising cat brought home a sausage, it fed the whole household.)

THE BEST LITTLE WHOREHOUSE

Picasso painted for several years in solemn tones of blue, a time that hence-forth became known as his Blue Period, which in turn was followed by the slightly more cheerful Rose Period. Over the years, his lines became bolder, and he began using simple shapes such as ovals, triangles, and circles to depict objects and figures. About the same time, Picasso was introduced to African art and became entranced by the powerful forms and bold abstractions of ceremonial masks. These two influences—geometric abstraction and African masks—came together in a revolutionary painting from late 1907, *Les Demoiselles d'Avignon*, named for the Avignon Brothel, a whore-house in Barcelona.

The painting shows five prostitutes presenting themselves for inspection to clients. *Les Demoiselles* is composed in harsh-edged shapes. A breast is a jagged triangle and a leg a jutting block; several of the women's faces resemble African masks. Even Picasso's most ardent supporters were flab-bergasted by the painting. The collector Leo Stein dismissed it as "amus-ing"; Stern's sister Gertrude called it "a veritable cataclysm"; and dealer Ambrose Vollard described it as "the work of a madman." Even now, with eyes trained by a century of Modernism, the painting is still challenging. Picasso calls into question the entire tradition of painting the female nude. He deliberately evokes icons of beauty, and then demolishes them.

CUBISM MEANS NEVER HAVING TO ADMIT YOU'RE A SLOB

Les Demoiselles pointed the way toward Picasso's next artistic period. In fall 1908, he and his friend Georges Braque submitted to the Salon d'Automne several paintings that completely ignored perspective, shattering their subjects into multiple flat surfaces. Henri Matisse made a slighting comment about how the paintings were just "little cubes." The term caught on, and thus Cubism was born.

In Cubism, subjects are broken up and reassembled in geometric forms; because no single viewpoint is given precedence, you might see the front and the side of an object at the same time. Cubism quickly became the first "-ism" in modern art: Hordes of artists furiously debated its proper aims and approaches, and before long the style became loaded with rules and intellectual theorizing, little of which Picasso endorsed.

At least by now he was making enough money to move into a decent apartment, although he remained as much a slob as ever. Friends describe the artist living among towering piles of papers, receipts, canvases, empty bottles, and crusts of bread through which tiny paths gave access to the bathroom or the easel.

ALL ABOUT THE WOMEN

Fernande, meanwhile, drifted away from their filthy nest, and Picasso began an affair with Marcelle Humbert, whom he called Eva. The outbreak of World War I shattered his circle of artists, and life grew more dismal when Eva died of tuberculosis in 1916. A distraction presented itself the next year when Picasso designed sets and costumes for the Ballets Russes, along the way falling in love with the Russian dancer Olga Koklova. They married in 1918.

The end of the war and Olga's pregnancy (a son, Paulo, was born in 1921) brought out a desire for traditionalism in Picasso. He entered a neo-classical period, painting scenes of mothers and children and images from Greek mythology. By the mid-1920s, however, his relationship with Olga had deteriorated into a series of tantrums, scenes, and sulks. The couple formally separated in 1927, but Picasso refused to divorce her because, under French law, the two would split his now considerable estate.

Instead he started a new affair with a Frenchwoman named Marie-Thérèse Walter, with whom he had a daughter, Maia. That didn't stop him from also taking up with a talented photographer named Dora Maar in 1936. He first saw Maar at the popular café Deux Magots; she took off her gloves, laid her hand on the table, and stabbed between her fingers with a sharp knife. When she missed, blood spurted into the air. Picasso was entranced.

TAKING A STAND

Picasso had celebrated the creation of the Spanish Republic in 1931, and he despaired at the outbreak of the Spanish Civil War in 1936, particularly when Nationalist forces besieged his hometown, Málaga. In April 1937, the undefended village of Guernica was hit by wave after incendiary wave of Luftwaffe bombers. It's a sad statement that today 1,600 casualties doesn't seem like that many, but in 1937 it was profoundly shocking. Picasso suddenly felt thrust into a fundamental battle between good and evil. He had previously been asked to paint a large mural for the Spanish

pavilion of the Paris International Exhibition, and he decided to depict the horrors of the bombing.

The result is the enormous canvas *Guernica*—nearly 11½ tall by 25½ feet long. Painted in black, white, and gray, the painting deliberately evokes newspaper photographs and shares the same startling documentary quality. Surrounded by wailing women, a soldier lies broken on the ground like a statue hewn into pieces. A wounded horse screams, and a menacing bull advances from the left. Above it all, an electric light bulb shines as an all-seeing eye. Two touches of hope are a candle held by a swooping woman and a small flower growing beside the fallen soldier. With *Guernica*, Picasso became the inheritor of Francisco Goya's legacy, using all the techniques of Modernism to paint the truth of human suffering.

He felt he had found his calling in fighting the forces of evil through his art, but the stakes were raised when German forces broke through the Maginot Line and invaded France. The danger to Picasso was real. He had taken a public stand against fascism, his work had been proscribed as "degenerate," and he was suspected (incorrectly, but not that it mattered) of being Jewish. His first instinct was to flee to the Atlantic coast, and he could have escaped to England, the United States, or South America. Instead, he deliberately returned to Paris. It was the most courageous decision of his life.

Picasso endured an endless parade of German officials trooping through his studio. They checked, double-checked, and triple-checked his papers; they questioned him about the whereabouts of Jewish artists. Picasso simply smiled and handed them postcard reproductions of *Guernica*. According to lore, once the German ambassador picked up a postcard and sneered, "So you did that, Monsieur Picasso?" "No," Picasso said, "You did." Although most biographers discount the story, it's easy to imagine the brash artist taking such a bold stand.

STURDY OLD GOAT

Somehow, Picasso survived the Occupation, and the Liberation of Paris marked the beginning of a period of remarkable fame. He became the first art celebrity, and some critics say his work suffered as a result. The style of his later years is varied; he completed political pieces similar to *Guernica*, Cubist-influenced paintings, and colorful landscapes that are almost Matisse-esque.

One of his most memorable later works is a bronze sculpture of a pregnant goat titled *La Chèvre* (She-Goat). Constructed from discarded materials including cardboard, plaster, broken jugs, and a worn-out basket for the belly, the work is perversely fun, with the goat appearing both absurd and defiant.

The artist's personal life continued to be complicated. About 1944, he had begun a long affair with Françoise Gilot that produced two children, Claude and Paloma, but she became annoyed by Picasso's affairs and left him in 1953. His next long relationship was with Jacqueline Roque, whom he met when she was twenty-seven and he seventy-two. They married in 1961, a few years after Olga's death. Jacqueline worshipped her husband—she liked to kiss his hands and referred to him as "The Sun"—and his children and friends complained that she shut them out of his life. In truth, he had developed a passion for privacy, especially after Gilot published a highly unflattering book about him.

Picasso remained remarkably healthy and energetic until the late 1960s, dying of heart failure in April 1973. His output was staggering. He left behind him some 1,900 paintings, 3,200 ceramics, 7,000 drawings, 1,200 sculptures, and 30,000 graphic works. Equally amazing is his influence, as profound as that of Michelangelo four centuries years earlier. Every artist since has had to acknowledge his work, either by building upon it or by renouncing it. No matter what your opinion of Picasso, you have to admit that, after him, Western art was never the same.

MORAL CORRUPTION

Picasso lived a tornado of a life, leaving a trail of devastation in his wake. Dora Maar had a nervous breakdown when he left her for Françoise Gilot. Paulo, his eldest son and namesake, never found any career or pursuit other than as his father's chauffeur and ended up a hopeless alcoholic. Gilot's children Claude and Paloma were shut out of their father's life after their mother's tell-all book; his last wife, Jacqueline, even banned them from their father's funeral.

The anguish didn't stop with Picasso's death. Marie-Thérèse Walter hanged herself, and Jacqueline Roque Picasso shot herself.

Even the next generation was affected: Paulo's daughter Marina penned a book blaming her miserable childhood on her grandfather, and her brother Pablito killed himself by drinking peroxide. Dora Maar might have been on to something when she said to Picasso, "As an artist you may be extraordinary, but morally speaking you're worthless."

LIFE IMITATES ART

Picasso's close friendship with writer Gertrude Stein not only brought him a generous patron and an open invitation to the most fascinating salon in Paris, it also prompted one of his early masterpieces. He began a portrait of Stein in 1905 but struggled with her face, and after as many as ninety sittings he painted it out, much to Stein's disappointment.

He then left on a vacation to Spain, where he produced canvases emphasizing a new angularity and geometry. On his return, Picasso returned to the portrait and repainted Stein's face. Her features became a mask, with the mouth a firm line, the cheek an oval, and the eyes asymmetrical almond shapes. Her friends hated the painting but Stein liked it, claiming, in her usual tortured prose, "It is I, and it is the only reproduction of me which is always I, for me."

When friends noted to Picasso that the painting didn't look like Stein at all, he replied simply, "It will." He was right. As Stein aged, her features increasingly resembled those of the painting.

GRAND THEFT PICASSO

You may remember the most famous art heist in history from a previous chapter—the theft of the *Mona Lisa* in 1911. But did you know that Pablo Picasso was, however incidentally, involved?

It started a few years before, when Picasso's good friend, the poet Guillaume Apollinaire, befriended a rakish Belgian named Géry Piéret and employed him occasionally as a secretary. In 1907, Piéret visited the Louvre and walked out

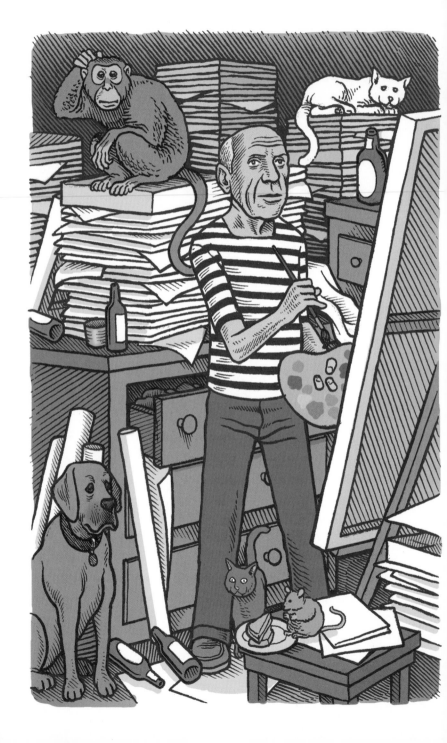

with two small stone Iberian sculptures hidden under his coat (museum security wasn't what you'd call "tight" in those days). He gave the statutes to Apollinaire, who presented them to Picasso. In 1911, when Piéret lost a lot of money at the racetrack, Apollinaire bailed him out; in gratitude, Piéret stole another Louvre statue and gave it to the poet.

A few days later, news of the missing *Mona Lisa* hit the headlines. Piéret decided he could make some money out of the situation, so he took his most recent looted artwork to a newspaper, telling a colorful tale about how he had stolen it to prove the ineffectiveness of museum security. Of course, the police got the whole story out of him, and within days Picasso and Apollinaire were in prison.

The two men immediately confessed to everything, and the Paris cops realized the hapless poet and artist had no connection to the *Mona Lisa* case. They were released within days on the condition that they return the stolen statues. To this day, the statues' official catalog descriptions note that they were "temporarily in the possession of M. Picasso."

A TOTAL SLOB, PABLO PICASSO WORKED AND LIVED AMID TOWERING PILES OF PAPERS, RECEIPTS, CANVASES, EMPTY BOTTLES, AND CRUSTS OF BREAD—ALONG WITH A MENAGERIE OF DOGS, CATS, MICE, AND EVEN A SMALL APE.

OUR BOMBS ARE SO MUCH SMARTER NOW

Guernica undoubtedly had power in its time, exposing the brutality of fascist war, and it has lost none of its punch in the interceding years. In February 2003, U.S. Secretary of State Colin Powell appeared before the United Nations Security Council to explain the U.S. rationale for war with Iraq. After his presentation, he and Security Council members walked into a hallway to speak to reporters. Television reports later showed Powell and other international leaders standing before a large blue curtain. Behind that curtain? A reproduction of *Guernica*. Apparently, U.N. officials thought it would be "inappropriate" to talk about starting a new war against the backdrop of the most iconic representation of war's outrages. Good call.

AFRICAN ART

The story goes that in 1906 Henri Matisse was on his way to visit Gertrude Stein when he spotted a small African artwork in the window of a curio shop. Transfixed by its powerful abstract form, he purchased it. He arrived at Stein's apartment to find Pablo Picasso at work on Stein's portrait. Matisse showed off his find, and Picasso was so enthralled that he visited the Paris Ethnographic Museum to see more African art, taking particular interest in West African masks.

Picasso said the experience transformed him: "Then I understood what painting really meant. It's not an aesthetic process; it's a form of magic that interposes itself between us and the hostile universe, a means of seizing power by imposing a form on our terrors as well as on our desires." He wasn't too far off: The ceremonial masks have ritual purposes far beyond aesthetics. Usually worn with elaborate regalia, masks are used in such rites of passage as initiating young men or women into a tribe or welcoming spirits of ancestors back to the community.

What Picasso and most other Europeans misunderstood about African art was its sophistication. Entrenched racial biases meant Europeans downgraded anything African as "primitive" and believed the masks' abstracted features were the result of lack of ability. In fact, all African masks and sculptures are the products of long-established cultures that, although different from those of the West, have their own sophisticated and complex modes of thought. They express entire realms of spiritual wisdom about the forces of the natural world and the power of relationships. ■

EDWARD HOPPER

JULY 22, 1882–MAY 15, 1967

ASTROLOGICAL SIGN:
CANCER

NATIONALITY:
AMERICAN

STANDOUT WORK:
NIGHT HAWKS (1942)

MEDIUM:
OIL ON CANVAS

ARTISTIC STYLE:
AMERICAN REALISM

SEE IT YOURSELF:
ART INSTITUTE OF CHICAGO

"WHAT I WANTED TO DO WAS PAINT SUNLIGHT ON THE SIDE OF A HOUSE."

QUOTABLE

You may have noticed a trend in the last dozen or so artists: Either they were French, or they moved to France to study art. It's not surprising, really, that Paris was the birthplace of Modernism.

Edward Hopper went to France, too. He was in his early twenties, fresh out of art school, and primed for inspiration. He came home quoting French poetry; he was infused with Impressionism; he was ready to paint masterpieces. Except he didn't.

No, for Hopper to succeed he had to unlearn everything French. He had to embrace who he was—an American—and discover how to paint from his national identity. The result was seminal art that captures the essence of the American city.

AD NAUSEUM

The Hoppers were modest shop owners in Nyack, New York, in the Hudson River valley. Devout Baptists, they raised their children Edward and Marion to avoid drinking and dancing. When Edward showed artistic promise, they agreed he should further his talent as a professional illustrator; the thought of their son becoming a professional artist was simply too outlandish. So they signed him up for the Correspondence School of Illustrating in New York. Young Hopper chafed at the school's mechanical approach, and the next year he convinced his folks he could do better at the New York School of Art, where, in short order, he moved away from illustration and into fine art.

After six years, Hopper felt it was time to study in Paris. American artists still looked to Europe for inspiration, and the most renowned worked in Paris and London. Hopper's mother took some convincing, but in the end she arranged for her son to board at the Baptist mission in Paris—no slumming it in Montparnasse for her Eddie. He dutifully sent home letters detailing the quality of his meals and the status of his underwear.

Hopper made three trips to Europe over the next four years. His art became thoroughly Frenchified as he took on both the light brushwork of the Impressionists and their contemporary settings. On his return, he eagerly showed his work depicting Parisian cafés. No reaction. He sold one painting in 1913, a single success followed by ten long years of failure. Forced to support himself through the commercial art his parents had thought so promising, Hopper grew to abhor the work, and hated even more the process of marketing himself to potential clients. He reportedly had to

walk around the block of an advertising agency several times before he could bring himself to go inside.

URBAN RENEWAL

On vacation in Gloucester, Massachusetts, in the summer of 1923, Hopper ran into the artist Josephine Nivison, a friend from art school. A modern woman who had graduated from college, taught school, and acted professionally, Jo shared Hopper's love for all things French and his devotion to an artistic life. The next May the two married. They made an odd couple: Forty-one-year-old Hopper was a gangly six-foot-five; forty-year-old Jo was barely five feet tall and weighed less than one hundred pounds.

Marriage wasn't the only turning point in 1923. Hopper had also developed an interest in printmaking that paid off with invitations to exhibit. The prints opened the door for his watercolors and oils, and soon he was able to stop commercial illustration forever. He gradually cast off his French style and began to focus on American settings, such as the New England coast, with its white-painted lighthouses. Another preoccupation was the American city—not, mind you, glamorous skyscrapers and monuments but brownstone apartments, pharmacy storefronts, and dingy offices. Once Hopper embraced these uniquely American scenes, his popularity took off. It seemed Americans were hungry for images of their own experience.

SCENES FROM A MARRIAGE

By the 1930s, the Hoppers' lives took on a predictable rhythm. Winters were spent at their fifth-floor walk-up (seventy-four stairs!) in Greenwich Village that featured the scant comforts of a coal stove and communal bathroom. Come summer they traveled to the Southwest or Mexico, returning to Cape Cod, Massachusetts, where they lived in a tiny cottage until early fall.

Jo managed her husband's accounts and posed for all his female figures, but their relationship was stormy. The chatty Jo found Hopper's endless silences annoying, and Hopper resented her reluctance to take on household responsibilities. Even though when courting he had admired her independence, he expected his wife to transform into an old-fashioned homemaker churning out pies. Sex was another difficulty. Jo, a virgin when she married, complained about Hopper's sexual insensitivity. Most contentious was her painting. Hubby didn't respect her talents and didn't bother

to hide that fact. Frankly, Jo wasn't much of an artist; although technically competent, her paintings of flowers and cats lean dangerously into the realm of sap. But Hopper showed his mean streak by publicly mocking her—and all women artists—as incompetent. It's tempting to read into his paintings an expression of his conflicts with Jo. Rarely do the individuals relate to one another, and his couples seem particularly disconnected.

DON'T CALL ME SHIRLEY

The outbreak of World War II terrified Jo, who packed an emergency bag in case they had to evacuate the city. Hopper remained outwardly resolute, but the tensions found expression in his art. Although not obviously related to the war, *Night Hawks*, his most famous work from 1942, distills the anxiety of the times. The patrons at an all-night diner sit mournfully over their coffee cups. They are trapped inside a fishbowl of light as the plate-glass windows send an artificial glow blazing into the dark street. The details are exact, down to the waiter's white cap, and the light has the greenish cast of early fluorescent fixtures. The scene could be entirely innocent, but the lack of communication between the figures, along with their hard faces and ambiguous gestures, lends the scene an ominous feel.

ONCE, OUTSIDE A CAPE COD RESTAURANT, DINERS WERE TREATED TO THE SITE OF EDWARD HOPPER WRESTLING HIS WIFE, JO, OUT OF THE CAR BY HER LEGS AS SHE CLUNG TO THE STEERING WHEEL.

Since Hopper provides no narrative, as viewers we feel compelled to invent one. Such is the case with many of his paintings. Take *Office at Night*, in which a man sits at a desk while a woman stands at a filing cabinet. It's easy to invent a sordid tale of intrigue straight out of a film noir. (In fact, noir movie directors loved Hopper's paintings and often turned to them for visual inspiration.) Hopper detested story-telling about his paintings, saying of *Office at Night*, "I hope it will not tell any obvious anecdote, for none is intended." But even Jo found it hard to resist; she even named the secretary Shirley.

FINAL BOW

The end of World War II saw the rise of Abstract Expressionism, whose brutal nonrepresentation was epitomized by Jackson Pollock's drip paintings. Hopper stubbornly continued with his own realism, deriding the "gobble-dygook" of abstract art. His paintings over the next decades became even more stripped down, with some depicting only the pure geometry of sunlight in an empty room.

Bad health troubled Hopper in the 1960s, but he worked as long as he could. He chose for his last painting (and he knew it would be his last) *Two Comedians*, which shows a couple from commedia dell'arte on stage at the end of a performance: he and Jo, bowing out. Hopper died in his beloved Greenwich Village apartment in May 1967. Despite all the turmoil of their marriage, Jo was devastated, referring to herself in letters as an "amputee," "one half sliced off & bleeding." She died less than ten months later.

Hopper's influence is hard to define. His was a lonely voice calling for realistic art in a world of abstraction. Later representational artists, including Andrew Wyeth and David Hockney, owe him a debt of gratitude. Today, his paintings are celebrated for their quintessential American-ness, with their evocation of the American zeitgeist of the mid-twentieth century.

Hopper wasn't entirely pleased about bearing the "American" tag; he once said that the "American Scene" business made him mad, for "the French painters didn't talk about the 'French scene.'" But he did call for the evolution of art in America "into something native and distinct," and he surely deserves credit for painting the first distinctly American modern masterpieces.

EDWARD HOPPER: WIFE BEATER?

Yes, it's true—Edward Hopper beat up his wife, but she beat him up in return.

The fiery-tempered Jo frequently lashed out at Edward, who met her rages with stony silences. She struggled to find a means to retaliate, refusing to speak to him, but feared he found this treatment to be more a relief than a punishment. Once when she was sick and felt Hopper wasn't taking enough care of her, she went on a two-day hunger strike that finally brought him to heel.

More often than not, the culmination of their fights was physical violence. Jo

complained her husband was the better hitter because of his long arms, but wifey didn't hesitate to scratch and bite in return. She noted with satisfaction that Hopper made one trip to Cape Cod with two long scratches on either side of his face, and another time she bragged to friends that she had bitten him to the bone.

HOPPIN' MAD

A perennial source of conflict between the Hoppers was their car. Edward often forbade Jo to get behind the wheel, which she saw as just one more example of his innate selfishness. Maybe. Or maybe she was a lousy driver. She did get in a significant number of fender benders, and Hopper saw every encounter between Jo and a light pole as another reason she shouldn't be allowed to drive. Even when she did, Hopper would insist on taking the wheel when it came time to park, and if Jo refused, he had no problem forcing her from the car. Once outside a Cape Cod restaurant, diners were treated to the sight of the gangling artist wrestling his petite wife out of the car, pulling by her legs as she clung stubbornly to the steering wheel.

THE QUIET, REALLY SILENT TYPE

Hopper earned a much-deserved reputation for his silences, and he admitted that he communicated better through his canvas than through language: "If you could say it in words, there'd be no reason to paint." Some found his silences endearing, others exasperating. When the artist Henry Varnum Poor accepted the gold medal from the National Institute of Arts and Letters on Hopper's behalf in 1955, he said, "From the safe distance of Monterrey, Mexico, Edward Hopper has sent his acceptance speech. . . . If he were here to make it by spoken word it would have been, 'Thanks,' or if he felt really expansive, 'Thanks a lot.'" Jo put the matter this way: "Sometimes talking with Eddie is just like dropping a stone in a well, except that it doesn't thump when it hits bottom."

DESOLATION VACATION

Jo and Edward made several vacation trips to Mexico and the American Southwest, both regions famed for their picturesque, art-inspiring scenes. For Hopper, not so much. On his first arrival in Santa Fe, he complained to Jo that there was nothing to paint. She gestured to the sky, the desert, the mountains, but he waved them away. Finally one morning, he found a subject that suited him: an isolated rail station and a boxcar of the Denver and Rio Grande Railroad.

A NIGHT AT THE HOPPERA

Georges Seurat and Marc Chagall may have had hit musicals based on their paintings, but only Edward Hopper inspired an opera—or, as the work was generally known, a "hoppera." To coincide with a major Hopper exhibition at the National Gallery of Art in Washington, D.C., the University of Maryland commissioned librettist Mark Campbell and composer John Musto to create a musical work based on Hopper's paintings. Titled *Later the Same Evening*, the work premiered in November 2007. It takes as its starting point several iconic works, including *Two on the Aisle* (1927) and *Room in New York* (1932), whose anonymous figures are given personalities and motivations. A woman sitting alone in a room is imagined as an aspiring dancer who has decided to give up on her dreams in New York and return home to Indianapolis. Singers were carefully dressed to mirror their painted inspirations, and the lighting took on a distinctly Hopper-esque fluorescent glow.

DIEGO RIVERA

DECEMBER 8, 1886–NOVEMBER 24, 1957

ASTROLOGICAL SIGN:
SAGITTARIUS

NATIONALITY:
MEXICAN

STANDOUT WORK:
DESNUDO CON ALCATRACES (NUDE WITH CALLA LILIES) (1944)

MEDIUM:
OIL ON CARDBOARD

ARTISTIC STYLE:
SOCIAL REALIST

SEE IT YOURSELF:
NOT POSSIBLE—IT'S IN A PRIVATE COLLECTION

"ART MUST NO LONGER BE THE EXPRESSION OF INDIVIDUAL SATISFACTION . . . BUT SHOULD AIM TO BECOME A FIGHTING, EDUCATIVE ART FOR ALL."

QUOTABLE

Diego Rivera invented the most fabulous stories about his life. He claimed to have fought in the hills with revolutionary Emiliano Zapata, plotted the assassination of a Mexican president, and even engaged in cannibalism. It's hard to understand why he felt compelled to invent these tales because, truth is, his life didn't need embellishment. Born into a downtrodden country suffering political upheavals, he became one of the most remarkable artists of the twentieth century, one who brought unprecedented recognition to indigenous peoples and helped invent a national myth for Mexico. Along the way, he became the close friend of such varied personalities as Pablo Picasso and Leon Trotsky and married (twice) one of the century's most extraordinary artists, Frida Kahlo.

Cannibalism? Who needs it?

THE MAN, THE MYTHS

The first myth about Rivera that must be dispelled is his name. He was baptized Diego María Rivera and not, as he later claimed, Diego María de la Concepcíon Juan Nepomuceno Estanislao de Rivera y Barrientos Acosta y Rodríguez. He later tacked on a new name for each biographer—after all, he had to keep up with Pablo Picasso.

The story of his birth might or might not have been myth: He claimed he was pronounced dead by the midwife, who deposited him in a bucket of dung, but then his grandmother revived him by killing several pigeons and wrapping him in their warm entrails. Maybe. What is certain is that he was the first born of twins to a middle-class family; his twin brother died very young.

Rivera grew up in a Mexico under the control of Porfirio Díaz, whose dictatorship lasted more than thirty years. Rivera, who had showed early talent in drawing, benefited from the state sponsorship of the arts during the Porfiriato but also witnessed the oppression of the working classes, particularly indigenous populations. Nevertheless, Rivera did not, as he later claimed, march alongside striking mill workers in rural Mexico, nor did he join a band of medical students experimenting with the health benefits of cannibalism. Instead, he attended the state art academy, competed in government competitions, and eventually won a scholarship to study in Europe.

VIVA LA REVOLUCIÓN

Rivera left for Spain in 1907 and two years later moved on to Paris, where he took up with a young Russian artist named Angelina Beloff, who became his common-law wife. He also became pals with artists like Pablo Picasso, Georges Braque, and Amedeo Modigliani. (Rivera famously said, "I've never believed in God, but I believe in Picasso.") His personal life was complicated by a love affair with Marevna Vorobev, whom he pursued while Beloff was in the hospital giving birth to their son, also named Diego. (The baby died at the age of fourteen months.)

Meanwhile, back home, the Mexican Revolution broke out. Glorious words about freedom were bandied about, although the resulting social conditions resembled anarchy more than liberty. Rivera saw the conflict through the lens of Beloff's Marxist ideology and soon became a Communist. This wasn't the only change in his life. Rivera had adopted Cubism in 1911, but by the end of the decade, quarrels with other Cubists had soured him on the movement. One day he was struck by the sight of fruits and vegetables outside a Paris shop and exclaimed to Beloff, "Look at those marvels, and we make such trivia!" He began experimenting in the style of Paul Cézanne. The move away from Cubism was completed in 1920 when he met the critic Elie Faure, who proposed that artists should contribute to the advancement of society by painting large-scale works of socialist propaganda. Infused with revolutionary fervor, Rivera decided to return to his homeland and begin painting for the people, setting off in 1921 and leaving behind Beloff, Vorobev, and their daughter Marika.

MURAL, MURAL ON THE WALL

Mexican officials were as eager to promote public art as Rivera was to paint it, envisioning a series of large-scale murals for public buildings. The artist set to work, although at first he struggled with the demands of fresco painting, and the results were a bit spotty: At one point, he announced he had rediscovered the secrets of the Aztecs, touting a paint base made with nopal, the fermented juice of cactus leaves. Not only was this "discovery" pure fantasy, but the nopal also made a terrible paint binder, eventually decomposing and leaving blotchy stains on the wall.

To look at Rivera's murals, you would never know he had once been a Cubist. Inspired by pre-Columbian sculptures as well as neoclassical Euro-

pean art, Rivera created simplified figures of bright colors and strong lines. His early murals, often populated by scenes of invading Spaniards, focused on past brutalities. Over time, he created works in which a positive future is built on the precolonial past. In *The History of Medicine in Mexico*, the right side of the mural shows ancient medical practices under the Aztecs— a midwife helping a woman give birth, for example—while the left shows a modern hospital, complete with masked doctors and enormous scanning equipment undertaking the same tasks.

PARTY POOPER

Rivera jumped into leftist politics, co-founding a revolutionary union and joining the Mexican Communist Party. He even made a short trip to Moscow to celebrate the tenth anniversary of the Russian Revolution. In 1929, however, Rivera was expelled from the party for continuing to accept commissions from the bourgeois government. He protested, saying that his paintings depicted the class struggle, but the Mexican party organization had no room in its ranks for the undisciplined, outrageous artist.

A FABULIST OF EPIC PROPORTIONS, DIEGO RIVERA CLAIMED TO HAVE SMUGGLED A BOMB IN HIS SOMBRERO IN AN ATTEMPT TO ASSASSINATE MEXICAN PRESIDENT PORFIRIO DIAZ.

And outrageous he certainly was. As he started on a mural for the National Palace, he was having simultaneous affairs with a U.S. art student and Frida Kahlo, a young Mexican artist. (All this after a short-lived marriage with Guadalupe Marin and several other flings.) Kahlo shared his passionate belief in Communism and a devotion to art, and their relationship soon intensified. Casting off his other lovers (temporarily, at least), he married her in August 1929. Kahlo was twenty-two and Rivera forty-three.

By the 1930s, mural work in Mexico dried up as the international depression wrecked the Mexican economy. The United States was also devastated but still had a core of wealthy art lovers who could commission big projects, and for several years Rivera found most of his work north of the border. After working for the Pacific Stock Exchange, he painted a mural for the lobby of the Detroit Institute of the Arts, depicting the manufacturing

process at a Ford auto factory. (The irony of a dedicated Communist painting a stock exchange and an assembly line seems to have been lost on Rivera.)

COMRADES IN ARMS

Rivera then headed to New York to decorate the lobby of the RCA Building in Rockefeller Center. He went to work on a fresco that showed two possible futures: one a capitalist hell and the other a Communist heaven. That would have been bad enough, but then he added a portrait of Lenin to his masterpiece. Panic erupted among Manhattan's dedicated capitalists. Nelson Rockefeller insisted that the portrait of Lenin be painted over, but the artist refused, offering only to add a portrait of Abraham Lincoln to the mix. The developer handed Rivera a check and escorted him from the building. A few weeks later, in the middle of the night, workmen destroyed the fresco. Rivera later got his revenge: Reworking the mural in Mexico, he included a portrait of Rockefeller holding a martini glass, the ultimate decadent capitalist.

Meanwhile, on the marriage front, Rivera seemed incapable of remaining faithful. His attractiveness to women is hard to understand—by the 1930s, he weighed nearly three hundred pounds and disliked bathing. Kahlo walked out on him in 1935 but returned after both agreed that theirs would be an "open" marriage. The situation was too precarious to last, and in 1939 they divorced, only to be brought back together by one of the figures who had driven them apart, the exiled Bolshevik Leon Trotsky, with whom Kahlo had had an affair. After Trotsky's assassination, Kahlo was roughly questioned by the police. She fled to San Francisco, where Rivera was working. Despite the fact that Rivera was shacked up with one woman and sleeping with another, the two remarried in late 1940.

THE MYTHMAKING LIVES ON

World War II saw the decline of mural commissions, so Rivera devoted himself increasingly to portraits and oil paintings. The most famous of these, *Desnudo con Alcatraces* (Nude with Calla Lilies) is typical of the period: It shows a woman with her back to the viewer, kneeling as she embraces a basket overflowing with enormous white lilies.

After the war, Rivera grew increasingly active in the peace movement, with Kahlo participating as best she could as her health steadily declined;

after years of suffering, she died in 1954. Rivera stage-managed her funeral into a Communist demonstration, a sign of loyalty that finally persuaded the Mexican Communist Party to readmit him as a member.

The last years of Rivera's life found him as irrepressible as ever. In 1955 he married his dealer Emma Hurtado, although he soon started an affair with a prominent collector. The philandering finally ceased when he died in 1957. Despite his wishes, his ashes were not mingled with Kahlo's and buried in the mock-Aztec temple he had built for himself. Instead, he was laid to rest in the National Rotunda of Illustrious Men in Mexico City.

Diego Rivera believed art could change the world. He didn't succeed in the way he intended, nor did his paintings usher in a Communist paradise. But Rivera did offer to the Mexican people a vision of themselves as heroes, not victims of bloody colonialism and political repression. The myth-maker Rivera gave his country something it desperately needed: an uplifting story of national identity.

REALITY AND RIVERA

After studying the life of Diego Rivera, one must conclude that his capacity for invention was matched only by the gullibility of his audiences. In 1910, he briefly visited his home country to hold an exhibition in Mexico City. All well and good except that, according to Rivera, he had an ulterior motive: to assassinate President Porfirio Díaz with a bomb that he smuggled into the country in his sombrero. He was forced to abandon his plans, he claimed, only when the president's wife, rather than the president, attended the opening.

Rivera also claimed he spent six months fighting alongside Emiliano Zapata in the south of Mexico, becoming an explosives expert who could blow up trains without harming passengers. Rivera recounted that he had been dragged forcibly from Zapata's side by a government official who warned him he was about to be sent to the firing squad. The adventures of the voyage concluded with Rivera rescuing his ship from foundering in an Atlantic storm. In fact, Rivera sailed home on calm seas well before Zapata's revolt. And instead of throwing bombs at the president, he went to great trouble to ensure the government would continue to pay his scholarship.

L'AFFAIRE RIVERA

After the first flush of excitement over Cubism, artists quickly found themselves split over the "correct" Cubist approach. Synthetic Cubists quarreled with Analytic Cubists, collage-creating Cubists fought with paint-only Cubists, and Rivera developed theories about the fourth dimension that, frankly, make no sense whatsoever. The whole thing came to a head at a dinner party hosted by the art dealer Léonce Rosenberg during which the critic Pierre Reverdy charged that Rivera was basing his art on the discoveries of others. Rivera slapped Reverdy in the face. China and glassware shattered as punches flew. Friends managed to separate the two, although on his way out Reverdy hurled the foulest epithet he could find: "Mexican!"

It didn't stop there. Reverdy published an article in which he labeled Rivera a "savage Indian," a "monkey," and "human only in appearance." The hubbub was widely reported in Paris newspapers as *l'affaire Rivera*, although you'd think that in 1917 the French had more important things to worry about. The whole matter gave Rivera a distaste for Cubist theorizing, and within a few years he gave up Cubism altogether.

THE WAITER DEFENSE

In the late 1940s, Rivera was charged with opening fire on a truck driver outside his Mexico City house. He protested having fired the shots because he thought the driver was going to knock him down. "Who has not fired a shot in the air to celebrate the New Year?" he asked the judge. "Who has not fired a shot during thirty or more years for the sheer joy of it, even without the blessing of constitutional law? Who has not fired a shot just to get a waiter's attention?"

ARTISTIC PERSPECTIVE

Rivera kept Kahlo well informed of his love affairs, particularly after their second marriage, and she made no secret of her dislike for her rivals. Once she groused that one of her husband's favorites had "huge, ugly breasts." Rivera protested that the woman's breasts weren't that big, but Kahlo snapped, "That's because you always see them when she's lying down."

HIS HOUSE WAS HIS TEMPLE

In the late 1940s, Diego Rivera decided to build himself a house—but not just any house. He wanted a temple dedicated to his glory. He called the structure Anahuacalli and based it on the design of Aztec temples, which were more often associated with human sacrifice than with comfy residences.

Constructed primarily of black volcanic stone carved into fantastical shapes, the building is entered by passing through enormous stone gateways and then crossing a moat, which lead to a huge courtyard surrounding a massive stone table. Inside the structure are dimly lit, winding corridors that lead to cramped rooms filled with Rivera's collection of Pre-Columbian art. At the center of the pyramid on the lowest level is a small room containing a pool of water. The space is reminiscent of the "offering chamber" in which Aztec priests would leave the bones of their victims. Rivera intended the chamber to contain the remains of himself and Kahlo.

Rivera never lived in the house; he died before construction was complete. It was opened to the public in 1964 and today serves as the Diego Rivera Museum.

MARC CHAGALL

JULY 6, 1887–MARCH 28, 1985

ASTROLOGICAL SIGN:
CANCER

NATIONALITY:
BORN IN THE RUSSIA EMPIRE (NOW BELARUS); LATER A FRENCH CITIZEN

STANDOUT WORK:
I AND THE VILLAGE (1911)

MEDIUM:
OIL ON CANVAS

ARTISTIC STYLE:
CUBIST / SURREALIST

SEE IT YOURSELF:
MUSEUM OF MODERN ART, NEW YORK

QUOTABLE ➡ *"ARE THERE COWS IN AMERICA?"*

For some, history happens in the background; for others, it kicks them in the guts. All the artists who lived through the turmoil of the first and second world wars were touched by history, but Marc Chagall was more than touched—he was punched in the face. Exiled, banished, exiled again. Both the gulags of Siberia and the death camps of Germany were near misses. That he survived is little short of miraculous. Yet Chagall never lost his will to paint nor his ability to transform suffering into luminous scenes of love, harmony, and joy. For a guy who lost it all more times than he could count, his achievement is astounding.

THEY CALLED ME MOISHE

In 1887, the modern world had little impacted Vitebsk, Russia, and the city's Hasidic Jews were content to be ignored. Better obscurity than pogroms and persecution, they thought. Vitebsk had the amenities of a provincial capital—a rail station, an onion-domed cathedral—but the Shagal family stuck close to their neighborhood that, with its twisting streets, resembled the Jewish villages, or shtetls, of the countryside. Moishe Shagal was born into this close-knit world, the oldest of nine children of a herring-merchant father and shop-owner mother.

Shagal showed early talent in art, to the bewilderment of his family to whom the rarified world of galleries might as well have been Mars. Moishe's mother encouraged him, first paying a bribe to get him into the local state school (from which Jews were banned) and then enrolling him in a local art school. In 1907, young Moishe set out for St. Petersburg, where patrons arranged his admittance to the School of the Imperial Society for the Fine Arts and obtained the residence permit required of Jews. (One evening, when caught out after his permit had expired, he was beaten and thrown into prison for two weeks.)

After three years in St. Petersburg, Shagal set out for Paris to see the new art being created there. He arrived in the fall of 1910 and immediately fell in love with the city, quickly adopting a French name: Marc Chagall. He found the religious freedom of France particularly invigorating, and no one ever demanded to see his residence permit! He experimented with Fauvist colors and Cubist planes, but always his imagination returned to the world of his childhood, the twisting streets and small synagogues of Vitebsk. And so Chagall transformed Cubism and Fauvism to his own ends in works such

as *I and the Village* of 1911. Painted in glowing red, green, pink, and blue, a mild-eyed cow stares into the eyes of a man; in the village, man and beast live in harmony. The scene is dreamlike and allusive. In the space between the two figures, a line of houses evokes the streets of Vitebsk; two of the houses are upside-down.

REVOLUTION DOESN'T NECESSARILY MEAN REVOLUTIONARY

Chagall's paintings received immediate acclaim, so when he decided to visit Vitebsk in the summer of 1914, he wasn't just catching up with family, he was returning in triumph. You can't blame him, but maybe—just maybe—he should have read a newspaper. The outbreak of World War I caught him completely by surprise. With two front lines between him and Paris, he settled down to wait out the war. Fortunately, Vitebsk offered some comforts, in particular a comely one named Bella Rosenfeld, the daughter of local merchants. The two had fallen in love in 1909 but hadn't seen each other during Chagall's years in France. Their relationship rekindled on his return, and they married in the summer of 1915. A daughter, Ida, was born in 1916.

Then came the revolution. Chagall was elated, particularly since under the Soviet state Jews were given equal rights for the first time. He believed a revolutionary government would welcome revolutionary art, which he envisioned as including Cubists, Futurists, and other Modernists, and at first it seemed that scenario was possible. In 1918, Chagall was appointed Commissar of Fine Arts for the province of Vitebsk and immediately established a progressive art academy. But he was unwilling to concede to the revolutionary dogmatism taking hold in Russian art, and infighting in the academy, combined with political pressures, forced him out.

The Chagalls moved to Moscow, where he took a position with the Moscow Yiddish State Theater, painting nine monumental murals in which modern and ancient, Jewish and secular, collide. Musicians fiddle while *shofars* (ram's horns) are blown, angel horns accompany modern dancers, and the Ten Commandments hover near an artist's palette. In the mural titled *Music*, a giant green-faced fiddler stands on the roofs of shtetl houses.

Chagall was never paid for the theater work, and soon he was forced to take a position teaching art at a Jewish orphanage. That job also came without a salary, but at least it included food and lodging. Realizing that the Soviet state held no future for him, Chagall arranged for an exhibition of his

work in Lithuania. He left Russia and probably saved his own life, for the fate of Jewish intellectuals under Stalin was uniformly grim.

CROSS ROADS

Chagall found the Europe of 1922 a darker place than the one he had known in 1914. He had left forty paintings with Berlin dealer Herwarth Walden, who had marketed them assiduously, but the small fortune made from the sales had been reduced to a pittance by postwar inflation. Walden had also engaged in some financial fancy footwork—transferring several paintings to his ex-wife—and Chagall had to mount a lengthy legal battle for their return.

After several months in Berlin, the family moved on to Paris. Chagall rushed to his former apartment in Montparnasse, where he had left his paintings nine years earlier, only to find an aged pensioner inhabiting the place and the paintings long gone. The building's owner had gathered up Chagall's canvases and stacked them in an unsecured storehouse, where they were later scavenged, one finding new life as the roof of the concierge's rabbit hutch. Between Berlin and Paris, Chagall's entire artistic output had been lost. Undeterred, he started over, painstakingly re-creating and reinventing several works in an attempt to recover what had been lost.

For more than a decade, the Chagalls enjoyed a comfortable life in France, but the Nazi menace loomed. In 1933, three of his paintings were burnt in Mannheim, and his works in German museums were ripped from the walls and denounced as degenerate. Soon after Kristallnacht, the night of November 9, 1938, when the synagogues, homes, and businesses of Jews throughout Germany were destroyed, Chagall poured his anxieties into the painting *White Crucifixion*. The subject may seem a strange choice for a Jewish artist, but Chagall depicts Christ not as the Christian savior but as a Jewish martyr. The crucified figure stands in the center as scenes of horror swirl around him. Homes and synagogues burn, the Red Army marches forward, and Jews flee on foot and in boats. This is Chagall's shout of protest, his *Guernica*, and it is remarkably prescient of the Holocaust to come.

In 1937, Chagall obtained French citizenship, and two years later he and Bella fled to the south in advance of the German Army. Their hopes to remain in Europe were dashed by the Vichy government's issuance of harsh anti-Semitic laws. Only the courageous efforts of Varian Fry, director of the American Aid Committee, and Harry Bingham, the American Consul in Mar-

seilles, to arrange passports and visas saved the family from the concentration camps. The Chagalls sailed into New York Harbor on June 23, 1941, the day after Germany invaded Russia.

JOY TRIUMPHS

To the middle-aged couple, New York City was an alien place. Chagall was most comfortable on the Lower East Side, where he could speak Yiddish, and in the countryside upstate. When Paris was liberated in August 1944, the couple decided to return. They started packing their bags, but then tragedy struck: Bella died suddenly from an infection. Chagall was devastated—Bella had been his constant muse and companion. He didn't paint for nine months.

Chagall couldn't bring himself to return to France for several years. Meanwhile, he met a young woman named Virginia Haggard, and the two had a son, David. Eventually the trio moved to France, although the relationship with Virginia gradually cooled. In 1952, he met a vivacious Russian emigrée named Valentina Brodsky, and the two married later the same year.

> ANXIOUS ABOUT IMMIGRATING TO THE UNITED STATES, MARC CHAGALL REPORTEDLY ASKED, "ARE THERE COWS IN AMERICA?" FORTUNATELY, HE FOUND PLENTY OF BOVINE COMPANIONSHIP IN THE RURAL NEW YORK STATE COUNTRYSIDE.

Chagall's late work took many forms. Like Henri Matisse, he created stained glass; like Pablo Picasso, he decorated pottery. His most significant project was the design of windows for the synagogue of the Hadassah University Medical Center in Jerusalem in 1960; each of the twelve windows portrays one of the tribes of Israel.

Chagall died on March 28, 1985, and was buried in the small town of Vence, a suburb of Nice where he had lived for several years. What is perhaps most amazing about the artist is that, although he lost so much, his paintings retain a sense of joy. He wasn't in denial—works like *White Crucifixion* demonstrate his awareness of the sufferings of his era and his people—but he was an artist with true exuberance for life. That he retained this joy in the face of all he endured is his most lasting legacy.

THE FIDDLER CONNECTION

Does Chagall's image of a fiddler standing on the roofs of shtetl houses, from his Yiddish theater mural, seem familiar? It should. It inspired the hit 1964 Broadway musical *Fiddler on the Roof*, which was based on the Tevye stories of Sholem Aleichem. The title directly refers to Chagall's painting.

Turns out that the original Broadway set designer was Boris Aronson, a Russian Jew who began his career at the Moscow Yiddish Theater in 1920, when Chagall was serving as its principal artist. The backdrop Aronson designed featured little houses that echo those in *I and the Village* and the same vibrant colors as Chagall's palette. As for the rooftop fiddling, it wasn't magical realism; it was reality. Shtetl rooftops were low and easy to climb. To escape floods or rampaging armies, residents often took to the roofs; they also found rooftops to be nice spots to relax since the houses below were so cramped. Chagall recalled that his grandfather liked to climb up on his roof to chew on a carrot and watch the world go by.

One would love to have Chagall's opinion of the musical, but it appears that, despite a lengthy run in Paris, he never saw it.

HAVE COWS, WILL TRAVEL

After the fall of Paris, Chagall's life was truly endangered. It was only a matter of time before German collaborators in the Vichy regime sent him to the death camps. Chagall was eager to flee the country, although he had misgivings and repeatedly asked the American activist Varian Fry before his departure, "Are there cows in America?" The question has sometimes been interpreted as revealing enormous ignorance about the United States, but that's too simplistic. Chagall was really asking, "Will I still have a subject to paint in America?" or even "Will I be able to paint in America?"

As it turned out, some of Chagall's happiest days in the United States were spent in rural New York farming country, where, in fact, there were plenty of cows.

MARCEL DUCHAMP

JULY 28, 1887–OCTOBER 2, 1968

ASTROLOGICAL SIGN:
LEO

NATIONALITY:
FRENCH (LATER AN AMERICAN CITIZEN)

STANDOUT WORK:
FOUNTAIN (1917)

MEDIUM:
PORCELAIN

ARTISTIC STYLE:
CUBIST/DADAIST/SURREALIST

SEE IT YOURSELF:
ORIGINAL IS LOST, BUT AUTHORIZED REPRODUCTIONS ARE ON DISPLAY AT THE INDIANA UNIVERSITY ART MUSEUM, THE SAN FRANCISCO MUSEUM OF MODERN ART, THE PHILADELPHIA MUSEUM OF ART, AND THE TATE MODERN IN LONDON

"UNLESS A PICTURE SHOCKS, IT IS NOTHING."

 QUOTABLE

 You know when you're fifteen years old and you're simply Too Cool? You put on an attitude of ironic detachment and hope beyond hope that everyone sees you as a rebel, a self-imposed outcast, a bad boy or girl. Transfer those attitudes to a grown Frenchman, and you've got Marcel Duchamp. He reveled in the bad boy role, gleefully antagonized the art world, and layered on the ironic disengagement so thick he could barely be bothered to talk.

So how much of this 'tude was a put-on? Impossible to say, but it's hard to take seriously a man who publicly renounced art at the age of thirty-six but spent his last decades secretly constructing one of his largest artworks, a work even more shocking than what had come before.

THE ANTI-CUBIST

Choosing a career in art was one of Duchamp's least rebellious decisions. Though his father was a notary, his grandfather was a painter and both his older brothers pursued art, one becoming a printmaker and the other a sculptor. After leaving school in Rouen, Duchamp joined his brothers in Paris, where his earliest paintings were unimpressive Post-Impressionist knock-offs.

Then Pablo Picasso and Georges Braque unveiled their Cubist paintings, energizing the avant-garde community. Numerous rules about "correct" Cubism quickly developed, including a ban on the human nude (nudes were so over) and objects in motion. So Duchamp painted his own Cubist work: *Nude Descending a Staircase*. When it was unveiled, Duchamp hit the trifecta: He offended Cubists, traditionalists, and the general audience all at once. The Cubists hated it because it violated their rules: The painting has as its subject a nude, and instead of showing a still figure from multiple viewpoints, it depicts an object in motion from a single viewpoint. Traditionalists hated it because nudes were supposed to be the highest ideal form; to shatter a nude into a jillion planes was bad enough, but for a nude to do something as mundane as walk down a staircase was undignified to the point of blasphemy. Everyday audiences hated it because they couldn't find the nude in the painting, and even worse, they couldn't tell if the figure was a man or a woman. (Hint: It has a penis.)

Duchamp was delighted. He painted a few more anti-Cubist paintings but quickly decided it wasn't enough to poke fun at art's reigning movement; he wanted to challenge the premises of all art. He painted mundane objects to question why certain ones are considered appropriate subjects

for art and others are not. He described strange or even impossible "works" on scraps of paper, thus questioning if art even had to be created to "be."

READYMADE ICON

When World War I broke out, Duchamp was found unfit for service—he claimed it was due to a heart condition, but the real reason was probably psychological. Tired of explaining to strangers why he wasn't at the front, in the summer of 1915 he boarded a ship bound for New York.

The artistic games continued there. He purchased a snow shovel and carved onto the handle the nonsense phrase "In advance of the broken arm." He mounted a bicycle wheel vertically on a kitchen stool. These were "readymades," he announced, to the bewilderment of audiences. At a 1916 show, he revealed the ultimate readymade: a porcelain urinal, which he'd signed "R. Mutt" and called *Fountain*.

What was the point of the readymades? Duchamp defended them on the grounds that he "took an ordinary article of life, placed it so that its useful significance disappeared under the new title and point of view." You might think this means he wanted audiences to see readymades in new ways, but actually he argued that beauty was beside the point. He wanted to get away from visual, or as he called them "retinal," considerations to achieve purely intellectual, or "cerebral," considerations. The point was not to see a urinal in a new way but to think of a urinal in a new way. I, ah, see.

WHO'S YOUR DADA?

In 1917 the United States entered the war, Duchamp fled again, this time to Buenos Aires. When the conflict ended he returned to France, where he found a new art movement protesting war and the society that created it. Its founders took as their name Dada, a French children's word for a hobby-horse, and rejected all norms and conventions, including the very notion of art. They were anti-artists who sought to violate aesthetics, offend audiences, and destroy values. Sounds right up Duchamp's alley, right?

Wrong. All it took for Duchamp to reject a movement was for it to, well, be a movement. Nevertheless he produced a work that became one of Dada's icons when he picked up a cheap postcard reproduction of the *Mona Lisa*, penciled in a crude mustache and goatee, and wrote in the bottom margin "L.H.O.O.Q." When spoken in French, the letters sound like the phrase "elle

a chaud au cul," which generally translates as "she's got a hot ass." With his quick scribbles, Duchamp mocked the very notion of "masterpiece" and laughed in the face of centuries of Western culture.

A RROSE BY ANY OTHER NAME

In the early 1920s, Duchamp worked intermittently on a complex composition known alternately as *Large Glass* and *The Bride Stripped Bare by Her Bachelors, Even*, which is made up of two enormous glass panes and incorporates lead foil, fuse wire, and dust. After years of work, the project petered out when Duchamp became distracted by the creation of his alter ego—a woman, in fact, named Rrose (yes, two r's) Sélavy.

Rrose produced her own artworks, published numerous puns, and was photographed by Man Ray. (Duchamp looked pretty good in drag.) The stunt contributed to his astounding fame, and a dealer offered him an annual salary of $10,000 for just one painting a year. But in 1923 Duchamp announced he was abandoning art for chess. For her part, Rrose Sélavy continued to issue a stream of puns and bizarre statements through the 1920s. (In 1924, "she" suggested a design of a dress "exclusively for ladies afflicted by hiccups.") But Duchamp's time was primarily taken up by the chessboard, and he was pretty darn good, becoming a chess master in 1925 and playing on the French team of the international Chess Olympiads.

ONE MORE TRICK BEFORE I GO

At the outbreak of the Second World War, concerned American patrons in the United States went to enormous effort to secure Duchamp's passage back to North America. Despite his dawdling and seeming lack of appreciation for their efforts, he finally arrived in the United States in June 1942, remaining there after the war. In 1953 he rather unexpectedly married Alexina Sattler, nicknamed Teeny, who was the first wife of Pierre Matisse, the son of Henri Matisse and a prominent New York art dealer. The Duchamps split their time between Paris and Manhattan and remained in the thick of the art scene, getting to know everyone from Salvador Dalí to Jackson Pollock. Duchamp died in 1968 of a sudden heart attack after a pleasant dinner with friends.

What no one expected was that he had saved up a final surprise. Almost a year after his death, a new artwork was unveiled at the Philadelphia Museum of Art. Duchamp had left detailed instructions for the construction of

a work called, in English, *Given: 1. the waterfall, 2. the illuminating gas*. It consists of an enormous pair of wooden doors pierced by two small peepholes. When you look through the holes, you see a shattered brick wall through which can be glimpsed a life-size nude mannequin sprawled on a bed of twigs and holding a torch. Of Duchamp's shocking artworks, this one is probably the most shocking—the sense of violation, of voyeurism, is palpable. Duchamp, who had officially given up art forty-five years before, shocked everyone yet again.

Duchamp essentially framed the conversation for the next century of artists, and maybe longer still. He questioned every premise about art: that it should be beautiful, meaningful, or understandable; that it should be the product of individual effort; that it should even exist. Every artist since has had to answer Duchamp's challenge.

Call it the bad boy's revenge.

DESECRATING THE FOUNTAIN

Despite being named the most influential artwork of the twentieth century by four hundred leaders of the British art world, Duchamp's *Fountain* has been the subject of several recent attacks. In the spring of 2000, for example, two performance artists named Yuan Chai and Jian Jun Xi attempted to urinate in the Tate Modern's version. (The Tate now encloses the piece in a transparent box to prevent further, er, uses.) The artists might have been attempting to imitate an earlier stunt by another performance artist, Pierre Pinoncelli, who had succeeded in urinating in another version of the work in 1993. Pinoncelli wasn't done yet with *Fountain*: In January 2006, he attacked the sculpture with a hammer, inflicting a slight chip. After being arrested, Pinoncelli claimed that he was making a statement that the work no longer had provocative value and, further, that Duchamp would have approved. Considering Duchamp actually lost the original version of *Fountain*, it's hard to argue with him.

CHECK MATE

In 1927 Duchamp married, much to the surprise of Mary Reynolds, his lover of five years. Duchamp's bride was twenty-five-year-old heiress Lydie Sarazin-Levassor, a strange choice for a forty-year-old artist/chess player. They married on June 7 and spent a week honey-

mooning in the south of France. Poor Lydie was shocked when Duchamp spent his days and nights pouring over chess problems. She was so distraught that one morning she glued all the pieces to the chessboard. After the honeymoon from hell, they never again lived together, and six months later, Lydie filed for divorce. Wonder what took her so long.

DESPITE HIS OUTRAGEOUS STUNTS, INCLUDING CROSS-DRESSING AS HIS ALTER EGO RROSE SELAVY, MARCEL DUCHAMP COMPETED AS A CHESS MASTER ON THE FRENCH TEAM AT THE INTERNATIONAL CHESS OLYMPIADS.

TAKE THAT, CHRISTO

Even after he "abandoned" art, Duchamp remained a favorite choice for staging exhibitions of other artist's work. For a 1939 Surrealist exhibition in Paris, he covered the ceiling in coal sacks and insisted no lighting be installed; instead, each guest was given a flashlight. After the first day, however, lights needed to be brought in because the opening-night guests had taken home all the flashlights, assuming they were souvenirs.

For a 1942 Surrealist show in New York, Duchamp wound sixteen miles of twine around and about the exhibit halls, deliberately obstructing passageways and blocking views. A *New York Times* critic noted dryly that the twine wasn't a particular hindrance—the pictures might look even better through a web of string.

IT WAS HILARIOUS IN REHEARSALS

In 1959 Duchamp participated in a performance of modern music with composer John Cage. (Cage is most famous for his 1952 composition *4'33"*, which consists of four minutes and thirty-three seconds of total silence.) For *Reunion*, Cage and Duchamp took their place on stage across a chessboard wired to speakers set up to emit recorded sounds when pieces were moved. Duchamp and Cage played one whole game, but their second game was suspended when someone noticed that the entire audience had left the theater.

GEORGIA O'KEEFFE

NOVEMBER 15, 1887–MARCH 6, 1986

ASTROLOGICAL SIGN:
SCORPIO

NATIONALITY:
AMERICAN

STANDOUT WORK:
COW'S SKULL WITH CALICO ROSES (1931)

MEDIUM:
OIL ON CANVAS

ARTISTIC STYLE:
AMERICAN MODERN

SEE IT YOURSELF:
ART INSTITUTE OF CHICAGO

QUOTABLE

"I'VE BEEN ABSOLUTELY TERRIFIED EVERY MOMENT OF MY LIFE—AND I'VE NEVER LET IT KEEP ME FROM DOING A SINGLE THING I WANTED TO DO."

Georgia O'Keeffe did not suffer fools gladly, or for that matter children, fans, competitive women, aggressive men, or anyone who told her what to do. When she met people she didn't like, she ignored them. When she started on a path, she pursued it and ran right over anyone who got in her way. When she saw something she wanted, she took it. Maybe that's what it took for Georgia O'Keeffe to become an artist. Women weren't supposed to be world-renowned painters in the early 1900s, and she had to be tough enough to ignore the chorus predicting failure. So if she came off as harsh, she didn't have much choice.

Still, it was best to stay out of her way.

THOSE WHO CAN'T, TEACH

The O'Keeffe family ran a large dairy farm in Sun Prairie, Wisconsin, where they had seven children; Georgia was the second child and first girl. In 1902 the brood moved to Williamsburg, Virginia, to escape the cold Wisconsin winters, but the move didn't help the person for whom it was intended—Georgia's mother, Ida, who had contracted tuberculosis. Combine Ida's poor health with father Francis O'Keeffe's alcoholism, and you've got a recipe for trouble.

In the meantime, Georgia had resolved to become an artist, and a famous and successful one at that. She knew the road ahead would be hard, given that in 1910 general opinion thought women artists were suited only for teaching and painting pretty flowers. Undeterred, O'Keeffe enrolled at the Art Institute of Chicago (where she ran in embarrassment from her first class with a nude male model) and then the Arts Students League in New York City. Despite winning prizes and scholarships, she endured the contempt of her male colleagues, one of whom said to her, "It doesn't matter what you do [in art school]. I'm going to become a great painter and you're just going to end up teaching art in some girl's school." That student was Eugene Speicher. Ever heard of him? Didn't think so.

But O'Keeffe feared he might be right. With her family's finances in increasing disarray, she dropped out of the academy. She spent a few miserable months as a commercial artist in Chicago and then learned of an opening for an art instructor in the public school system in Amarillo, Texas. It meant becoming the stereotype she had most feared, but she had little choice.

WESTWARD HO

The West was a revelation. The enormous sky, the wide-open spaces, even the constant wind struck O'Keeffe as starkly beautiful. She started drawing simple compositions of the sky, the plains, and the clouds. When she discovered Palo Duro Canyon, a maze of sandstone cutting through the Texas plain, she spent hours drawing there. Pleased with her progress, she then sent some of her drawings to a friend in New York, who was so impressed she immediately took them to 291 Gallery to show owner Alfred Stieglitz.

Stieglitz was more than a dealer; he was a pioneering Modernist photographer and a tireless promoter of the avant-garde. He was fascinated by the drawings, and the two started corresponding, with O'Keeffe sending him more work, although she never intended him to exhibit it. Of course, that's exactly what he did. O'Keeffe was horrified, but Stieglitz refused to take the works off his gallery walls.

The outbreak of World War I made life difficult for the antiwar Texan artist. She yelled at a shop owner selling a Christmas card with the tender message "Kill Huns" and encouraged a young man to finish his education rather than enlist. After she fell ill during the Spanish flu epidemic in 1918, Stieglitz convinced her to come to New York to recover. O'Keeffe headed to Manhattan in June 1918.

COMPROMISING POSITIONS

It must not have taken O'Keeffe long to realize Stieglitz, fifty-four years old to her thirty-one, was interested in more than her health. He wanted to photograph her. In the nude. A lot.

Hour after hour, in Stieglitz's house, O'Keeffe stood, sat, and lay in every conceivable position as the photographer captured each curve of her body. Things got ugly when Stieglitz's wife, the imperious Emmy, walked in on the pair. For years, the marriage had been nothing more than a convenience, but this incident pushed Emmy over the edge. She kicked Steiglitz out, and he and O'Keeffe started sharing a studio.

They made an odd couple. At Saturday evening dinners for artists, Stieglitz argued passionately about artistic theory while O'Keeffe devoured beef in oyster sauce and spoke to no one. Neither seemed to feel much compulsion to remain faithful, and O'Keeffe's most passionate relationships reportedly were with women.

SEX SELLS

In 1921, Stieglitz exhibited his nude photos of O'Keeffe. The art world was abuzz about her even before most had seen her work. Impressions of O'Keeffe as Stieglitz's sex object weren't helped by her paintings, series of flowers in extreme close-up that resembled sexual organs. O'Keeffe could protest all day that she was simply painting flowers, not vaginas, but no one believed her, particularly when Stieglitz (who knew that sex sells) emphasized the connection. Of course, the paintings provided the perfect response to critics who deplored flower paintings by women. Yet even if they do resemble female genitalia, O'Keeffe's flowers contain nothing "feminine." It would take years for the New York art world to see her as independent from Stieglitz.

In 1924, Stieglitz and O'Keeffe married, although both seemed ambivalent. By the late 1920s an aging Stieglitz was troubled with digestive and circulatory problems. O'Keeffe didn't have a nurturing bone in her body, and the routine of straining, sieving, and measuring food for her petulant spouse drove her nuts. She left, heading to New Mexico at the invitation of the eccentric heiress and art collector Mabel Dodge Luhan.

DESERTING TO THE DESERT

The northern New Mexico desert fascinated O'Keeffe like nothing since the Texas plains. Although her first visit was complicated by a game of musical beds (in which O'Keeffe slept with both Luhan and her husband), she returned every summer. After the crowds of New York, she wanted to be far, far away from prying eyes, and eventually she found the perfect getaway: Ghost Ranch, an isolated dude ranch for the super-wealthy. In 1940, she bought her own small house on the property.

O'Keeffe adored painting New Mexico—the mountains, the sky, even the bones of animals found lying in the desert. The works she produced there cemented her reputation, and, with Stieglitz's nonstop promotion, they sold for ever higher sums. In 1936 Elizabeth Arden slapped down the $10,000 commission for a mural for her New York beauty salon, and the Art Institute of Chicago held a retrospective in 1943. O'Keeffe had the fame and fortune she'd always desired.

Stieglitz, however, continued to decline, and in July 1946, a telegram reached Ghost Ranch stating that he had suffered a stroke. O'Keeffe rushed

to New York to find her husband in a coma from which he never recovered. The loss of Stieglitz severed O'Keeffe's last tie with New York. She had already purchased a ruined house in Abiquiu, New Mexico, and she set about restoring the adobe structure, moving there in 1949.

EQUAL OPPORTUNITY EMPLOYER

Always touchy, O'Keeffe grew even more cantankerous as she aged. The employees who cooked and cleaned for her were mostly immune to her rages since they spoke little English and could easily ignore her, but the succession of young women she hired to manage the staff and act as her secretary didn't fare as well. O'Keeffe referred to them as her "slaves"; when one finally quit, the enraged artist screamed at her, "You can't quit me! No one quits me!" It didn't help that in the late 1960s, her eyesight began to fail as well.

> ENRAGED AT BEING SPIED UPON IN HER STUDIO BY HER HUSBAND'S NIECES AND NEPHEWS, GEORGIA O'KEEFFE EMERGED SHRIEKING AND BRANDISHING HER PAINTBRUSH AT THE LITTLE INTRUDERS—WHO HAD NO IDEA THE ARTIST FREQUENTLY WORKED IN THE NUDE.

In 1973 a young artist named Juan Hamilton arrived in Abiquiu and told O'Keeffe he had been sent to her by spirits. Apparently, O'Keeffe believed him, and soon he was answering the mail, screening phone calls, and dealing with her agent. Many old friends feared Hamilton was taking advantage of the elderly woman, but others believed he genuinely cared for her. In 1984, realizing Abiquiu was too far from hospitals for the ailing artist, Hamilton moved O'Keeffe to Santa Fe, where she died on March 6, 1986.

O'Keeffe's greatest legacy was to break ground for American women. After her, no one could say to a female artist, "You're just going to end up teaching art in some girl's school." Today, the world's museums and galleries contain the work of talented women who perhaps wouldn't be there if Georgia O'Keeffe hadn't gotten there first.

!

UNDUE INFLUENCE

O'Keeffe rewrote her will several times in her last years, and each time Juan Hamilton was the better for it. By 1984, the bulk of the estate, valued at $80 million, went to him. But O'Keeffe's single surviving sister and one of her nieces, June O'Keeffe Sebring, thought the whole thing rather fishy. They sued Hamilton after the artist's death, claiming he had exerted undue influence. They certainly had a case, for O'Keeffe showed signs of dementia and had, over the years, told many people that she intended to leave the majority of her artwork to museums. Yet Sebring barely knew her famous aunt, and the family's motives hardly seem completely pure, either.

Hamilton eventually decided to settle the case out of court, but don't feel too sorry for him. He ended up with about $15 million. Meanwhile, the largest portion of O'Keeffe's estate went to the Georgia O'Keeffe Museum in Santa Fe, which holds more than one thousand of her paintings.

ARTIST IN THE BUFF

The Stieglitz family owned a house on Lake George in the Adirondack Mountains, and in the 1920s Stieglitz started taking O'Keeffe along for summer trips to the lake, where they were joined by numerous aunts, uncles, nieces, nephews, and cousins. O'Keeffe, who liked her space, found the influx of chatty, combative in-laws exasperating. She was particularly irritated by all the children, whom she didn't hesitate to slap when they got on her nerves. To get some peace, she would work in a makeshift studio she called the Shanty, from which others were strictly banned.

Once, some of Stieglitz's nieces and nephews tiptoed into the Shanty's forbidden territory and peeked through the window. What they didn't know was that O'Keeffe preferred to paint in the nude. The kids let out startled gasps, attracting the artist's attention. An enraged (and still unclothed) O'Keeffe emerged shrieking and brandishing a paintbrush as the children ran away as fast as their little legs would carry them.

M. C. ESCHER

JUNE 17, 1898–MARCH 27, 1972

ASTROLOGICAL SIGN:
GEMINI

NATIONALITY:
DUTCH

STANDOUT WORK:
RELATIVITY (1953)

MEDIUM:
LITHOGRAPH

ARTISTIC STYLE:
REALISM? OP ART? HE'S HARD TO PLACE.

SEE IT YOURSELF:
MASTER PRINTS ARE ON DISPLAY AT SEVERAL MUSEUMS, INCLUDING THE NATIONAL GALLERY OF ART IN WASHINGTON, D.C., THE NATIONAL GALLERY OF CANADA, AND THE ESCHER MUSEUM AT THE HAGUE.

"ARE YOU REALLY SURE THAT A FLOOR CAN'T ALSO BE A CEILING?" **◀ QUOTABLE**

*I*t had been a long while since the days when Leonardo da Vinci spent so much time exploring geometry problems that he couldn't concentrate on his paintings. Few artists had cared much about math, except to compare their commissions to their bar tab. And then along came M. C. Escher.

Escher didn't start out as the mathematician's artist—he was a print-maker, fascinated with depictions of the Italian countryside—but a visit to a Moorish palace and a glimpse at a fascinating world of interlocking patterns revealed that math could be used to create art. The results were bizarre, fascinating works that to this day are more popular among the lab-coat set than museum curators.

MATH'S HERO WAS A MATH FAILURE

Maurits Cornelis Escher was born into a prosperous Dutch family in Leeuwarden, the youngest son of a successful civil engineer. The family moved to Arnhem when he was five. At school he did poorly in every class but art, failing math and geometry. In 1919 Escher enrolled at the Haarlem School of Architecture and Decorative Arts, where his father hoped he would study architecture. He quickly switched his focus to printmaking, thus the world has been robbed of Escher's architecture everywhere except on paper. (One can't help but wonder where the stairs would have started and ended.) He finished school in 1922 and set off on a trip to Italy. So entranced was the young artist by the Italian hills that he decided to settle there. He produced print after print of tiny Italian villages and craggy hillsides, without particular commercial success. He was more successful in love, falling for a young Swiss woman named Jetta Umiker; they married in 1924 and had three sons. The family's happy life in Rome was disrupted by the rise of fascism, prompting a move to Switzerland, where they lived for two years before relocating again to a suburb of Brussels, Belgium.

TITILLATING TESSELLATIONS

Escher seemed to have reached the artistic limits of his landscapes when a summer visit to Spain provided a new source of inspiration. In 1936 he boarded an ocean freighter and sailed around the Spanish coast, a trip he got for free in exchange for making prints of the company's ships and ports

of call. Along the way he paused to draw, with one rest stop bringing him to the Moorish palace of the Alhambra in Granada.

Muslim art is, by religious mandate, nonrepresentational, and so over the centuries Islamic artists have developed intricate abstract forms. The Alhambra includes several magnificent tessellating tile works in which each plane is divided into interlocking geometric shapes. Escher was fascinated by the tessellations and spent hours sketching the tiles. Upon returning home, he struggled for weeks to create tessellations as beautiful and complex as those he had seen in Granada, but the process was a time-consuming matter of trial and error. Escher confided his difficulties to his brother Berend, a professor of geology at Leiden University, who immediately recognized that Escher's tessellations were mathematically related to concepts in crystallography, the study of how crystals form. Berend sent his brother a list of articles on crystallography and plane symmetry, the study of two-dimensional symmetry and repeating patterns. Escher didn't quite understand all the math (he'd failed algebra, remember?), but he intuitively understood the concepts described within.

Soon he was off, applying the new mathematical concepts to his artwork. Once he mastered tessellations, he started experimenting with subtle variations: A tessellation of fish and birds became a gradual metamorphosis between one creature and the other. Why stop with two-dimensional surfaces? Escher tried tessellations on a sphere, carving interlocking swimming fish onto a wooden beech ball. Then he depicted three-dimensional tessellations on a flat surface by creating elaborate graphs.

SAFETY IN NUMBERS

The outbreak of World War II interrupted these enjoyable artistic/mathematic musings and sent the family scrambling from Brussels to Baarn, in the Netherlands. Food was short, and the Nazi presence frightening. Escher's Jewish art teacher from college, Samuel de Mesquita, was seized and killed. Escher responded by turning inward. Rather than depict the real world, he created an imaginary one. His imagination was a far more logical place than the fantasy land of the Surrealists, although it was just as odd. Take *Relativity* (from 1953 but based on work begun during the war years): Figures in a building are shown walking up and down stairs and along corridors. Nothing seems unusual, until you real-

ize that the image is impossible: Every surface is at once a floor, a ceiling, and a wall. On one staircase, people walk on both the top and the bottom of the stairs.

Escher had again happened upon a field usually reserved for scientists: optical illusions. By providing conflicting clues, his art confuses the brain, which tries to make sense of what it sees but fails. *Waterfall*, of 1961, features a precisely drawn, but physically impossible, scene of a waterfall feeding itself. We want to believe that the series of zigzagging channels is ascending—one corner is clearly positioned above another—but ignore the corners and what you're left with is a flat channel that can't possibly carry water up. Look at the image long enough and your brain starts to hurt.

> MICK JAGGER IMPLORED M. C. ESCHER TO DESIGN THE COVER OF THE NEXT ROLLING STONES ALBUM, BUT THE OLD-WORLD GENTLEMAN-ARTIST WAS TURNED OFF BY THE ROCKER'S PRESUMPTION IN ADDRESSING HIM AS "MAURITS."

REVENGE OF THE MATH NERDS

For most of his life, Escher worked without recognition, a fact that certainly had a lot to do with the division between graphic arts, such as printmaking, and fine arts, such as oil painting. Plus there's the simple fact that Escher's work was downright odd.

Perhaps appropriately, mathematicians were the first to discover the artist. In 1954, an exhibition of his work was held in Amsterdam to coincide with the International Congress of Mathematicians. The math people recognized immediately what Escher was trying to do—and they loved it. Scientists started inviting him to lecture at colleges and universities, and by the late 1950s he was struggling to find time to create new designs amid his busy touring schedule. Ill health started to trouble him in the 1960s, and he made his last lecture trip to the United States in 1964. In 1968, his wife of forty years up and left for Switzerland; apparently she had never liked living in Baarn. (Their son said of the split, "She was tired of playing second fiddle.") In 1970, Escher moved to a home for retired artists, where he died in March 1972.

Assessing Escher's influence is difficult. Even today, you're more likely to see an Escher print on the wall of a physics professor's office than in an art gallery. (The Museum of Modern Art in New York has none of his work in its collection.) Yet Escher's work took root in popular culture and pops up everywhere from episodes of *The Simpsons* to the *Tomb Raider* movies. There's a definite geek element to his fan base—mathematicians still write articles based on his work—so maybe it's not surprising to find Escher references in such eccentric places as video games, comic books, and Japanese *manga*.

MATH AND THE MODERN ARTIST

The conversation about math wasn't one way, for Escher also contributed to mathematical research with his exploration of tessellation and symmetry. In 1958 he published a paper titled "Regular Division of the Plane," in which he detailed his mathematical approach to artwork. It summarized how he categorized combinations of shape, color, and symmetry and set out pioneering methods that were later adopted by crystallographers.

CALL ME SIR, MICK

In the 1960s, as Escher's popularity was growing, Mick Jagger decided it would be a great idea to have the artist design the cover of the next Rolling Stones album. The rock-and-roller wrote a letter that began, "Dear Maurits . . . " Escher, a man of an earlier, more formal time, replied, "Don't call me Maurits."

SO THAT'S WHAT IT STANDS FOR

Escher really hit the big time in 2006 when he got a mention in the Weird Al Yankovic hit "White & Nerdy," from *Straight Outta Lynwood*. A parody of the hip-hop single "Ridin'" by Chamillionaire and Krayzie Bone, the song features Weird Al reveling in his nerdiness by collecting comic books, playing Dungeons & Dragons, and editing Wikipedia entries. In one line, he claims, with sincerity that many a geek could appreciate, "M.C. Escher, that's my favorite M.C."

THROW-AWAY ART

Many modern artists dismissed the work of M. C. Escher, who happily returned the favor. He deemed the emotional, spontaneous art being created during the mid-twentieth century as sloppy and incomprehensible and complained that his contemporaries could never explain why they painted what they did. When several of Escher's prints were exhibited alongside the works of modern Dutch artists, he scribbled on a catalog that he sent to a friend, "Whatever do you make of such a sick effort as this? Scandalous! Just throw it away when you have looked at it."

Curiously, one of the few artists that Escher admired was Salvador Dalí. Despite their opposite personalities, Escher approved of Dalí's skill in drawing, stating: "You can tell by looking at his work that he is quite an able man."

RENÉ MAGRITTE

NOVEMBER 21, 1898–AUGUST 15, 1967

ASTROLOGICAL SIGN:
SCORPIO

NATIONALITY:
BELGIAN

STANDOUT WORK:
SON OF MAN (1964)

MEDIUM:
OIL ON CANVAS

ARTISTIC STYLE:
SURREALIST

SEE IT YOURSELF:
NOT POSSIBLE—IT'S IN A PRIVATE COLLECTION

QUOTABLE

"I DETEST RESIGNATION, PATIENCE, PROFESSIONAL HEROISM, AND OBLIGATORY BEAUTIFUL FEELINGS. I ALSO DETEST THE DECORATIVE ARTS, FOLKLORE, ADVERTISING, VOICES MAKING ANNOUNCEMENTS, AERODYNAMISM, BOY SCOUTS, THE SMELL OF MOTHBALLS, EVENTS OF THE MOMENT, AND DRUNKEN PEOPLE."

*T*here's nothing very dramatic to say about René Magritte: His was not an exciting life. While Marcel Duchamp nurtured a public persona and Salvador Dalí produced one stunt after another, Magritte stayed home in Brussels, working. He didn't sleep around like Pablo Picasso, he didn't get involved in radical politics like Diego Rivera, he wasn't mean-tempered like Georgia O'Keeffe. He was faithful, quiet, polite, and self-effacing.

Instead, Magritte saved up his oddities and poured them into his art, creating images as astounding as anything the most extravagant avant-garde artist could imagine. Trains emerge from fireplaces, tubas burst into flames, and rocks hover effortlessly with the clouds. Magritte hid an outrageous imagination behind a flawless persona, like a man in a bowler hat hiding his face behind a shiny green apple.

MILD-MANNERED MAN

René-François-Ghislain Magritte was born in Lessines, Belgium, the first of three sons of a tailor named Léopold and his milliner wife, Régina. The family later moved to Châtelet, and there Magritte's apparently happy childhood ended when his mother drowned herself in the river Sambre. It's unknown what prompted this horrific event, and Magritte rarely spoke about the suicide. The only comment he made as an adult was that, as a child of twelve, he felt a certain pride at being the center of a drama.

Léopold then moved the family to Charleroi, where René graduated from high school. Apparently he had been drawing for some time, and soon he enrolled at the Académie des Beaux-Arts in Brussels. In 1920, while walking in the Brussels botanical gardens, he encountered Georgette Berger, a young woman he had met several years before at the annual town fair; to shock her, he told her he was on his way to see his mistress. Either Georgette didn't believe him or it didn't matter. They were married two years later.

The early 1920s were financially difficult for the artist. As well as doing promotional work and painting sheet music covers, Magritte took a job designing wallpaper. He also began to develop his own style. In a magazine he saw *The Song of Love*, a painting by Giorgio de Chirico, which depicts a limp surgeon's glove, at enormous scale, hanging on a wall next to the head of a classical statue. The painting showed him "the ascendancy of poetry over painting" and moved him to tears. Artists since James Whistler had

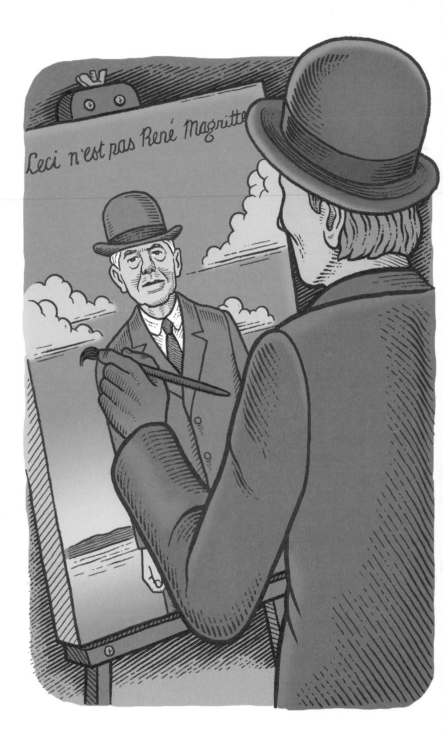

created art for art's sake, but Magritte wanted to create art that was about ideas. Aesthetics, for him, took a back seat to concept.

THE DREAMER AS SURREALIST

Soon Magritte was creating paintings with remarkable detail and a verisimilitude possible only in dreams. In *Dangerous Liaisons*, a nude woman faces us, holding a mirror that seems to reflect the same woman from the back. In *Attempting the Impossible*, an artist paints a nude woman who seems to stand next to him in a room, except one of her arms has yet to be painted. Many works display Magritte's unique pictorial language, such as a veiled woman, balustrade-like pillars, a racing jockey, and, oddly enough, a flaming tuba.

The late 1920s started out well. A Brussels dealer signed Magritte to a contract, freeing him from commercial work, and in 1928 he and Georgette moved to Paris to join like-minded Surrealist artists. The Surrealists combined the nonsense of Dada with an interest in the work of Sigmund Freud and an emphasis on the unconscious. Their leader was André Breton, a trained psychiatrist who learned Freud's theories while working with shell-shocked soldiers during World War I. Breton practiced free association and dream interpretation and encouraged the use of dreamlike images in art.

> HIMSELF THE BLAND, BAFFLING MASTER OF ANONYMITY, RENÉ MAGRITTE CREATED AND ENDLESSLY REPRODUCED THE REMARKABLE SYMBOL OF A MODERN ANONYMOUS EVERYMAN: THE INSCRUTABLE MAN IN THE BOWLER HAT.

Magritte immediately joined the endless Surrealist café talk, although he had no interest in unplanned art such as automatic drawing; he wasn't interested in exploring the subconscious mind. Instead, he wanted to play with our understanding of reality by creating images that violate reality. In reality, rocks are heavy, but in Magritte's surreality, enormous boulders float effortlessly. In reality, you can tell the difference between a painting and a scene outside a window, but in Magritte's surreality, a canvas placed before a window is indistinguishable from the view outside. The other Surrealists ate this stuff up, but Magritte grew annoyed with Breton's endless organizing.

BOWLED OVER

After Magritte's Brussels dealer closed his gallery, the artist lurched into a financial bind. In 1930, he and the family returned to Belgium, where he resumed commercial art to pay the bills. There Magritte remained, residing in a simple Brussels apartment. Where many Surrealists promoted the notion that their very lives were works of art, Magritte preferred to be thought of as a craftsman, a bourgeois attitude that others found baffling.

Ultimately, Magritte created a remarkable symbol for his own modern anonymity: a man in a bowler hat and suit, a sort of everyman, his identity subsumed by his image. Often his features are obscured; either he turns his back to the observer or his face is covered by hovering objects, from pipes (*Good Faith*) to birds (*The Man in the Bowler Hat*) to apples (*The Son of Man*). Other times the bowler-hatted man is duplicated, with two or three engaged in conversation. At the extreme is *Golconde*, in which hundreds fall like rain over a city.

For decades, Magritte continued to live quietly with Georgette, but by the 1960s retrospectives were opening at museums worldwide and his paintings were selling for significant sums. In 1965 ill health forced him to cut back on his artistic production, and he died of pancreatic cancer on August 15, 1967.

As well as influencing other Surrealists, Magritte's work profoundly affected the midcentury Pop artists who applied his straightforward painting style to their own work. Meanwhile, popular culture discovered in Magritte a powerful source of imagery. Rock bands adored putting his work on album covers, and various of his paintings appear on recordings by such diverse artists as Jackson Browne and Styx.

Magritte is unusual among twentieth-century artists: Many people know the art but not the artist. He stands out among so many exotic personalities by not standing out. The master of anonymity, Magritte probably would have preferred it that way.

THIS IS NOT WHAT IT IS

In the late 1920s, René Magritte started exploring the connection between words and images in his art. In 1929, he completed *The Treachery of Images*, which is a simple depiction of a smoker's pipe so carefully drawn it could be an illustration for an advertisement. Below the pipe, written in simple cursive, are the words "Ceci n'est pas une pipe." ("This is not a pipe.")

Get it? It's a pipe, but it's not a pipe, because a real pipe can be picked up and packed with tobacco. This is just an image of pipe, not the actual object. Magritte plays with the idea that images and words are not equivalents; they evoke one another, but they can't be substituted for one another. This was Magritte's favorite visual joke, one he played with for the rest of his life.

AN IMPRESSIONABLE SURREALIST

In May 1940, Nazi troops invaded Belgium, beginning an occupation that would last until the country's liberation in 1944. Artists reacted in varying ways to the horrors of occupation. Picasso remained defiant, but Matisse retreated into beauty. Magritte's response was closer to Matisse's—he turned suddenly to a sort of Impressionism, with an emphasis on light, color, and beauty hitherto absent from his canvases. The paintings were still Surrealistic; in one, a nude woman's legs become the fins of a mermaid, and in another a reclining nude is painted in all the colors of the rainbow. Magritte said of the period, "The experience of war taught me that what matters in art is to express charm. I live in a very disagreeable world, and my work is meant as a counter-offensive."

The only problem? Critics hated the paintings. French critics in particular thought that Magritte was exploiting and mocking the late style of Auguste Renoir. Even today organizers of exhibitions showcasing his work often leave out the neo-Impressionist canvases. Magritte resigned himself to abandoning his experimentation and returned to his old style.

SALVADOR DALÍ

MAY 11, 1904–JANUARY 23, 1989

ASTROLOGICAL SIGN:
TAURUS

NATIONALITY:
SPANISH

STANDOUT WORK:
THE PERSISTENCE OF MEMORY (1931)

MEDIUM:
OIL ON CANVAS

ARTISTIC STYLE:
SURREALIST

SEE IT YOURSELF:
MUSEUM OF MODERN ART, NEW YORK

QUOTABLE

"EVERY MORNING UPON AWAKENING, I EXPERIENCE A SUPREME PLEASURE: THAT OF BEING SALVADOR DALÍ, AND I ASK MYSELF, WONDERSTRUCK, WHAT PRODIGIOUS THING WILL HE DO TODAY, THIS SALVADOR DALÍ."

If all the world's a stage, then one of the greatest performers to walk its boards must be Salvador Dalí. We call Dalí a Surrealist, but perhaps a better description would be performance artist, the first ever. Everything Dalí did was calculated to amaze, astonish, and amuse. Even his appearance was more costume than clothing. Take his mustache, which he grew to a remarkable length and waxed into sharp tips, or his suits, which were made of brilliantly colored velvets encrusted with golden embroidery.

Was there a real man behind the mask? Maybe. Occasionally we get a glimpse of a vulnerable figure clinging for support to his domineering wife and expressing a longing for genuine spirituality. But the world loved the crazy Dalí, the man of the mustache and the embroidered waistcoats, and so that's what he gave them.

The great tragedy of his life took place before his birth. In 1901, the Dalí family of Figueres, Spain, had a son named Salvador, after his father, but he died at twenty-one months. Nine months and ten days later, the family had another son, whom they also named Salvador, who survived. But the parents never really recovered from the first loss. They talked nonstop about the dead baby, convincing the new Salvador he was only second-best. Perhaps not unexpectedly, the boy developed a horrific temper and preferred to leave excrement in the hallway than to use the bathroom. School, too, was an unmitigated disaster.

TO BE YOUNG AND SURREAL

As a boy Dalí took drawing classes and, showing promise, had his first public exhibition at his local hometown theater in 1919. The talented young artist moved to Madrid in 1922 to enroll at the School of Fine Arts. After a few years of quarrelling with his professors, Dalí was expelled for refusing to take a final exam, claiming that none of the faculty were competent to judge him.

He longed for greener pastures: Paris and the Surrealists. Surrealism was the hip new art movement that preached the nonsense of Dada, the psychoanalysis of Freud, and the politics of Marx. Dalí was particularly fascinated by its emphasis on the subconscious and wanted to use his meticulous drawing skills to create absurd and irrational images. In 1929, he boarded a train for France, but, to his dismay, instead of welcoming him as the conquering hero, the Surrealists didn't even notice he'd arrived. He made only one friend, the Surrealist poet Paul Éluard, whom he invited to

visit him that summer in Cadaqués, the village on the Catalan coast where the Dalí family spent their holidays.

Dalí returned to Spain in a deep depression, but not long afterward Éluard arrived with his wife, Gala. Born Elena Ivanova Diakonova in Russia, Gala Éluard was some ten years older than Dalí (she lied about her age); she was also dynamic, imperious, and insatiable. Éluard and Gala had met as teenagers at a tuberculosis sanitarium in Switzerland, and she later crossed Europe during the chaos of World War I to marry him. After the war, Éluard became a leader in the Dada movement, and Gala reveled in the role of muse and mistress, although by 1929 she was growing frustrated at her husband's limited financial prospects.

FOR THE LOVE OF GALA

Initially Gala dismissed Dalí (she said he looked like a professional Argentine tango dancer), but then she saw his paintings. That's when she locked onto him like a laser-guided missile. She was one of the first to realize the extent of his talent and to appreciate that talent could produce incredible wealth. Meanwhile, Dalí was so smitten with her that he paraded about with a geranium behind his ear, concocted a bizarre perfume from dung, and for some reason shaved his armpits until they bled. Their sexual tendencies seemed to be at odds; close friends described Gala as a nymphomaniac, whereas Dalí abhorred being touched and seemed to have homosexual leanings. And yet, the two functioned well together: Dalí liked watching, and Gala loved being watched. Éluard accepted her defection with remarkable grace; of course, it helped that she still liked to have sex with him. In 1932, Gala and Éluard divorced so that he could remarry, and two years later Dalí and Gala were wed in a civil ceremony.

PERSISTENCE PAYS OFF

Henceforth Gala devoted all her energies to promoting Dalí. She became an expert bargain shopper, for the pair lived in incredible poverty, subsisting on Dalí's rare sales and a few checks from Éluard. In summers they returned to Spain, staying in a tiny fisherman's hut in Port Lligat across the harbor from Cadaqués. Dalí completed some of his most significant works during those early summers, including *The Persistence of Memory*. The eerie, ominous work is straight of out Dalí's subconscious. On a dark plain, a lump of

flesh that might be a face lies next to a table or block from which a barren tree thrusts. Over the face, tree, and table droop pocket watches that seem to have softened and melted into jelly. The idea for the watches came to the artist while looking at a wheel of Camembert cheese softening after dinner. After he painted the work, he asked Gala if it was an image she would remember; she replied that no one could ever forget it. And so Dalí gave the work its title, for the persistence of his own creation in the viewer's mind.

The 1931 exhibition featuring *The Persistence of Memory* was a huge hit. Gala and Dalí became the darlings of the smart set, who adopted the artist's bizarre mode of talking (a society grande dame might say of a concert by Stravinsky, "It was beautiful, it was gluey! It was ignominious!"). But not everyone appreciated Dalí's growing fame. Other Surrealists felt he had hijacked their movement. Then Dalí started making outrageous statements about, of all people, Adolf Hitler, claiming there was nothing more Surreal than the dictator. (Hitler didn't return the compliment, stating that Surrealists should be sterilized or executed.)

The Communist Surrealists insisted that Dalí retract his statements, but he protested that if Surrealism was about exploring dreams and taboos without censorship, then he had every right to dream about Hitler.

ALWAYS KEEP THEM GUESSING

If Dalí dreamed of Hitler, he certainly didn't want to live under his rule. When German forces marched toward Paris at the start of World War II, he high-tailed it as far from the Nazis as possible. In August 1940, he, Gala, and an astounding amount of luggage sailed from Lisbon for New York.

The couple split their time between New York and Pebble Beach, California, with U.S. magazines breathlessly following their every move. Yet, even as Hollywood celebrities and New York socialites embraced him, Dalí began to change his style. He painted Gala in a realistic, even beautiful portrait, with nary a melting watch, pork chop, or flying elephant to be seen. He painted religious themes—a crucifixion, a Madonna (modeled, however improbably, by Gala), a Last Supper. Friends were baffled. Dalí, spiritual? Dalí, serious? The thought of Dalí in prayer was ridiculous.

What Gala found ridiculous was the thought of Dalí pursuing anything other than his incredibly lucrative work. Long gone were the days when she scoured Paris markets for the cheapest bread; now she dined only at the

finest restaurants and dressed in Chanel couture. She could always persuade Dalí to take on even the most outlandish (and well-paid) commissions. He designed the dream sequences for the Alfred Hitchcock movie *Spellbound* (although they were later reshot) and partnered with Walt Disney on a short animated film (although Disney later canned the project). He designed jewelry (a melted watch), furnishings (the "lobster phone"), and furniture (a sofa modeled after Mae West's lips). His fame soared. No matter what stunt he pulled—arriving at a lecture in a white Rolls Royce filled with cauliflower, entering the rhinoceros cage at a zoo with a painting of a rhinoceros—reporters covered it and readers ate it up.

COURT OF MIRACLES

If Dalí's greatest fans in the 1930s had been Parisian high society, in the '60s he was adored by hippies who flocked to Port Lligat with plentiful supplies of marijuana and LSD. Dalí labeled his entourage the Court of Miracles and fawned over what one biographer calls "a fluctuating cast of dwarf hermaphrodites, cross-eyed models, twins, nymphets, and transvestites."

> SALVADOR DALÍ ARRIVED FOR A LONDON LECTURE ACCOMPANIED BY TWO RUSSIAN WOLFHOUNDS AND DRESSED IN AN OLD-FASHIONED DIVING SUIT. HE NEARLY SUFFOCATED BEFORE FRIENDS FREED HIM FROM THE HELMET.

And then the sex really got out of hand. Gala, now in her seventies, adored having access to so many fresh young men, and Dalí arranged "erotic Masses," orgies in which rooms were devoted to different groupings. All this decadence was enormously expensive, and Gala, who didn't hesitate to lock Dalí in his studio when commissions came due, had to invent increasingly elaborate ways to make money. She had her husband sign hundreds of blank sheets of paper that could later be printed with "limited edition" lithographs.

Old age finally caught up with Gala and Dalí. Her skin started erupting with horrible lesions along the sutures left from her multiple facelifts. She died in June 1982 of heart failure. Dalí spent the next six years waiting to join her. He refused to eat, wept constantly, and spent his days lying alone

in the dark. A bell was mounted by his bed to summon a nurse always on duty, and at night he would ring it incessantly. The annoyed nurses finally had the bell replaced with a light, and one night he pressed the button so many times it short-circuited and set his bed on fire. The staff found him crawling in a haze of smoke and flames with burns on nearly 20 percent of his body. Everyone assumed the burns would kill him, but he survived, recovering enough to give an interview to *Vanity Fair* in 1986. It was his last rally, though he hung on three more years, dying on January 23, 1989.

What, today, can we make of Salvador Dalí? Many art historians dismiss his post–World War II work as self-indulgent kitsch; some go further and deride his entire oeuvre. A recent critic described him as a "puerile pervert whose ability to generate undeserved fascination in the convoluted workings of his misanthropic mind continues to astonish." (Ow.) What no one can deny is his influence: Dalí invented the idea of life as art.

!

NOW I GET IT!

In the 1930s, the Dalís' social circle expanded to include aristocrats graced with the most distinguished family trees. At one dinner party, Dalí was cornered by Madina di Visconti, who tried to explain that she was descended from Julius Caesar. Frustrated that he seemed not to appreciate her illustrious heritage, she said, "You must understand that my mother was a Pappadopoli." Suddenly Dalí seemed to get it. "Oh! Now I understand!" he exclaimed enthusiastically. Then he turned to a companion and asked in a stage whisper, "What exactly is a 'pappadopoli'?" The friend replied, "A Pappadopoli is the name of an aristocratic Venetian family. What else do you suppose it could be?" "Oh!" said Dalí. "You must excuse me, Madina! I though a pappadopoli was something like a duckbilled platypus."

A BREATH OF FRESH AIR

Once at a lecture in London titled "Paranoia, the Pre-Raphaelites, Harpo Marx, and Phantoms," Dalí made a magnificent entrance, as usual. Holding two white Russian wolfhounds on a leash in one hand and a billiard cue in the other, he was dressed in an old-fashioned diving suit and helmet topped with a Mercedes radiator cap.

He tried to speak but soon realized that, without a supply of oxygen to the helmet, he was unable to breathe. The audience blithely watched him struggle for air, thinking it was part of the act, but finally two friends realized something was amiss. They frantically attempted to hammer off the bolts on the helmet. Finally, a stagehand arrived with a wrench and released the nearly suffocated Dalí.

YOU WANTED A SPECTACLE, YOU GOT A SPECTACLE

During World War II, the Dalís befriended a publicist named Herb Caen, who proposed they hold a benefit party for artists in Europe. Dalí embraced the idea: They would throw a Surrealist ball par excellence. He quickly presented a list of his requirements to Caen, including two thousand pine trees, four thousand gunny sacks, the largest bed in Hollywood, a wrecked automobile, several nude store mannequins, a dozen or so wild animals including a baby tiger and a giraffe, and twelve hundred shoes in which to serve the first course. The redoubtable Caen went to work. He found a bed for ten on a Hollywood sound stage, a wrecked car at a junkyard, and mannequins from a department store. A zoo agreed to supply all the animals except the giraffe—it was too tricky to transport.

Guests from throughout the United States arrived for the "Surrealist Night in an Enchanted Forest," including the Vanderbilts, Alfred Hitchcock, Bob Hope, Bing Crosby, Ginger Rogers, and Clark Gable. But when it was all over, Herb was left with an arm broken in three places (was it the wild animals?) and a bill that far exceeded the revenues. No money was left to send to starving European artists.

FRIDA KAHLO

JULY 6, 1907–JULY 13, 1954

ASTROLOGICAL SIGN:
CANCER

NATIONALITY:
MEXICAN

STANDOUT WORK:
*SELF-PORTRAIT WITH THORN NECKLACE
AND HUMMINGBIRD* (1940)

MEDIUM:
OIL ON CANVAS

ARTISTIC STYLE:
SURREALIST

SEE IT YOURSELF:
HARRY RANSOM HUMANITIES RESEARCH CENTER
AT THE UNIVERSITY OF TEXAS AT AUSTIN

QUOTABLE *"I PAINT MY OWN REALITY."*

Frida Kahlo recalled that in her life she had two great tragedies. One was the horrific trolley accident in her youth that broke her spine and pelvis in multiple places, crushed her foot, and doomed her to a lifetime of suffering and pain. The other, she said, was Diego. The (two-time and two-timing) husband who tormented her with his multiple infidelities. "Diego," she said, "was by far the worst."

Yet both disasters brought her unexpected rewards. Her long convalescence gave her the opportunity and the will to paint, and in pain she found her most important theme. Despite his many flaws, Rivera gave her financial support, worldwide exposure, and enduring affection. In the end, Kahlo's accidents were crucial in shaping her talent. You wouldn't wish her suffering on anyone, but without it, would we have the brilliance of her art?

ACCIDENT #1

Guillermo Kahlo and Matilde Calderón y Gonzalez made an odd pair. He was a German Hungarian atheist Jew and she was a Mexican Catholic of indigenous origin. The couple had four daughters, the third being Magdalena Carmen Frieda. (With the rise of anti-Fascist sentiment in Mexico in the 1930s, she changed the German spelling of her name to Frida.) The little girl suffered from an illness (most likely polio) that weakened her right leg. In 1923 her father enrolled her in the most prestigious secondary school in Mexico, the Escuela Nacional Preparatoria, where she developed an interest in leftist politics and observed with fascination the work of an artist painting a mural for the school's auditorium: one Diego Rivera.

Kahlo's plans for the future were cut short on September 17, 1925, when the bus she was riding was rammed by an out-of-control electric trolley, and she was impaled by an iron rod. Her injuries included several broken vertebrae, a broken collarbone, two broken ribs, and a shattered pelvis; her right leg had eleven fractures, and her right foot was crushed. The rod had pierced her entire body, exiting through her vagina, causing Kahlo to later say that the accident took her virginity. She spent a month in the hospital, immobilized in plaster casts and traction, followed by several months in bed at home. Boredom was as much a torment as was pain, and so she cast about for something to occupy herself. She decided to paint. Other than attending required art classes at school, Kahlo had no artistic experience and, apparently, no artistic inclinations. Yet lying in plaster casts and

metal corsets, she suddenly developed a passion for art matched only by her prodigious talent.

MARRIED TO THE DEVIL

Every artist needs validation, however, so she decided to approach the one artist she knew, Diego Rivera. In 1928 she located him at work on his current mural, showed him her canvases, and asked if she had any talent. Rivera's answer: absolutely.

The rest was, perhaps, inevitable. Rivera was incapable of not flirting with a pretty girl, and soon the two were embroiled in a passionate affair. He quickly proposed marriage, and she accepted. One might have expected Kahlo's parents to be concerned about the marriage of their twenty-two-year-old daughter to a forty-three-year-old philanderer, but in fact they were relieved to have found a man who could take care of their Frida. She would need medical care for the rest of her life, and Rivera could afford the treatments—though that didn't stop Guillermo from dropping a word of warning. He took Rivera aside in confidence and said of his daughter, "She is a devil." "I know it," replied Rivera. "Well, I've warned you," said Guillermo.

The couple married on August 11, 1929, and the next few years were peaceful and happy. Rivera worked on a series of murals in Cuernavaca, and Kahlo quickly picked up his interest in indigenous Mexican culture. She took to dressing in the clothing favored by the women of the Tehuantepec region: an embroidered and ruffled white blouse, a long purple or red velvet skirt, and necklaces made of gold coins. She painted little in the first few years of marriage, although it doesn't seem she missed it, and soon found herself expecting a child. When doctors told her she would be unable to deliver a baby normally because of her damaged pelvis, she agonized over whether to continue the pregnancy. At three months, however, doctors announced that the fetus was incorrectly positioned and recommended an abortion. Despite Rivera's objections, she tried four more times to have a child, but each time it ended in miscarriage or medically recommended abortion. So Kahlo poured her maternal longings into the care of her nieces and nephews and her enormous collection of dolls.

THE KING AND QUEEN OF MELODRAMA

Another demon tormented Kahlo: Rivera's constant infidelities. It was bad

enough when he slept with strangers, but then he had an affair with her very own younger sister, Cristina. Kahlo was devastated, but henceforth their relationship was on new terms: Each was free to have sex with whomever they wanted.

For a while, this arrangement actually seemed to work, and Kahlo had several affairs with men and women alike. The one with the greatest consequences was her affair with the exiled Russian revolutionary Leon Trotsky. Kahlo nicknamed him *el viejo* (the old man) and found his vigorous, intellectual personality irresistible. Of course, conducting an affair with Rivera's hero was also a most effective revenge.

Meanwhile, Kahlo's art had become increasingly refined and highly personal. She painted her own experience in an artistic exorcism that perhaps only Edvard Munch would have understood. Even relatively straightforward works such as *Self-Portrait with Thorn Necklace and Hummingbird* have multiple layers of meaning. In this work, a necklace like Christ's crown of thorns pierces her neck, and a pendant takes the form of a hummingbird, symbol of the souls of Aztec warriors killed in battle.

The art world was quick to take notice of the fantastical images Kahlo produced. In 1938, a New York gallery owner invited her to hold a one-woman show, in which she was celebrated as a painter in her own right. She went on to a second show in Paris.

While Kahlo was away, Rivera learned of her affair with his political hero and felt deeply betrayed. Soon after she returned in 1939, the couple began divorce proceedings. Various explanations have been offered for the separation—Kahlo's affair with Trotsky, Rivera's affair with the American actress Paulette Goddard—but only Kahlo and Rivera knew the truth, and they never really explained. Even once divorced, not much changed, and they continued to see each other almost every day. The biggest difference for Kahlo was that she wanted to be financially independent of Rivera, so she painted more than ever.

Unexpectedly, the ever-troublesome Trotsky once again changed their lives. On August 20, 1940, an agent of the NKVD (a precursor to the KGB) snuck into his house and struck him on the head with an ice axe. He died the next day. Kahlo had met the assassin in Paris while circulating in Communist circles, so she was interrogated by the police for twelve hours. Rivera, working in San Francisco, urged her to join him in California, so she packed up and traveled to meet him. The two remarried on December 8. Kahlo knew Rivera could not remain faithful to her, and she didn't feel com-

pelled to remain faithful to him either, but she knew he loved her and she loved him. A good friend (and lover) said of the remarriage, "He gave her something solid to lean on."

FRIDAMANIA

Back in Mexico, Kahlo painted between bouts of illness. Many treatments to straighten her spine seemed worse than the disease, such as having sand bags attached to her feet while being suspended in a nearly vertical position for almost three months or being hung from steel rings in the ceiling. Nothing worked. In the 1950s, she spent almost a year in a Mexico City hospital. When she could paint, a frequent subject was her own body in pain. *The Broken Column* of 1944 depicts a nude Kahlo in one of her medical corsets. Her skin is pierced by nails and her body seems to open to reveal a shattered Greek column in place of her spine. On her face are pale tears.

There was one triumph left: In the spring of 1953, a gallery in Mexico presented the only one-woman show of her work during her lifetime. Doctors told her she was too ill to attend, but Kahlo insisted, so Rivera arranged a large four-poster bed in the middle of the gallery. Kahlo arrived by ambulance to crowds of fans. She lay in the center of the excitement, her face ravaged from pain but exultant.

> FRIDA KAHLO'S HUSBAND, DIEGO RIVERA, USUALLY NEEDED ENCOURAGEMENT TO BATHE, SO SHE MADE A RITUAL OF SCRUBBING HER 300-POUND SPOUSE IN A BATHTUB FILLED WITH KIDDIE TOYS.

Later that same year, her right leg, infected and gangrenous, was amputated below the knee. She fell into deep depression and, at least once, tried to kill herself with an overdose. On a rainy July 2, 1954, she insisted that Rivera take her to a Communist rally against CIA intervention in Latin America. With Rivera pushing her in a wheelchair, she was a heroic figure of revolutionary zeal. But the price of such exertion was high. She wrote in her diary of the end she knew was near: "I hope the exit is joyful—and I hope never to come back." She died early on the morning of July 13.

Kahlo's influence waned during the decades immediately after her death, with Rivera becoming the more famous of the two. The balance started to

shift in Kahlo's favor in the 1980s with the rise of the Neomexicanismo movement, which celebrated her use of imagery from Mexican culture. Kahlo's fame increased in the 1990s when she was adopted as an icon by American celebrities; Madonna, Salma Hayek, and Jennifer Lopez all competed to portray the artist in a 2002 biopic. (Hayek won the part and was nominated for the best actress Academy Award.) The hubbub has been labeled "Fridamania" and deplored by those who think it cheapens her art, but others applaud the attention given to Kahlo as unprecedented for a woman artist.

HOW TO HARASS A CAPITALIST

In the 1930s, with Rivera working on mural commissions in the United States, Kahlo delighted in deliberately shocking their establishment hosts. At the home of Henry Ford's sister, she talked enthusiastically about Communism; when learning that another hostess was a devout Catholic, she made sarcastic quips about the Church. And when invited to a formal dinner in the home of Ford, an avowed anti-Semite, she waited for a quiet moment at the dining room table, then turned to him and asked sweetly, "Mr. Ford, are you Jewish?"

OUT OF THE MOUTHS OF PARROTS

Kahlo kept an enormous number of pets. She adored the little hairless Aztec dogs known as Xoloitzcuintli and mischievous spider monkeys. A friend recalled that when she visited Kahlo for lunch, a spider monkey promptly sat on her head and stole her banana. Kahlo also kept birds, including doves, an osprey, a pair of turkeys, and parrots. Her favorite parrot, named Bonito, liked to nap with her under a blanket and steal butter off the dinner table. Another large parrot was kept on the patio; someone had taught him to say "No me pasa la cruda!" ("I can't get over this hangover!"), and he squawked it over and over during dinner parties.

WHATEVER FLOATS YOUR RUBBER DUCKIE

When Kahlo first met Rivera, he was hard at work on a mural for her school. Fascinated by the engaging, and enormous, artist, she slipped into the auditorium and spent hours watching him work. School friends were baffled by her obsession with the middle-aged, overweight artist. When one day Kahlo announced her life's ambition was to have a child with Rivera, a friend protested that he was a "pot-bellied, filthy, terrible-looking" old man. Kahlo calmly replied, "Diego is so gentle, so tender, so wise, so sweet. I'd bathe him and clean him."

And that's exactly what she did. Rivera usually needed encouragement to bathe, and so Kahlo made a ritual of it, scrubbing down her three-hundred-pound spouse in a bathtub filled with children's toys.

PRE-COLUMBIAN ART

Just as Pablo Picasso and Henri Matisse drew inspiration from the art of Africa, Diego Rivera and Frida Kahlo found inspiration in the art of the Americas—except that for Kahlo and Rivera, it was the art of their own people. The pair gave Pre-Columbian art a respect most Europeans were slow to offer.

When the Spanish conquistadors poured into South and Central America in the early sixteenth century, they found empires rich with artistic traditions, but all the invaders cared about was their richness in gold. In 1520, German artist Albrecht Dürer got to see a stash of golden treasure stolen from the Aztecs on display in Brussels. Awed by the quality of the craftsmanship, Dürer wrote that he "marveled at the subtle genius of men in foreign lands." Pity no one agreed with him. The objects were melted down for the Spanish treasury.

Pre-Columbian art is hard to describe in general terms, since it encompasses the output of two continents and several millennia. The best-preserved early art is, not surprisingly, made from stone. The Olmec civilization (in what is today Mexico) produced masterful sculptors who created huge, mysterious portrait heads that scholars believe honored individual kings. Religion was certainly an important theme for most Pre-Columbian art, along with propaganda. The best thing to do after conquering another city-state was to commission a carving to celebrate the victory. Both the Maya and the Aztec carved intricate calendars that were beautiful as well as functional.

Rivera and Kahlo each adopted imagery from the art of their ancestors. Rivera's complex murals, with their multilayered compositions, echo many large pre-Columbian wall carvings, and Kahlo integrated Aztec symbolism into her paintings. Rivera acquired an enormous collection of pre-Columbian art and, to house it, built Anahuacalli, a mock Aztec temple/museum/studio, complete with a burial chamber intended to house his and Kahlo's ashes. Today, Anahuacalli is open to visitors, with Rivera's 52,000-piece collection on display. ■

JACKSON POLLOCK

JANUARY 28, 1912–AUGUST 11, 1956

ASTROLOGICAL SIGN:
AQUARIUS

NATIONALITY:
AMERICAN

STANDOUT WORK:
NUMBER 5, 1948 (1948)

MEDIUM:
OIL ON CANVAS

ARTISTIC STYLE:
ABSTRACT EXPRESSIONIST

SEE IT YOURSELF:
CAN'T; IT'S IN A PRIVATE COLLECTION

"WHEN I SAY ARTIST I MEAN THE MAN WHO IS BUILDING THINGS—CREATING, MOLDING THE EARTH, WHETHER IT BE THE PLAINS OF THE WEST OR THE IRON ORE OF PENN. IT'S ALL A BIG GAME OF CONSTRUCTION—SOME WITH A BRUSH—SOME WITH A SHOVEL— SOME CHOOSE A PEN."

QUOTABLE

Jackson Pollock couldn't get the pencil to do what he wanted. He would hunch over his sketchbook, grimacing with concentration as he tried to force it to obey his wishes. All around him, art students effortlessly whipped out drawing after drawing. Pollock couldn't even trace correctly. Yet, despite the visible disdain of fellow students, Pollock didn't quit. He knew he had something to say in paint—he just didn't know how to say it.

In time, he would show them all how much talent he truly possessed, along the way inventing the first truly American art movement, Abstract Expressionism. His success was short-lived, doomed from the start by his own self-destructive demons, but for a few amazing years, Pollock shoved his triumph in the faces of all those who had doubted him.

But he never did learn to draw.

JACK THE NIPPER

Roy Pollock was a hard-working Westerner without pretensions, but his wife Stella's reading of ladies' magazines had given her a glimpse of a life of elegance the family could not afford. Jackson was the baby of the family, born in 1912 in Cody, Wyoming, shortly before the Pollocks moved to Phoenix, Arizona. Roy gave all he could to a miserable dirt farm, but when hard times hit, Stella refused to economize and the farm was auctioned off. The family moved to California and lurched from failure to failure until Roy finally walked out in 1921. Jackson muddled through school, with art the only class that interested him, in part because his older brother Charles had set off for New York to become an artist. When Pollock was finally expelled from high school, Charles encouraged him to head east.

Pollock entered the Arts Student's League, but on top of his difficulty with drawing, he made little progress because of his frequent drinking. Despite Prohibition, New York provided endless opportunities to get utterly, completely blitzed, and Pollock seized them all. He was a mean drunk, picking fights with total strangers and running into the street to dare oncoming cars. Once he attacked Charles's paintings with an axe; frequently he groped unknown women. At one point he vanished for four days, finally turning up at Bellevue Hospital. The family had Pollock admitted as a charity patient at a private mental asylum. But you know how admitting that you have a problem is the first step in solving it? Pollock refused to admit—ever—that he was an alcoholic. Once he dried out, he told the staff he was completely cured. For some reason, they believed him.

THE LOVE OF A GOOD WOMAN

Back in New York, Pollock found a new supporter in artist/impresario John Graham, who invited him to participate in a show he was organizing. Also on Graham's list was a young artist named Lee Krasner. She had met Pollock before at an Artists Union party in 1936; a drunken Pollock had stumbled up to her and whispered, "Do you like to fuck?" Krasner slapped him—hard—in the face. Apparently she hadn't learned his name, or had forgotten it, because in November 1941, when she heard Pollock was among those exhibiting with Graham, she decided she had to meet him. She marched to his studio, where she found him miserably hung over but still willing to show her his work. Despite her later claims, she was more blown away by the artist than his art, but in any case Krasner pursued Pollock with single-minded intensity, and soon they were living together.

The tough-as-nails Krasner, who had never before cooked a meal and spent all her energy on her own paintings, suddenly became a model housekeeper, excellent cook, and first-rate promoter. Her own work went untouched.

MARCEL DUCHAMP TO THE RESCUE!

With Krasner's support and a reason to stay off the booze, Pollock became, in a remarkably short time, a force to be reckoned with. In 1942 Peggy Guggenheim offered to support him while he painted exclusively for her gallery and completed a mural for her apartment. When his first one-man show opened a year later, it attracted significant critical attention.

But he still had to complete Guggenheim's mural, all eight-by-twenty feet of it. At nightfall the day before the deadline, Pollock started painting and worked for fifteen hours straight. The result was a pulsing parade of heavy black verticals interspersed with swirls of turquoise, yellow, and red. As soon as the paint was dry, he and Krasner rolled up the canvas and hauled it to Guggenheim's apartment, where they realized in horror that it was too long!

Pollock called Guggenheim, and she sent Marcel Duchamp to help. Duchamp calmly suggested they cut eight inches from the painting. By then Pollock had found Guggenheim's liquor stash and was beyond rational communication, so the canvas was trimmed at one end and tacked to the wall. The artist stormed into Guggenheim's apartment in the middle of a party, staggered to the marble fireplace, unzipped his pants, and urinated. It had been a hell of a day.

JACK THE DRIPPER

It was also the start of one hell of a few months. To stop the binges, Krasner demanded that Pollock marry her. Then she found a house in Spring, a rural community on Long Island, and the two moved out of the city. Gradually, the quiet of the countryside fell like a spell over Pollock. He cut back on the drinking and started painting. He appropriated an old barn for his studio—an enormous space suitable for his large canvases. But the canvases proved unwieldy, so Pollock decided to lay them on the floor. The next step was, in an odd way, logical: He would drip paint onto them from above.

A lot of stories arose about how Pollock "invented" drip painting—that he accidentally thinned his paint too much, that he threw a brush in anger, that he kicked a pot of paint—but really he didn't invent anything. Other Modernists had dripped paint, not to mention flicked, poured, splattered, shot, and thrown it. What was different was not only the way Pollock covered the entire canvas with dripped paint but also the mastery he achieved in the technique. He developed such control that he could dribble and blob paint exactly where he wanted it. For one who had struggled so long with artistic mastery, who couldn't draw—couldn't even trace—to have such complete and utter control was enormously rewarding.

The initial reaction to the drip paintings was hesitant, but within a few years the floodgates opened and praise poured in. What tipped the balance was an August 1949 profile in *Life* magazine that included a photograph of Pollock leaning against one of his paintings dressed in blue jeans, with a cigarette dangling from his lips. There was something defiantly American about Pollock, and the public loved the idea of art that owed nothing to Europe.

> JACKSON POLLOCK HIT ROCK BOTTOM WHEN HE TOOK A BAD FALL OFF HIS BIKE WHILE TRYING TO PEDAL DOWN THE ROAD WITH A CASE OF BEER UNDER ONE ARM.

ON AND OFF THE WAGON

Even better, Pollock wasn't drinking. In 1948, he'd taken a bad fall off his bike while trying to pedal down a dirt road with a case of beer under his arm. The doctor who patched him up offered to help. He told Pollock that alcohol was his personal poison (so far so good), that he should never drink

again (okay . . .), and that he should take tranquilizers instead (oh, boy). What's strange is that it seemed to work. For nearly two years, Pollock hardly touched liquor (although he kept a bottle of cooking sherry buried in the backyard—just in case) and used the tranquilizers only occasionally.

Too bad it didn't last. In the winter of 1951, Pollock fell off the wagon—and fell hard. He started threatening to kill either himself or Krasner. He had hit Krasner before, but now the abuse became routine. At first she tried to deny what was happening, but then a sort of self-preservation took hold. She entered therapy and started painting again; her work enraged Pollock, who had always been jealous of her talent. A split was inevitable, even if the final trigger was unexpected. Pollock, who never slept around, suddenly found himself a girlfriend: Ruth Kligman, a voluptuous brunette, pursued him with even more determination than Krasner had fifteen years before. Pollock flaunted his affair before Krasner, who replied with an ultimatum: Stop seeing Ruth, or I'll leave. Fine, said Pollock, leave. She did.

AN AMERICAN ENDING

Pollock was stunned. Krasner headed for Europe, and the delighted Kligman moved into the house at Spring. Everything went well for about a week, and then Pollock suddenly turned his rage against her. After only three weeks, Kligman walked out.

Kligman was gone a week, during which Pollock was as lonely as he'd ever been in his life. When she returned for the weekend, bringing with her a friend, Edith Metzger, Pollock's mood was dark. The three prepared to go to a party, but when Pollock got behind the wheel he was already drunk. They hurled down the road, and when they reached a slight turn, Pollock lost control. The car hit a tree, spun around, and flipped end over end. Kligman was thrown clear, unharmed; Metzger was crushed to death when the vehicle landed on top of her. Pollock was shot fifty feet from the car and died instantly when he hit a tree.

When the phone rang for Krasner the next morning in Paris, she seemed to already know what was coming. She looked up and said, "Jackson is dead."

Jackson Pollock's influence was enormous. Along with artists Willem de Kooning and Mark Rothko, he is credited with inventing Abstract Expressionism. As the first art movement that originated in America, Abstract Expressionism became the United States' primary contribution to modernism and helped New York steal from Paris the title of cultural capital of the world.

It's hard to imagine where Pollock would have gone with his art had he lived,

but all that ended with his suicide, for his death was a suicide as surely as was van Gogh's. His story is as tragic as any in this book: so much potential squandered by a man who didn't need to draw to be a great artist.

!

THE BIGGEST POLLOCK PAINTING IN THE WORLD

The Pollock-Krasner house in Spring was just up the road from East Hampton and the estates of New York's richest. One night Pollock was driving with a friend when they passed the estate of a wealthy businessman named William Seligson, whose house was set in an enormous, immaculate lawn. "Did you ever see such a lawn?" Pollock said. "It's a goddamn green canvas. God, I'd like to paint on that." Later the same summer, after several days of rain, he drove back to the house and swerved onto the lawn, careening about and crisscrossing the verdant surface with long ruts that quickly filled with rain.

The police figured out who was responsible for the damage, and an enraged Seligson headed to Pollock's house. The artist simply explained that Seligson was now in possession of the world's biggest Pollock painting. Unimpressed, Seligman insisted that Pollock pay the $10,000 needed to repair the lawn, but instead Pollock offered to go back and sign the lawn, adding, "Then you can pay me."

Seligman's response is lost to history, but he did drop the charges when he realized he'd never see a nickel in reparations.

THIS NEVER HAPPENS AT MARTHA STEWART'S PLACE

In 1950 the photographer and filmmaker Hans Namuth convinced Pollock to let him make a short film of the artist at work. The process dragged on into a damp, cold November, and Pollock got fed up painting outside and enduring Namuth's constant orders. By the last shoot on the Saturday after Thanksgiving, he was at the slow simmer that preceded his boiling rages. Krasner had invited Namuth and others to a late Thanksgiving dinner, and soon Pollock pulled out a bottle of bourbon and starting downing shots. Krasner called everyone to the table, but Pollock began a fierce argument with Namuth.

Suddenly, Pollock stood up, clutched the end of the table with both hands, and heaved it into the air. Plates, cups, saucers, forks, knives, gravy, dressing, salad, and turkey flew in every direction. When the last of the cutlery stopped rolling and smashing, there was a long silence broken by the sound of the back door slamming as Jackson headed into the yard.

"Coffee," said Krasner calmly, "will be served in the living room."

WHO THE $#%&?

Pollock's style is unique and yet so easy to imitate that it's occasionally been difficult to distinguish a real Pollock from a fake. A 2006 documentary called *Who the $#%& Is Jackson Pollock?* concerns one man's efforts to determine if a painting he picked up for five bucks at a thrift store might be a real Pollock. A former director of the Museum of Modern Art says yes; a friend of Pollock's says no.

In another case, Boston College's McMullen Museum of Art exhibited thirty-two purported Pollocks in 2007. The paintings had been discovered in a storage locker in East Hampton owned by a friend of the artist. (Again, some experts say the paintings are genuine, but others think they're forgeries.) The show prompted discussion on, of all places, Comedy Central's *The Daily Show with Jon Stewart*, where "resident expert" John Hodgman displayed a reproduction of Pollock's *Number 5, 1948*, took out a pocket knife, and repeatedly slashed the painting, explaining "the cutting-it-up-with-a-knife test" is one of the ultimate tests of authenticity.

Another test, Hodgman claimed, involves licking (yes, with your tongue) a painting, since each has a unique flavor (a van Gogh landscape, he said, tastes of "raspberries and horseradish"). "What attracts collectors to original art," said Hodgman, "is the chance to own a piece of history, to gaze upon something that was touched by genius, and then to take it to your mansion, where no one else may gaze upon it, and then to lick it—oh, to lick it."

ANDY WARHOL

AUGUST 6, 1928–FEBRUARY 22, 1987

ASTROLOGICAL SIGN:
LEO

NATIONALITY:
AMERICAN

STANDOUT WORK:
CAMPBELL'S SOUP CANS (1962)

MEDIUM:
SILK-SCREENED POLYMER PAINT ON CANVAS

ARTISTIC STYLE:
POP ART

SEE IT YOURSELF:
MUSEUM OF MODERN ART, NEW YORK

"IN THE FUTURE EVERYONE WILL BE FAMOUS FOR 15 MINUTES."

QUOTABLE

Andy Warhol wanted to be famous—twentieth-century famous. He wanted the kind of fame in which millions know your name and the paparazzi follow your every move. He wanted Picasso to be a nonentity by comparison.

No one understood celebrity like Warhol. No one else studied it so assiduously or cultivated it so carefully. And no one else was as capable of manufacturing fame. As the ultimate creator, consumer, and critic of fame, Warhol packaged and polished the name brand "Andy Warhol" until every household in America recognized the silver-wigged artist. He had a great run, with his fifteen minutes stretching well into a half hour, at least.

STAR SEARCH

Andrew Warhol was the third son of Julia and Andrei Warhola, immigrants to Pittsburgh from present-day Slovakia. Julia babied Andy, who suffered ill health in his childhood and took up drawing during months of convalescence. Young Andy was fascinated with movie stars, particularly Shirley Temple, saving up his pennies to join her fan club.

In college at the Carnegie Institute of Technology, Warhol majored in art, and his fascination with fame grew. He became obsessed with Truman Capote, who lived in New York, made vast sums of money, and attended parties with movie stars. Warhol decided that if Capote could do it, so could he, and he took off for New York immediately after graduation.

Warhol could have started painting and pursuing gallery owners, but instead he threw himself into commercial illustration—that's where the money was. He worked twelve to fourteen hours a day turning out charming illustrations and before long he was in huge demand, but commercial success only made it harder for Warhol to be taken seriously by the fine-art world.

Even more difficult was finding his own style, for the Abstract Expressionists continued to dominate the scene. He tried everything he could think of to develop a style that would get him noticed. He painted a series of shoes (Warhol had a bit of a fetish), but it was too similar to his advertising work. He experimented with oversized cartoons, but Roy Lichtenstein got there first. He depicted Coke bottles but still felt compelled to add Abstractionist drips and splotches. Then one night a friend suggested, "You should paint something that everybody sees every day, that everyone recognizes . . . like a can of soup."

MMM, MMM, GOOD

The next day at his local grocery store, Warhol bought one of each of the thirty-two varieties of Campbell's soup. He'd always loved Campbell's anyway, particularly tomato, since his mother used to serve it to him for lunch. He made color slides of each can, projected them on a screen, and drew the outlines. He painted each variety of soup against a white canvas.

With the death of Marilyn Monroe in 1963, Warhol took the technique a step further and created a series of portraits of the star. Rather than paint them, he used a silkscreen process, a sophisticated stenciling technique often used for T-shirts that allowed him to make a series of identical images. Warhol produced twenty-three different Marilyn paintings, from *Gold Marilyn*, a single image silk-screened onto a gold background, to the *Marilyn Diptych*, two hundred repetitions of the same portrait across twelve feet of canvas. The portraits were both an homage to and a critique of fame: So much repetition turned the woman into a commodity, the ultimate price of fame.

The reaction of the New York art scene was electric. Suddenly Abstract Expressionism was hopelessly passé. (Willem de Kooning, a friend and rival of Pollock, stopped Warhol at a party and shouted, "You're a killer of art, you're a killer of beauty, and you're even a killer of laughter!") Pop Art was everywhere, and no Pop artist was more famous than Warhol. He started showing up at parties accompanied by a retinue of lovely women and gay men. To keep his name in the papers, he hired publicists who slipped tidbits to gossip columnists. Meanwhile, he refined his look. He was losing his hair, so he wore wigs, first blond like his own hair and then silvery gray. He added heavy-framed glasses that emphasized his owlish look and donned black jeans, black turtlenecks or T-shirts, and black leather jackets.

FACTORY LIFE

By 1963 Warhol's silkscreen equipment took up his whole apartment, so he rented a warehouse and dubbed it "The Factory." People started showing up at all hours, people with names like Rotten Rita, the Mayor, the Duchess, and the Sugar Plum Fairy—misfits, all—many gay or transsexual, and most addicted to amphetamines.

Before long, the Factory became a round-the-clock party. Warhol got hooked on pills but somehow kept working, expanding his efforts into underground filmmaking and the management of the band the Velvet Under-

ground. He reacted to Factory shenanigans with a dispassion that teetered between voyeurism and Zen-like detachment. His attitude could be chilling. When a Factory regular named Freddie Herko jumped out of a fifth-story window while high on LSD, Warhol said only, "Why didn't he tell me he was going to do it? . . . We could have gone down there and filmed it."

Warhol began to feel his power. In 1965 he decided to invent a star, so he transformed Edie Sedgwick from socialite into phenomenon. She found herself starring in films and profiled in magazines, but she also developed a massive drug problem and mental instabilities that would lead to her death in 1971. Other followers OD'd or collapsed from exhaustion, and many became bitter as Warhol's wealth exploded and they remained in poverty.

> EVER A FAN OF POP CULTURE, ANDY WARHOL GUEST-STARRED ON THE LONG-RUNNING TV SERIES *THE LOVE BOAT*—PLAYING HIMSELF, OF COURSE.

I SHOT ANDY WARHOL

In 1968 Warhol closed the original Factory and moved his business operations to an austere office suite, but the damage was done. With so many followers blaming him for destroying their lives, at least one had to be unstable enough to strike back.

On June 3, a Factory hanger-on named Valerie Solanas arrived at the office looking for Warhol. Solanas, who had appeared in one of Warhol's movies, was a radical feminist who claimed to have founded the organization S.C.U.M., the "Society of Cutting Up Men." Soon after Warhol arrived to discuss an upcoming retrospective with the curator Mario Amaya, Solanas stepped off the elevator, reached into a paper bag, pulled out a gun, and shot him. As Warhol scrambled under a desk, a bullet entered his right side and exited his back. Solanas then turned and shot Amaya. As staff huddled in offices and under chairs, Solanas turned to Warhol's dealer Fred Hughes and aimed the gun at his face, but the weapon jammed. Suddenly the elevator doors opened. Hughes whispered, "There's the elevator, Valerie. Just take it." She did.

Warhol was rushed to the hospital and pronounced clinically dead, but a doctor cut open his chest and manually massaged his heart to restart its beat-

ing. The artist recovered, although his health would never be the same; he had to wear a surgical corset for the rest of his life, and his scars occasionally bled if he overexerted himself. Meanwhile, Amaya was released with only minor injuries, and Solanas turned herself in; she pled guilty to attempted murder and was sentenced to three years in prison.

PREMONITION OF THINGS TO COME

The shooting brought out a cautious side in Warhol. He quit taking amphetamines and began eating raw garlic. He was still a fixture on the New York party scene, but instead of transsexuals and speed freaks he was now accompanied by Liza Minnelli, Bianca Jagger, Diana Vreeland, Truman Capote, and the fashion designer Halston. Instead of the Factory, he partied at Studio 54. *Interview* magazine, which Warhol cofounded in 1969, took off in the 1970s with stories about the chic world Warhol inhabited. To finance his extravagant lifestyle, he painted portraits—$25,000 per picture for celebrities like Brigitte Bardot and Diane von Furstenberg.

However, another side of Warhol became apparent as the 1970s ended and the '80s began. The artist started telling people that he believed in God, and he would sometimes go to church. He even painted a series based on Leonardo da Vinci's *Last Supper*. This spirituality was perhaps prompted by a fear of death: In the 1980s, Warhol's friends were beginning to die of AIDS, and of course he had died himself briefly after his shooting.

When his gallbladder started giving him trouble and needed to be removed, he reacted with profound fatalism. Despite all reassurances the surgery was routine, Warhol believed if he went into the hospital he wouldn't come out. He was right. The procedure was without complications, but the next day Warhol died in his hospital bed. The hospital was later charged with negligence for overloading him with fluids and failing to adequately monitor his condition. As Warhol's body was lowered into the grave in Pittsburgh, next to those of his mother and father, a friend dropped a copy of *Interview* magazine and a bottle of Estee Lauder "Beautiful" perfume onto the casket.

Warhol certainly didn't invent the idea of the artist as celebrity, but while Picasso, Dalí, and Pollock were artists first and celebrities second, for Warhol, the fame was just as important as the art. He never would have been content producing masterpieces in obscurity. His every move was scripted to bring him closer to that luminous state of celebrity he so desired. Today,

Warhol seems eerily prescient about the American cult of celebrity. What we are left wondering is, Did it make him happy? Once his face was as well known as Marilyn's or Elvis's, was he satisfied? It's impossible to know, so deeply did he bury his emotions. Warhol got what he wanted. What no one knows is if he enjoyed it.

PASS THE PASTA, PLEASE

At the opening for his last show, the exhibit at which the *Last Supper* paintings were displayed, Warhol was asked by a journalist, "Why are you doing Leonardo da Vinci? Are you very much in touch with Italian culture?"

Warhol replied, "Oh, Italian culture—I only really know the spaghetti, but they are fantastic!"

LOVE, EXCITING AND NEW

It's true: In 1985, Andy Warhol set a course for adventure when he guest-starred on *The Love Boat*.

Naturally, he played himself. The plot of the episode concerns a Midwestern housewife played by Marion Ross (yes, Mrs. Cunningham from *Happy Days*) who is startled to find Warhol on board since she doesn't want her husband Tom Bosley (a.k.a. Mr. Cunningham) to know that in her dark and misty past she was a Warhol superstar. Naturally, it all turns out OK.

A sample bit of dialogue: Warhol wanders the deck with a camera, and Isaac the bartender quips, "When did Andy Warhol become the ship's photographer?"

Cue laugh track.

THE ADVENTURES OF ANDY AND MIZ LILLIAN

In the late '70s, Warhol occasionally took on commercial projects, usually high-profile commissions from magazines. In 1977 he was asked to do a cover portrait of the Democratic presidential candidate Jimmy Carter, so the silver-haired artist flew down to Plains, Georgia, where he was delighted to

receive two signed bags of peanuts from the soon-to-be commander-in-chief.

After the election, Warhol was invited to the White House, where he formed an improbable bond with the president's mother, Lillian Carter. The two made an odd pair one night at Studio 54, after which Mrs. Carter told Warhol she hadn't known if she was in heaven or hell, but she enjoyed it. She later confided to others that she didn't understand why all the boys were dancing together when there were so many pretty girls on hand.

GONE TO BLOOMIES

Julia Warhola barely spoke English and didn't know anything about art, but she loved her Andy, and in 1952 she packed up her Pittsburgh house and moved in with her son. Warhol, just getting established as an illustrator and starting to make connections in New York's underground gay scene, wasn't exactly thrilled to see Mom, but she was content to cook him dinner and wash his clothes, matters he couldn't be bothered with otherwise.

The two shared a haphazard existence: Julia was a lousy house-keeper and Warhol was a pack-rat, so the floors and the furniture were piled with junk. Warhol's two Siamese cats started having babies, so at any given moment there might be a dozen cats pissing wherever they pleased. Friends found Mrs. Warhola odd but charming and tried to stifle their giggles when she said she was staying only long enough for Andy to meet a nice girl and get married.

As Warhol's fame grew, he moved with his mother to better, larger apartments, although the mess always expanded to fill the available space. Eventually, he settled her in the basement of his multistory home, whence she complained to the press that she never got to see her boy. Sometimes she would listen in on Warhol's phone conversations from a line in her room; the world-famous artist would whine like a teenager, "Hey, Mom, get off the phone!" It's not clear if she ever really understood Warhol was gay, even though she was on hand for several long-lasting relationships, such as Warhol's twelve-year affair with Jed Johnson.

Julia died in 1972, and Warhol promptly repressed any emotion he felt at her passing. Most Factory associates didn't learn about her death until several years later. When a friend asked Warhol about Julia, he replied, "I switch to another channel in my mind, like on TV. I say, 'She's gone to Bloomingdale's.'"

SELECTED BIBLIOGRAPHY

Anderson, Ronald, and Anne Koval. *James McNeill Whistler: Beyond the Myth.* London: John Murray, 1994.

Bailey, Anthony. *Vermeer: A View of Delft.* New York: Henry Holt, 2001.

Bockris, Victor. *Warhol.* New York: Da Capo Press, 1997.

Callow, Philip. *Lost Earth: A Life of Cézanne.* Chicago: Ivan R. Dee, 1995.

Etherington-Smith, Meredith. *The Persistence of Memory: A Biography of Dalí.* New York: Random House, 1992.

Herrera, Hayden. *Frida: A Biography of Frida Kahlo.* New York: Harper Perennial, 1983.

Hogrefe, Jeffrey. *O'Keeffe: The Life of an American Legend.* New York: Bantam Books, 1992.

Hughes, Anthony. *Michelangelo.* London: Phaidon, 1997.

Hughes, Robert. *Goya.* New York: Knopf, 2006.

Lee, Simon. *David.* London: Phaidon, 1999.

Levin, Gail. *Edward Hopper: An Intimate Biography.* New York: Rizzoli, 2007.

Marnham, Patrick. *Dreaming with His Eyes Open: A Life of Diego Rivera.* New York: Knopf, 1999.

Marquis, Alice Goldfarb. *Marcel Duchamp: The Bachelor Stripped Bare.* Boston: MFA Publications, 2002.

Naifeh, Steven, and Gregory White Smith. *Jackson Pollock: An American Saga.* New York: Harper Perennial, 1989.

Nicholl, Charles. *Leonardo da Vinci: Flights of the Mind, a Biography.* New York: Penguin, 2004.

Prideaux, Sue. *Edvard Munch: Behind the Scream.* New Haven: Yale University Press, 2005.

Roe, Sue. *The Private Lives of the Impressionists.* New York: HarperCollins, 2006.

Schama, Simon. *Rembrandt's Eyes.* New York: Knopf, 1999.

Spurling, Hilary. *Matisse the Master: A Life of Henri Matisse, the Conquest of Color, 1909–1954.* New York: Knopf, 2005.

Steward, Desmond. *Caravaggio: A Passionate Life.* New York: William Morrow, 1998.

Sund, Judy. *Van Gogh.* London: Phaidon, 2002.

INDEX

ACKNOWLEDGMENTS

Thanks must go first to Mindy Brown, Quirk Books associate publisher, for coming to me with such a fantastic project. I'm also grateful to Mangesh Hattikudur and Neely Harris of *mental_floss* for recommending me to Quirk and for inviting me to write about art in the first place. Mary Ellen Wilson guided me through the editing process and made the book so much better, while Mario Zucca contributed fantastic illustrations that make the book the entertaining art-historical romp it is.

The staffs of the Texas Christian University and Kimbell Art Museum libraries were endlessly helpful during the research process. Special thanks to Professor Babette Bohn of Texas Christian University and Professor Craig Harbison of the University of Massachusetts. Of all the sources used for research, the Art and Ideas series from Phaidon was consistently useful and informative.

I must also thank the mom's group at University Christian Church as well as Paula Gruber, Laura Moore, and Charlotte Huff for their nurturing friendships. Thanks to all my family, particularly Zena McAdams, for being such a loving and generous mother-in-law, and my parents, Tom and Martha Lunday, for their lifetime of support—and all the free childcare. To my husband, Chris, I say thank you for your constant encouragement and for listening so patiently to the artist anecdotes; to my son, Nathan, I hope you understand someday why Mommy was so distracted during the summer of 2007. Finally, as the orchestra plays loudly to get me off the stage, I dedicate this book to my beloved grandfather, Maurice Llewellyn Stanton.